The New Video Game Idea Book

Adam Jeremy Capps

The New Video Game Idea Book

2021, Adam Jeremy Capps.

Public Domain

ISBN: 978-1-300-02956-4

For the opportunity to help with creating a great game.

A Guide to Making Good Video Games:

Introduction

I can't program a game but hopefully you can. I will give you my best ideas here for a new game or to make an old one better. It's as simple as that.

I'll cover the best method and the best things I can teach you in your game making approach. I'll begin with I'll cover the things that make a good game. Then I will cover different ways that ideas are used- like how a character jumps or uses in-game money. Afterward I will give you ideas you can use in making new games. ND whatever good things I can write about concerning video game creation will also be written about.

My ideas here are free to use. With or without credit. With or without profit. And keep in mind that this is a public domain book. I don't good it under copyright. So please share my book. Maybe we can get some great new games made together.

My biggest interest is retro gaming. So maybe this book is better for older game styles. But often they go hand in hand. I am very often online watching all forms of it. Whether it is news, playthrough videos or just listening to music from them. As well as reviews of old games, top ten stuff, hacked video games and remakes, etc.

It's a great community- *the best*. A very large one, too. You'll find a large piece of the internet revolves around it. People are eager to talk about old games. To share their ideas, and so on. I invite you into it if you have not yet given it much consideration.

And may your game turn out very well and you have a lot of fun in creating it.

You can read this book randomly if you like until you've digested it fully. It is a short book that doesn't have to be read from the first page to the last. And thank you for reading!

Part One: An effective philosophy of game making

Some precepts, instructions, and advice:

The best games are simply those that are fun and involving. Fun and involving should be key words for what you are creating. Be after making a good product. One well polished, presented just as good as it could possibly be.

Cloning a game should be done better in a different way.. not just shadowing it.

Consider how the best games have evolved. While the first in the series was thought of as a great game, the second or third may have outdone it a great deal.

Think into themes. The best stories have come from the same pieces, just pieces put together differently.

Games should have good controls. Not frustrating ones.

The best music composers for games have taken obscure music and reformed it into their own music. It's just the inspiration that the best composers have. I composed classical music from my early years. There were certain lessons that stood out and helped me the most. They were about tonality. Tonality is all in making the music "make sense." That is done by not having the music be too complex to understand. I learned a simple method to make whatever I wrote be tonal. It is to emphasize the three tones of the scale's triad. That is the first note of the scale, the major or minor third (depending on the scale you are on) and the major fifth above the first tone of the scale. By emphasizing them with repetition, duration, and frequency, any music you write will be "tonal." The person that hears it will always be able to grasp it that way. Other than that a composer should be able to write nice melodies, and evoke the right feelings. As for an orchestra, you shouldn't at all need one. There is notation software for that. In fact many popular movies and games have employed them.

You don't have to go from beginning to end when making a game. You can work on things as they come along and tie them together later. Take the first as a draft and go from there. Strive to make a good product and you will.

Compare games to each other. Like one old fighting game to the next that took its place in popularity. It's never one that was just a pure rip- off clone. They did it "differently better." Look into the insides of games to see what you find. What is good about them or not will reveal a lot of good information for you. You can be inspired without outright copying a game. If you have a real desire to do whatever was done before but better and in your own way then that will lead to something new and good. If however you just want a quick buck- you'll get it, but you won't be remembered for it.

Resources for making games are larger than they've ever been and are sure to just become both more and better. No code is needed to know. There are many put-together softwares out there. There are things like pixel drawers and notation software too. Things like packaging is available- stickers, boxes, and mass copies of the physical games in some formats. The more you use these resources the more familiar and better at them you become. They might seem tricky at first but just continue using them because you will just get better and better at it.

Some games are just copies and they appear as ugly siblings to the gamer. It's always been true that as soon as a great new game comes out everyone else wants in. For every 1 original game there must be at least 5 that imitated it. A good game makes the same thing different enough to stand on its own. For example Mortal Kombat compared to its inspiration: Street Fighter 2. And did you know that Ninja Gaiden was inspired by Castlevania?

Don't depend too much on gimmicks. Some games steer too far off course because of them. Some are fanciful but just not traditional enough. Sequels that are that way don't feel like sequels. It's like a smart talker. They have neat things to say but they say things that are just useless in someone's everyday life. Making a smart game doesn't hold as much fascination as the programmer thinks.

Many things have been done and redone over and over in video games. They will *always* work well in any game however they are in it, like the use of money. Some ideas can't get

any better, it seems. And so don't feel you have to be totally different. Those things have stood the test of time and will always be things the gamers want in their games.

A good story is going to take the most work. If it is just glanced over in it's creation then you'll not have made a game that can compare to those that have. Some games are successful and have remained so just based on that.

Are you having trouble with knowing where to start? I would say begin by making something simple, gain a talent at it, and move onto bigger things. You might have questions like "it's not for the latest going system, so I don't want to bother." Or you find it easy to make a game for a much older platform, but that platform is obsolete. Actually because of the size of the retro gaming community and things like emulators, re-releases of older systems either as clone systems or mini versions, these concerns shouldn't be.

When you look at the first game to the third game in any gaming era, for 8 bit, 16 and so on, using the same hardware they have multiplied the quality of their games. They were certainly good at taking an old game and making it much better. New technology calls for new games. From very primitive music to full orchestrations, CD sound, 3D graphics, etc. Sometimes new hardware makes a genre popular when before its games were few and far between- such as shooters as 3D made it ideal. Being with the times is a sure way to go. After the 3D appeal cooled down we found many going back to 2D pixelated styles, or at least 2.5 D. We all like cartoons. There are people though that would think otherwise. They think movies are always better. That's not true though. People like cartoons just as much as they always have. In today's times, programmers are trying to make things life-like, realistic. That just makes a game tedious, plain, and boring. There's no imagination that way. No "escape." For a while it could have been said that old game formats were becoming lost. Old games were cheap just about everywhere you bought them. Like a dime a dozen. Now? They are among the most pricey things to collect. People are modding old systems, bringing to them modern hookups. Even a light gun made to operate on a modern TV. Old systems restored- new caps, new screens for portable handhelds of long ago, new 72 pin connectors, new optical drive, you name it!

Try to keep things simple. Keep it tangible for you. Know exactly what you have done and are doing. There is a lesson to be learned about the painter who didn't know when to quit. After a while the whole painting was given a whole other (and worse) coat. You want the gamer to have an easy grasp about what the whole game is about. If you have

a ton of items to pick from and buy in the game you'll never know which to get and when. Sometimes quantity is good, sometimes not, so measure your stones. One of the most important but most underlooked elements for game making is striking the right balance for its content. Things become convoluted over time. Everything that has been done has been done and its original appeal just isn't as striking anymore. So in measuring your new thing, trim it down and don't produce a thing that is over bloated.

Inspiration taken from movies isn't uncommon. It seems more frequent in some genres than others, such as fighting and beat em up games. There are a great deal of licensed games. Some companies were not able to secure a license so they just made it roughly the same. Metroid was influenced by the Alien franchise but not any kind of licensed game for it. It is a good feeling to take your favorite things and put them into game form. It doesn't take a lot to make them different enough if you don't want to obtain a licence or are unable to.

 All things are made up of the same pieces, just put together differently. Like a puzzle that makes a new image from thing to thing. Some pieces may not be used, some may be altered, but things like movies and games are based on their creator's favorite things only done their own way. Understanding your own tastes is very important. Going further than that by thinking how you would do it differently is, too. And of course it is important how well it all fits together.

There are good effects and graphics that are easily come by given some consideration and tricks. Music too and things. With limited possibilities from older hardware these had to have been come up with. On older hardware space mattered much more. So only the finer cuts could be included. Programmers were restricted from just putting anything in. There may be a lot more options now but many of the things in new games just seem to get in the way. I hear a fair amount of complaints against "better pixelated graphics" too. It loses a touch of the abstract that way. A picture had to tell a story. Games didn't go off into these long conversations. The RPG shop didn't give you anything imaginable. You didn't have to learn what all of those items did. On the other hand we are met with lush worlds in which so much can be done. Narration adds an element of personality to the characters. 8 bit was simply lacking whether we would admit it or not. So there was some loss but some gain. It depends on how it is all put together.

Do what you can to pull the gamer into the reality of the game. Being relatable is one of the best things you can do. Maybe that's why having human characters in fighting games makes them do better. The story can't be too generic. If The player likes the personality and appearance of a character so much the better. Over simplistic games

are nothing more than dull. Those games that are "collectathons" or require tedious "fetch quests" do no good for the player's interests. It is good to carefully give the player the weakest things to start out with and more and more better items as the game goes forward. Like Link's new tool or that amazing new spell. A story that captures the gamer's heart will build interest like nothing else. Having just the right variety, a lot of game area, contrast, and giving the player the ability to play as they want to, are other important things towards making a game be involving. Other than that, having a good game to begin with- control and mechanics are good, as is the music and playing in general.

Good games give the gamer the sense that *there is another place/world over there that I can't go to yet* (so wants to) and *there are going to be things in this area that I can't get that are better than what I currently have* (and so are invested in the game.) To invest a person in a game leveling up must be pleasant, gameplay must be smooth and operable, the music must be very good, and "what waits around the other corner" desirable to find, among other things. One of the worst things is to have a part of the story drag out longer than it should. The player wants to get to the next thing. Not continue on far too long for any given thing. For example those games that make you think you are going to get something but then the game hits you with additional quests before you can. You thought all along that it was practically in your hands only to find out there is one more thing to do or worse, a few more elongated things before it happens. That's like a friend who keeps saying he'll pay you back. "Wait one more day and I'll pay you more."

Can give the gamer a break from playing—giving them a little bit of cinematics or story telling. Tell them where they came from and how that led them to where they are. Give them an idea of progress

Sometimes the player doesn't want to be fully engaged and certainly doesn't for too long and too often. Like by having them face one boss after another or going after the same thing and they can't break from the game, it just keeps forcing them along. Maybe that's why mixed genres do well such as racing segments in a beat 'em up. Having a different flow from place to place is a talent that only the best game maker's know and use. First the fast pace then the next level a slower pace, is a good thing to incorporate into your game. Cut scenes between levels is a good thing to put in a game for these reasons. Zelda does all of this really well. Link can go off looking for heart pieces or exploring around if that's what the player would rather do- and it is very rewarding to do so. Breath of the Wild gave you a world where you could pretty much do what you want when you want and only if you want. So let the player take short cuts if it is the best thing to do. Fill the world with many things to gather.

Some games over text the gamer with forced pauses and such to read them. Give it as much as can be assimilated and no more. Wind Waker and its compulsive sailing may have sounded nifty to the programmers but really no gamer wants to have to walk places or sail places for long periods. Ghosts and Goblins expected you to replay the whole game again in order to officially beat it- with no difference. Some games have you beat the same bosses all over again without any differences to their reappearance. Another drawn out thing is when you are fully able to beat a boss except it takes twenty minutes or longer. They keep you at the threshold of about-to-die but you are fully able to survive. So you focus most of your time on healing yourself with a little bit of here and there attacking.

Don't be too unfair. Too unfair would be like forcing the gamer to take a hit, and couldn't prevent it. Enemies that respawn, pixel perfect strikes, being thrown backward when hit, and one hit deaths are some other unfair things. Some games expect you to get something you had no idea you needed in order to defeat a boss. Some expect you to solve puzzles that aren't really puzzles- holding down in Castlevania 2 in a certain area, for example, to go any further.

One game that has you re-routing yourself in different areas does well by making each area important but another would have you going out of your way to backtrack for little or nothing. Yet if you don't backtrack your character will die.

Don't be discouraged if your game doesn't immediately reach a desirable amount of success. There is a lot of competition. But there are many looking for hidden gems in the retro going community. My advice is to advertise it wherever you can. Get input from others. Maybe a sequel will do much better. Maybe your luck just isn't going well. Maybe it just needs better box art or be brought to greater attention. Just because your game doesn't do well doesn't mean that you made a bad game. There could be a number of other reasons for it.

Be cohesive. I'm sure there are a lot of things that people like to eat but to put it together in a soup could taste awful. Or you could relate this to a person whose clothes match up terribly though individually they are good shirts and shoes and stuff. Just like you mix a good drink, bring together a good game based on ingredients that suit each other. If this is true in any way then make a game of good taste.

Replay ability can be very important. With just a little change one level isn't beaten one way but also another. One level being played twice just for that. And even a flag pole at the end makes the level just a little different each time. Give the player enough continues to begin with. Make it challengeable but beatable. Assign more difficult levels where they should be. Place secrets in the game. Have a broad enough playing area to allow for at least a little exploration.

As they expect the game to go let it be. If every new element wasn't expected the gamer would have no idea of what's going on.

Some games were just too plain to have become successful. All the player did was strike and move forward. Least of all was strategy in them. No diversity really. And not even the platforms were ever different. A good game changes up the platforms, the powerups, items, graphics, adds water areas, underground areas, you can fly above, a world of ruin, a dark world on top of the regular one, can at first walk, then sail, then fly. They are robust with their soundtrack instead of quick tracks that wear out fast. They add new characters. They don't recycle enemies throughout- with no difference other than a color swap. They invite new powers, abilities, and tools for the gamer to use and go farther.

Ask yourself how you can include one thing in *your* game the best way. There are many ideas that have better or worse ways in their presentation. Making any given thing just right is a good thing to do. For example when Nintendo was making Super Mario Bros. 3 they wanted Mario to fly but they didn't want the gamer to just fly over every level. So they required that Mario needed to run before he could fly. Sometimes things get in the way of balance in the game. Sometimes the main weapon just invalidates all of the others. Some weapons and characters turn out to be useless. A good programmer gives everything its purpose. They execute things just right.

I've seen some very fun 2D games made by individuals but the graphics ruined them. They couldn't quite know how to make trees and things. They probably didn't practice. Drawing on paper is one thing, drawing on a grid is another. In pixel art form matters a lot. Such as the reason why Mario was given a hat.

The best items are sometimes a box of survival tools. The player collects these to proceed safely across. Adventure games can be surprisingly easy to make. Games like Zelda- not the more difficult made open world games in the series, but the 8 bit and 16 bit incarnations can be both fun and easy to create. You take things you find in life and put them into such a game, like a shovel, a flute. You add fairy tales. You provide tools that let the player enter into areas they couldn't before. Monsters on the field are creatively made. Really eerie dungeons are placed in and amusing people here and there. Personally it sounds like a lot of fun to program such a game.

Give the player what they want. Provide a character for every gamer. Like how Street Fighter 2 made a character for different major nations and a diverse set of characters. Then Mortal Kombat came along and gave people blood and gore. The SNES had a bloodless port- the Sega Genesis included it, the ESRB came along and Nintendo would decide to allow Mature rated games.

The question has often been asked: how do we combine different styles? Styles such as platforming with overhead views, or with a 3D perspective, sometimes with *pseudo* 3D. How can you have a Batman game without the Batmobile? For that reason Batman games sometimes have racing segments- like battle racing in the Batmobile or Batcycle. The rest of the game is usually some form of beat 'em up. The Legend of Zelda had a very subtle side perspective in dungeons at times. Super Mario Odyssey pulled off a neat 2D effect in a game that was mostly 3D. The Legend of Zelda: A Link Between Worlds allowed Link to become flat like a 2D image in order to pass through cracks in the wall. Dragon Quest 11 gave you the choice to play in either 3D or 2D form. Some games are 3D in a 2D way. The best example I can think of is Octopath Traveler. Some games have games within games like a visit to the arcade in an open world game or if it is just playing a card game. Mixing forms is an art. It sometimes works well for a game and sometimes not. Some people do not like it when one level is different from another.

The player should really have the sense that there is an interesting thing coming up. Give gifts to the gamer throughout. That could be job classes, new spells, new abilities, new suits, new weapons, a new world, the moon to travel to, and lots of other things. These can be alluded to. They can be predictable to some extent. Like Tellah who is trying to remember his greatest spell. Some of them could be called gifts for the player. The game just gives them good things again and again. They know that there are more espers to find. They know that defeating the legendary dragons will cause a good thing. They may not know what it is but they know it will bring about something good. In an RPG the gamer is always excited to see what set of monsters will be there in the

upcoming areas. They are always excited to learn what new weapons, armor, and relics will appear in the next town. They might have gotten bored in one area but they know if they continue then they will come to a new place. For sure RPG games have a "what's next" appeal to them. Really any game does to some extent. Like what the design of the next level will be. Where it will send you. The desert maybe, or an ice level. On top of a train, or wherever else. What the new set of enemies will be in a beat 'em up. What the next enemy boss will be and certainly what the last will turn out to be. So fuel that desire to see what comes next and the player will always be eager to move forward to the next thing.

The player should enjoy every place they go to. That's best done by giving each level or area their own unique personality. In Final Fantasy 6 towns were not just towns. They were none the same. It did really well in this regard. There was Narshe, a snow covered miner's area with homes on cliffs. There was Zozo, a town of crazy people. There was a town of secretive mages. There was a town of rich people. Certainly in every town you could find different kinds of people and had to engage with them in different ways.

Super Metroid is another good example. Every area had different enemies and great things to find- more powerful guns and suit enhancements. There was a spaceship to venture through, lava that could at last be traveled through. Monstrous aliens to defeat and one ominous setting more striking than before.

Make any given thing special. Who doesn't like going through the Lost Woods to get the Master Sword or stumbling upon the Magic sword in the graveyard beyond it? Or the charm of the ocarina player in A Link to the Past? You enter into a glade and there he is on a tree stump playing his flute. He disappears. You find that flute buried after you get the shovel. You play the same tune. A bird appears allowing you to transport to key areas. The point is- Link just didn't get the flute, the content surrounding it held a lot more magic for the player.

Make any tool have a robust amount of uses. Give it more importance than just a little bit of use.

Not dying over nonsense reasons: What is the worst thing that people always say about the original TMNT NES game? It was the level where you had to maneuver around the sewer water diffusing bombs. In that level if you came into contact with seaweed looking stuff you'd get shocked. It's not fun, it's just frustrating. In overhead games jumping on platforms can be tricky. Gremlins 2 for the NES was a great game- except for that. It was so easy to miss the platform for what should have been just a simple

jump. Who likes dying for nonsense reasons? You can defeat the hardest enemies but something silly like that takes your life over and over again. You could even say that the hardest boss in the game wasn't a boss but a platform.

Be cautious that one thing can make or break the game. The game could be wonderful yet it controls terribly. It has graphics anyone would gawk at. It is underwhelming. Some things are like good machinery with a wrench thrown into the gears.

There are a lot of sources to pull from. According to what you are creating you can read about old myths, cultures and their gods, ancient weapons and lifestyles, as you choose.

Ask yourself *why wasn't this ever in a game?* Movies can be a good inspiration. They always have been. I hear about it so often in the history of games that they say one movie or another inspired the idea. They weren't always direct copies but just representations. Maybe a good game maker is well read or has watched movies that fit well into games and so makes them. For making games a part of the maker's study could be just watching movies or reading. With how many books and movies there are there is no lack of material.

Find a good way to have the buttons used in a game. The most revolutionary games are those that innovated upon their uses. Not *just* new gamepads, but new uses of them in gameplay. I guess you could assign the color green to button x, for example. I always thought a gamepad that had LED lit color buttons would be a good addition to gamepads. Some games got it all wrong entirely- like having the down button make you jump. Some games require too much button work. Sometimes that makes the gamer fumble around clumsy with the controls. The NES may have had only two action buttons but it pulled it off very well. To throw a weapon you just press up with B. It may have been a little better for Mega Man however if you didn't have to open up the weapon screen. Really though that wasn't a problem. You may have only needed to switch weapons a few times during the level. Overall the L and R buttons on the SNES pad were never much used or useful. However in fighting games they were essential. That prompted Sega to make a 6 button controller. I would say be a minimalist on how many buttons are used. Even assign the same thing to different buttons as much as is practical. Keep it all cohesive- easily understood and remembered. Keep in mind that the button most used is the most remembered while the ones less used are the easiest forgotten.

When in doubt, look at life itself and the world. It has a lot to say. Shigeru Miyamoto made Zelda because of his childhood experiences about caves and adventuring around. Pokemon was made by a person that loved collecting insects. Some remember an old friend and base that on their character. A man was eating pizza and there was a slice missing- that's Pac Man. A person had a spouse that shied away from him whenever he looked at her- that's the ghosts in Super Mario Bros. 3. Games can be taken from your own biographical experiences. Just think of a place you loved as a child.

You can include biographical/autobiographical things in your game. The first town could be the one you were born in. The final town could be where you are today or perhaps where you would like to be. The items could be toys you liked as a kid. The main character could be all of your best friends in life. The music could be inspired by your favorite songs as a teenager. The clothing could be your favorite clothes or the styles of your time that you would like to return. Your relationships in your earlier years could be based on the love theme of the game. The architecture could resemble the homes you grew up in or places you loved to go to. And the cartoons, the movies, the things you enjoyed the most could all have their place in the game as well.

Ideas can be taken from history, from the Egyptians to the Romans, the Romans to the middle ages. Or the Dark Ages and the baroque. That could be based on the myths or fairy tales they believed in. It could take inspiration from their art and music styles. In particular their monsters could make good monsters in a game (the demons they feared or stories they believed about evil spirits.) They really believed in them and feared them! It made them good story tellers. We often see games have things based on them such as the Twamp in Super Mario games. If a game is going to have a fantasy medieval setting then studying their times is helpful.

They've often tried to change an old idea into a better thing, but to this day people prefer HP and MP and leveling up over variants of it. Good ideas never die. Some ideas should be included as are without contorting them too much. One of the biggest complaints about Final Fantasy 8 was that you got spells by drawing them. Whatever enemy you faced had spells and you used the draw command to take them. It was tedious and made the random battles much longer than they should have been. Sometimes innovation and creativity just sours a good thing.

New games for old systems can be made better than before. Space for a game has increased dramatically due to new chips. A person put a Doom game on a regular NES

cartridge. Emulators allow for different feats. Hardware is cheaper than it was before. A lot of this stuff is just old rudimentary tech.

It's hard to guess what will become standard. What new things are popular that weren't before. What new things resurface with much praise or what innovation will fail or succeed. We aren't brilliant enough inventors to really know, certainly not singularly. It's often said "why didn't I think of that?" But the truth is you almost never would have even with a great deal of thinking. Some game makers are more brilliant than others and have in fact made an enormous impact but those people are few and far between. Only the most dedicated will find that honor. Yet there are more games than not which they never could have devised themselves. Would Stephen King have written The Terminator? The Terminator is such a simple premise too. The simplest ideas turn out to be the greatest. A readily understood plot. An idea that suddenly appeared which led people to wish they'd thought of it themselves- how easy that would have been, yet they didn't.

Some innovation can be the worst thing. Like giving a famous character who was historically realistic looking a cartoon appearance. Some do not like how RPG games have turned more into adventure games. Some want random battles without randomness. To see an enemy then make a turn based battle come up, giving players the option to encounter no enemies, things like that are currently being hammered out. How much 3D should be in a 2D game? Are cartoon characters better than realistic ones? Sometimes the answer is easy. Sometimes less so. Usually the best answer is to let the player customize their own game to fit their tastes because not everyone wants the same game.

Let your imagination be active and fruitful. The best way to share your imagination is through a video game. It's the best way to put it into a form and bring it all together.

There are a *lot* of ideas around the Tarot that can be used. How these interpretations of each card are broad and applicable in real life lends them well into the life of a game. There are certain things in the world that are useful for developing imagination. Herbology for potions/ elixirs in a game, an encyclopedia of ancient weapons, certain books can help a lot and maybe even be fun to look for and buy.

Don't lay out all the cards on the table. Mystery is very involving. We want to know what is ahead. We want answers to these things that are hidden in mystery. Sometimes there is a power behind a power. Some enemies turn out to be your relatives. In Final Fantasy 8 your main party turned out to be your relatives from an orphanage. They just forgot

about that entirely because of the memory blocking effects of guardian forces. The King may have something up his sleeve when dealers a treaty with the resistance. Some games make you feel like you've figured it out all along, or at least suspected something all the while. Like that person who didn't seem to be powerful at all really is. They were just hiding their true powers "serving the king" but in the end took over his kingdom. Mystery is always a good thing in a game, depending on the genre anyway. It is easy enough- bringing about unexpected surprises. The best ones wow the player. The best one has the player put their hands over their mouth and think 'really?!'

Variety is important. It should be paid close attention to. In an RPG every place you go to should have its own personality. I've already talked about a lot of this but to go over things I haven't yet: you could say one good turn deserves another, to have two airships, the second one better than the one before, A wardrobe change in a game is always nice. Samus getting an enhanced suit, Link getting a blue tunic in about the middle of the game, Cecil becoming a paladin, or customizing your own suit like modern games often allow. Changing form was a nice thing in Final Fantasy 6. Terra could shift into Esper form and the story revolving around that was well done too. The more different you can make something from thing to thing the better. Like in a racing game even if it is just you go through mountains sometimes or race at night time. For a more extreme example there is Mario Kart where you go through Bowser's castle, ghosts houses and all kinds of things. Give the more rare thing. The thing is not impossible to get but just far less common. The player would even do all they can to get it. Whether it is the scroll items in Ninja Gaiden 2 (NES) or an item you steal with a low success rate. Like Mario Bros. 3 for a better example, getting the frog suit. There was only one in the game and it was arguably the best power up. In Breath of the Wild weapons broke often. It was a great idea but one perhaps too overused. However at least the Master Sword wouldn't break! And it was fun to go through weapon after weapon with just how different one was than the other. There are also rare occurrences that can be placed in a game. Such as in Mario Bros. If you hit the flagpole with certain criteria then fireworks will show.

To get the gamers attention is important. Things that put them to sleep or bore them are bad, of course. Yet so many games have long drawn out text and cutscenes. So many youtube videos I watch assume that I need a long introduction to the video that is about to come on. It is usually the same thing said so many different ways and it makes me feel like I am kind of stupid, not fully understanding the video that is about to be presented. Video games do this just as much sometimes. Modern RPG games often let you battle in quick mode. You don't really want to see the firework spells or hear the cheezy dialog- but just want to more quickly level up. I guess a little boredom in RPG games is inseparable. What's the point in auto-leveling up? Octopath Traveler was one

of the best RPG games I've ever played. Except for the long drawn out stories. Dragon Quest 11 had a fetch quest from hell in it when it came to the Rainbough. One often looked over thing is that towns and kingdoms in modern RPG games are far too large. Not only that but now places in the game let you go upstairs, from upstairs to the roof, from the roof onto a rope to another roof... And since it is a modern game it is far more than just finding some treasure chests. Now bookshelves have books to go through. Some of the books are just long stories like in a diary. Others though may have a valuable recipe for that stuff you find in the game. Some have side quests for you. A player could spend a half hour or more just to find a few good things in the whole city. What's worse, it is far more confusing since it is all in 3D! As for fighting games, someday the players are going to spend more time picking among the hundred or so characters than actually fighting. Yet they'd never find a character to fully appreciate with how many there are. In today's time minimalism matters a lot.

It is like Jack and the Beanstalk when in a popular game the character climbs up onto one onto a cloud with gold coins. They play the flute and a tornado takes them into a new land. Like mixing Mario with Wizard of Oz. I find a lot of things like that coming from certain games. It gives you coins to get an extra life. An arcade machine takes coins, the in game coins do the same thing. That's pretty smart! Castlevania 2 was like Zelda 2. One was Simon's Quest and the other was Link's Adventure. Both were black sheep in the family. Who ever notices that Yoshi has a frog tongue?

Some things may seem entirely bizarre yet work very well in a game. Kind of like in cartoons. Things that do not at all appear in real life. Or things in real life that are given life, like a ball and chain. Later that ball and chain was turned into a dog, in spirit. But they are kind of charming, a mushroom making you large? It reminds me of a childhood cartoon- Alice in Wonderland. I've always said that imagination is preferable over realism. The programmer has an opportunity to share their whole imagination with the world. There is DisneyLand, there is Mario Land too. We find few games with enough unique worlds behind them to make that so. The world of Mario has been fleshed out for sure.

You may find it very helpful to just draw and scribble on paper to come up with ideas. Coding may be difficult but every other aspect of game making can be a lot of easy fun. The ingredients must be just right. Have you ever seen the first draft of Yoshi? If they hadn't worked further on him we would have been left with this ugly looking dinosaur. Homework for game makers is just enjoying things that spur the imagination. It's not math problems but calculating the ways things are best done. It's not washing the

dishes but polishing the game. It isn't complicated cooking but just making sure the ingredients are right. It is drawing, art, writing, writing music. You can spend time on what you want to do among these. When you want to be doing something a little different then you can. Maybe the best virtue for game making is just patience. If you start to get too impatient then either work on something else or take a break. "Anything worth doing well is worth doing good." When you have produced a good product you can be sure it will always do well. It will be finished and when it is it will always be finished, a thing of your creation standing on its own.

Look into the opinions of others regarding games that are popularly considered either good or bad. They'll tell you what makes a game either good or bad. I would recommend the famous Youtubers that rate games. Like The Angry Video Game Nerd. There are many such Youtubers to watch and learn from. There is criticism, appraisal, reviews, history, and outright "good game making videos," among many others. Some game making companies won't even release a game before it has shown favor in the test market. Sometimes what the programmer thinks is good for the game turns out to be bad by most of the people who play it. Not just sometimes but often. If one piece in the system doesn't work then the whole machinery of it will not either. So what is most common in your game, like the most used functions in it, make sure they work and are appreciated.

Is it an acquired taste? RPG games once were. It took Final Fantasy 7 to popularize the JRPG in America. Final Fantasy 4 and 6 were steller games. They are now considered among the top ten games of the system. Chrono Trigger and Earth Bound especially have acquired a fan base much much larger than it had upon their releases. So in short- they were great games. They just weren't understood off hand quickly enough. Sometimes a game isn't quickly enough understood to be appreciated. They could be great games- once you learn how to play it. If a gamer doesn't know that then they might just drop the game before it was even given a chance. Maybe the second half of the game was great but the first half was very dull. First impressions are very important. Maybe it was better that Super Mario Bros came before Super Mario Bros 3 as the third game would have been too much on one's plate. Mario Bros didn't have a bad learning curve. In fact the first level was made just right as a tutorial. The gamer had time to familiarize themselves with the mushroom kingdom. Like my favorite line in any game: *It is dangerous to go alone! Take this.*

Don't feel as though you must cover all things right off the bat. That's what part two and three is for. Make a great game but don't overload it. Save that stuff for sequels. "Save

the best for last." It is like a good classical piece of music- the instruments appear gradually until they all come together. A simple story to start with is good. Sometimes it is as simple as "rise from the grave" in Altered Beast. One common complaint about modern games is that their tutorials drag on way too long. That can be called "super hand holding." Weapons and abilities in the game should be proportioned. Areas should be gradually accessible and a good programmer knows it. Having certain things unlocked after certain accomplishments is good game making. Through variety it may be done, giving levels secret exists for example, or branching paths.

You can provide a lot of chaos as long as you give the player an ability to sort it out and reform it with a natural skill. Wherever the game erupts with difficulty, provide this hidden thing to make it all easier. Jumping into an old Mega Man game can be quite daunting until you figure out the first boss you should fight. With whose power you can easily conquer the next, and from there in a paper rock scissors kind of way. There can be resources all around in an open world game. Simply make it easy enough for the player to learn how to use them. Don't require that ingredients be too precise. Just throw it in the pot and maybe a little good will come from it at least, and tell the gamer how that could be made better the next time. Very complicated things can actually be made to be easily understood. Like having so, so many abilities to learn but those are gotten based on job class, and just as you would expect, if you get the black mage you are going to be getting relatable abilities. If you pick the thief then all of that will be bundled in his domain. There are "branching trees" for new abilities/spells. With so many ability points you can climb the tree of abilities. The best ones are on top. That is another way to organize things in an understandable way. Some games have two buttons that do the same thing. Some let you pick what button does what so you can choose what most naturally suits you. Whenever you have new words for things in games make sure that the player is explained and understands what they are. Such as a character who says he is after the asterisk. What's that? If you are dealing with a lot of things in a game make sure the gamer knows what does what, how, when, etc., because with how much things new games have, the gamer could have either forgotten or missed an explanation for it, as there was so much to learn.

Simply teach the gamer what they need to know in order to fit themselves into it.

Having new or touched up characters is an important matter for sequels. You may have one or two characters to play as but before the series ends they have created many new ones for you. They are good contrasts to the original player in many cases. The graphics of them have been improved if they were in the original game. Any little thing that was

wrong before was corrected. In the new game you may be able to fight, race, or play as the enemy now. Characters that were not playable in the older game may be playable now. With many sequels being there a lot of characters in the game have accumulated. Some may have been ignored for a while but your new game includes them again. The characters may be used in an all different genre than before. Some games are highly suited for including all of the characters you or your people have produced in the past. Such as sports, board game video games like Mario Party, or some sort of fighting game. Most importantly, sequels should have new elements to them from characters to enemies in the game.

Then there are those times the character gains its opponent's power. To conquer them is to learn a trick of some kind or to take their spoils. Mega Man is one obvious example. He takes the robot master's power after he defeats them. Modern Metroidvania games allow you to take the power from whatever it is you defeat a few times. Kirby does it by sucking in enemies. Mario does it in Mario Odyssey by throwing his hat on top of their heads. Some RPG characters can take the monster's power in the game and reflect it back at them. In some RPG games you get a new job class from enemy bosses you defeat. For example an enemy boss that was a knight. After you beat him you can become a knight too. It is certainly a good thing to include in any game. You could say it is like being every character in the game or at least those with a lot of power. You can take that power from them and use it on others in the game. Who wouldn't like that?

Added value is when slight things are added to pre existing things. It makes them a little different, a little better than before. It is an extra touch and it can make a lot of difference. Polishing up games is like polishing brass. It looks good but it can look better. It helps to get a "later opinion." That is to wait a while after you look at something again to get a fresh perspective. It's like when you write a letter. Right after you are done you read over it and it seems fine. But if you wait a while before reading it over you find that things weren't worded right or some sort of thing like that. Likewise a fresh perspective for what you've had put in a game may suddenly appear to be done better if done a little differently. Extra touches can apply to any given thing in the game: its music, its graphics, and is a good thing to do here and there before your product is complete, and will make it as good as it can be.

Environment and atmosphere can set certain moods. Like when night comes in the game all of the monsters come out. Much better than just that if you consider Silent Hill. It could be a swamp you trudge through and must be careful there. Patches of light are

few and far between in the forest until you finally reach the glade you were looking for. It could be a forest with fairies and light gleaming down with a fantasy sort of music. They are special places with special things in the game. They could set the story and do so well. Some examples of the best intros in games? The Legend of Zelda, The Legend of Zelda: A Link to the Past, Wanderers From Ys 3, Mega Man 4, Ninja Gaiden 2, Most Final Fantasy games (4, 6, 7, 8, 4 Nintendo DS..) As for a mood set in a game not many games did much better than Super Metroid according to what it was trying to convey at least. You are on this alien planet. It seemed void of any enemy. Then you get a power up and a camera spots you. Enemies emerge. The bosses you found in the game were monstrous. It was such an eerie game. Contrast in setting can be very effective. That is, once you are in the regular world but now you are in the dark world or world of ruin. The Legend of Zelda: A Link to the Past, and Final Fantasy 6 could really be called two games in one. The map changed entirely after a certain point. No longer were things all gleeful but now a dark wreckage has been placed before you. Cecil looking into his soul is a very provocative thing. There he was before himself seeing the darkness within him, which he had to conquer before he could move any further in the game.

Evoking emotion gives the game a soul. Final Fantasy has done very well in doing so. I wasn't really surprised to find I wasn't alone when I felt what I did through the game and years later encountered others that expressed the emotional power of the series, too. Your very best characters, alive and joyful, at one point had to sacrifice themselves to save you. Celes attempts suicide when the world falls to ruin. She worked for the empire that caused all of it. Now she was abandoned on an island. After the only one with her, Cid, died, she tried to kill herself by jumping off of a clif. The game went from a regular enough tone to one of despair. Final Fantasy has always been a game about relationships and comradery, with friends so close they would sacrifice themselves for the others. Things like those give a game its soul. It isn't just an empty game but one rich with story and characters.

Frustration can lead to dedication especially if they are sure they can achieve it with enough practice. It may not be easy to do, but making a game that the player naturally gets better at just through repetition is the best way to go about this. There is at least one easy way to have it done, on second thought- which is through patterns. All of the enemies have their own patterns. That was how Ninja Gaiden was. After you learned the pattern it was much easier. If it was a difficult game it was because of other reasons. If it hadn't had those predictable patterns then the game would have been about impossible to beat. Another thing that can be done towards these ends is to give the enemies weaknesses. Whether that is a weakness to fire in an RPG or weakness against an item in one, or a weakness to a particular powerup in a platforming game. The idea is

that the player will find relief in finally conquering a boss. That sigh of relief will lead them much further into your game.

Part Two: Frequently Uses Ideas (the best of them.)

Some ideas never get old. These can be added to or possibly be used differently according to your imagination.

1- The player wakes up in a new bed. That's an expression of mine I made after seeing so many movies, stories, and games do it. It kind of makes the player feel like he or she has been elsewhere all along. It is a good place to start. You wake up and your mother or someone tells you something like "go to the King, he wants to see you." Or your uncle wanders off to save the princess. He woke you up and a moment later you followed him.

2- The player gets a treasure chest. Or a ball from a statue, or an item dropped by an enemy. Or buy it with in game money. Find it. Steal it. Earn it. Is given it. Smashes a block, it comes out. You can present items to the player in a limitless number of ways. Some are presented more neatly than others. So the question arises: what is the coolest way to give the player new things?

3- The money/coins buy a new armor, sword, ring, shield, herb. The money buys a weapon of some kind. The money buys a revival from the dead. The coins give you more life. The money is used in auctions. The money gets you various items. Gives you faster transport. Cures and heals. Gets you spells. Brings you help. Oh what money can do in a game!

4- An over world and an underworld. A dark and light world. A devastated world. A moon world. A heavenly world. A world of hell. Under water. On a mountain. In a cave. A dungeon. It shouldn't be just place to place with the gamer. It should open itself to all new places with all different people and things. To take any given thing and turn it upside down.

5- An item to continue. A favor. A note given. Permission given. Responsibility to continue. A needed airship. A train, a car. A raft. By conquering an enemy blocking the path. Magic to continue, the right spell. Buying your way through. Collecting pieces,

putting them together. These are among the many ways that a player can finally reach that new area. They could be given hints- like that higher area- why is it there? That raft in the water- why is that there? It could be something that makes the most sense. A guy in one area sells magic torches and there is this strange bush in your way in another part of the game. It only makes sense that the two would go together.

6- Jumping on an enemy. Striking or shooting one. Casting a spell on one. Barging right into them. Throwing something at them. Bonking them with your head. Things can be changed up too by picking up a weapon, new powerup, or stealing the abilities of your enemy. As great a weapon as it is, I am surprised that more games don't have a bouncing ball for a powerup, other than Mario land.

7- Collecting coins, bananas, special coins, keys, dots, parts. Collecting things in a side scrolling game is actually very satisfying. There's not much to it yet you want all of the coins or all of the bananas. There could be two or more things to collect such as regular coins, super coins, or letters to complete a word like "King." Sometimes if you get a certain amount of coins a new bonus area is opened up.

8- Food gives you extra health. A herb does. A tent. An inn. Certain accomplishments. A heart. They fight for pizza in Turtles in Time. Powerups have their own meter sometimes. Now you aren't just collecting coins but are collecting things to supply your weapons too. A common figure in games is of a heart. In Castlevania you use them for weapons. In Zelda you use them for health. In Popeye Olive is sending them towards you.

9- Certain things give you extra power. Just a dot (Pac Man), heart piece, ring, blacksmithing your sword or throwing your sword in a fairy pond. Charging your gun or sword for an extra powerful blast. Getting a new tunic or a new armor, a new shield, new suit, gives you greater defence. Some extra power costs your regular power- to cast a spell you have to use some of your health from your health meter. The whip can become longer, the dagger throws faster, the beam can become multiple shots.

10- The book or scroll gives you new magic. A wand, sword, other weapon, AP points, or just by leveling up gives you new magic. It could be a branch thing where you decide the direction of spells you learn trying to reach the top. They can be divided into job classes until the Red Mage who can learn both. It could be learned just by equipping a summon.

My most favorite of them is from Final Fantasy 6. Throughout the game only one character could cast magic. Turns out she is half esper. When you can equip espers then all of the characters can cast magic. What's more each esper gives you a choice as to what spells you will learn.

11- A character dies. A character joins. Changes. Betrays you. Turns out related. Becomes stronger. Does different things than the others. Has new talents, ones needed. Becomes good. Turns bad. Best of all are those that let you do neat new things. For example there are job classes for those and just certain characters given their own abilities. Final Fantasy 6 is the best example for this: Sabin can do Street Fighter 2 like moves (press a certain combination of buttons for a martial artist move), Cyan and his Sword Technique, Edward could use technology. Terra could use magic. After they all could use magic Terra was given the ability to transform into an Esper for more powerful moves (so she wouldn't be rendered useless.)

12- Eight enemies to defeat. Eight gems to collect. A certain amount of crystals to find. The most powerful sword. As long as it isn't a severe fetch quest then these can be good things in a game. If a sidescroller the equivalent to that is a collectathon. Unfortunately this was the only bad departure to form in Zelda. The original Zelda let you go anywhere, doing whatever you wanted really. The more you did the more powerful you'd get before the last boss. However- games after the original Zelda and the Zelda games before Breath of the Wild all had you go to places in a predetermined order. You would get a certain amount of orbs/spirit stones before you could proceed in the game. That just took the adventurous aspect of the game straight out. That at least until Breath of the Wild which is being praised by many to be the best Zelda game to date, if not in the top three for sure. Only those blinded by nostalgia would cite the original as the best, however.

There are a certain amount of dragons to defeat in order to get the grand summon. Those dragons aren't easy to find. They are even harder to defeat. The player knows they are out there though, and it adds both a mystery and an aspiration to the gamer. Ocarina of Time had Skulltulas. These spider-like things that were found throughout the game. Breath of the Wild had the Korak. Finding a certain amount would increase your inventory capacity. You just found them and gave them to this thing that did a special dance and poof! You can now carry more things. Which in a weapon break game, mattered a lot.

From the earliest days this idea was in games. At first it was just points. That representation of skill was lost with the arcades, pretty much. Have you ever seen the episode of Sinfield where George Costanza was trying to buy an arcade machine

(frogger) so he could save his point record? The store was selling the thing and he just couldn't lose his point record so he bent over backwards to preserve it. Games for a while longer had a point focus. Now they are just numbers to us. The first Mega Man game on the NES had points but not those after. For a while Nintendo Power was posting points in their magazine. You had to take a picture of your TV screen (this was long before digital cameras or smart phones) , develop the picture, hope for the best, mail it in, and get seen.

13- A hidden race (dwarf, elf, goblin, mages). A hidden castle, level, or item. They are sometimes hidden because of xenophobia. They may have an ability that would lead them into harm if they were discovered, such as making them a threat for a King's dominion. They may be in a place blocked off because of being misunderstood. What is misunderstood is feared causing a war between their kind and the other. Or they could just be underground dwellers who never knew there were people in the upper realm. They could just as well be a hidden faction against a dictatorship too. Final Fantasy 8 had a whole new city appear out of thin air. It was only shown to your party, those you are fighting for. It was a scientifically advanced area. A comparison could be drawn between it and Atlantis.

14- Transport by flute. Transport by item, beast, boat, vehicle, foot, raft, vine, moving platforms, magic carpet, cloud, horse, etc. One is just a minor transport to begin with. Like a thing that lets you travel across rivers but not the ocean. Then more and more opens up until you have an airship that can travel to the moon. One way of transport is having a bird pick you up and transport you. In A Link to the Past that was summoned with a flute. A Link Between Worlds, its sequel game, had a witch on a broom pick you up. Final Fantasy 6 decided not to go to the moon but rather a floating continent. It was a small area to get through but afterwards the whole world went to ruin. You were left again with limited ways to get around. Celes took a raft out of the island she was stuck on. You couldn't have a truly adventurous Zelda game without being able to spot any horse and ride it. Maybe riding a bear in that game went a little too far. Having a hang glider in that game was awesome, though. I would take that over Wind Waker's sailboat any day. Final Fantasy 8 had the best airship to date: a red dragon-like airship, complete with a gun. With such massive new games it is very nice when you come to the point the game gives you the ability to transport to any place you were before.

15- Bonded by responsibility. By kinship. By shared interests, responsibilities, relation, by fate, by desire. How all of the characters come together and how their relationships build over time gives the game its soul. They agreed to be together for a common

cause. They would go out of their way to save one of their own and sometimes do. They may include characters that were in it just for the reward much in Han Solo fashion. Over time though they see the importance of their cause. And then they go from only caring about themselves to caring about their team and the current bad world they are in. Every character can be involved in the cause for their own reasons. One may want revenge, others may want to save someone, or whatever else it is. Some just want a noble challenge. Others may just have no place else to be or to go. Some are just naturally your friend, in an innocent sort of way. Some are helping you because they know who you are, The Chosen One. While others just want to be with you out of love or interest.

16- Rescuing a princess, a friend, another's friend, those victimized, a mistreated being, a kingdom, is usually the most rudimentary of simple ideas. It's an easily understood plot that doesn't need a lot of story. Like Satan stealing your bride in Ghosts and Goblins. What other reason do you need? Bowser and the princess is just a spin on Dragon and the Princess like in the movie Dragon Slayer. Then there's Krull where the dragon was 'The Beast." Sometimes the game has you breaking into the jail to free a friend. In The Legend of Zelda: Link's Adventure Link is just trying to wake Zelda from her accursed slumber. That reminds me of Snow White where a kiss from the prince awakens Snow White. (Like it is so often movies are good inspiration.)

17- Limited time to leave an area. Limited time to beat a level. Limited time to defeat an enemy. Limited time to accomplish something. Limited time before nightfall. These are such adrenal pumping elements in games. At the end of Super Metroid you have only a short time to get back to your ship. The whole planet was about to be destroyed. The game basically told you "hurry up and beat the game!" It was a good way to end a good game. In Final Fantasy 6 while on the floating continent you had just a short time to get back to your airship. You could wait until you practically had no time left when suddenly Shadow appears and you take him with you. You reach the edge of the floating continent to your airship and it asks if you want to wait a little longer. If you say yes then Shadow will appear. It must have taken inspiration from Super Metroid, because in Super Metroid when the timer is running out you can side track into a little room to save some animals within it. (And if you do you will see some sort of pods evacuating the planet before it blows up.)

Super Mario Bros let you know that time was running out by having the music play faster. The whole idea of time running out in a level came from arcade games. That made sure that people were paying for the game.

Then there are time challenges and speed runs to kind of put into this idea- and really games should have speed running options. Such as precise timing instead of the player setting the timer himself apart from the game, options to set such as for deathless speedruns or no warping, since so many play old and new games just to speedrun them.

18- Bonus given for quickness, defeating an enemy, searching more carefully, more fullness, side tasks, or for helping a non playable character. In games you have a percentage completed. Super Metroid let you know what you were missing. The original Zelda game did, too, in the title screen. In Breath of the Wild you didn't have to do everything but if you did then you would have gained enough power to easily beat the game at the end. Some gamers are completionists. If not at first always, sometimes after beating the game they want to try for a higher competition. I was playing Bloodstained: Ritual of the Night, thinking I beat the game. I beat the last boss. But what did I get? A game over! It turned out you had to beat the last boss in a certain way. He was your friend. You are supposed to do a certain thing when the moon turns a certain way or something. Mario Land had you jump onto a quickly falling upper platform in order to get to the bonus room. Donkey Kong Country often had them only accessible when you were riding something, backtracking and bursting through a wall. Donkey Kong Country had it where your home was behind you. You think to go forward when the game starts. But if you go backwards then there is your home with some good things inside. Most players wouldn't know to go backward at the start of the level, so it was a nice trick. Sometimes it is done by having a monster treasure chest. The treasure chest still gives you treasure, only you must first defeat the monster inside of it. Any time a path branches out there should be a nice thing waiting there. I have played RPG games where you go out of your way for pitiful little reasons. The programmers may have thought it wasn't so out of the way but for gamers there is a different standard.

19- Becoming quicker, stronger, more resistant, immune, jumping taller, striking harder, lifting heavier things, noticing things better, becoming more able, reaching further with new items: it is the way a character evolves. It is a way they build muscle. In real life you are at the gym or a school to get stronger/ better in life. A better life in a game is in its unfolding, in its opening up. It carries the pride of things like going from level ten to really surprising yourself- you are now at level 40. What the gamer achieves they carry- it is shown in their suit, their weapons, and the gamer feels at least a little pride in it if they are going to enjoy the game at all. It can be quite pleasing to figure out a puzzle or have a question the gamer had for a while answered.

20- Fishing for items, slashing for items, breaking for items, finding them in bookshelves or wells, digging for them, climbing for them, swimming or saving money for them, is the economy of the game. Whole tombs and dungeons can be made just for one really special item- or summon, or new game characters. You could be at the edge of a clif in an area not easily found. It asks if you want to jump down. So the character does- and what they find below is one of the best things in the game. Getting items can be fun. They can be won in a mini game or be a prized treasure that lets you go underwater, deep in the sea searching for things. That is just a very specific example but all kinds of ideas like that can be included in the game. Who doesn't like going into someone's home, breaking all of their pots and taking their things without a word said about it? Some towns have waterfalls that you can pass through. Some have little water areas you can follow around until you find something at the end. Sometimes you may find a key that opens a treasure filled building.

21- The platform falls. The platform moves and twists. It hinges or tips. Is a rainbow beam or is on a chain. You turn on it in circles or bounce on it. You are shot out from it. It fades away, gets bigger or becomes smaller. These add color to the game. They are important, especially for platform games. (If the name of the genre doesn't say that then nothing else does.) It goes without saying that one of the most important parts of a platforming game are the platforms itself. Just look at what platforms have been made before and go from there. You may want a snake like platform as was found in Super Mario World, only the idea of it done your own way. You may want a falling platform. One that is bricks that disappear and reappear elsewhere- so you have to anticipate where it will next appear. You have to be quick in that case jumping from platform to platform. Some platforms can be reached by jumping upward straight through them. Some can be dropped down from by pressing the down button. Some characters can climb walls while others can jump from wall to wall. Some send you over water, others lava. Some are large chandeliers you swing around on. My advice is to just make it all really neat.

22- There are stairs. There are balconies, rooftops, there are walls, there are gates, and there are tree branches. There are hills, corridors, doors, and rafts taking you over water. There are missteps and some steps are better than the others. Safe places, dangerous places, and wealthier ones. In an open world game the player should have a sense of coming upon a whole different area, like a temple in the midst or a ghost town. First there are some weathered down walls until the center area of its kind is come upon. There could be a difference of trees in a certain area. It can be as simple as hills kind of going off into different areas. Things can be hidden behind other things. There can also

be shallow ponds, neat looking stones around them, abandoned houses or buildings, or anything you want.

23- Non playable characters that are soldiers, or friends. Helpful with advice or items. Reclusive ones, crazy ones. Defiant ones, and ones with a lot of personality that you may find throughout the game. In an RPG they should hint at where to go next or where to find things. Some of them can be funny like dancing for you in Final Fantasy 4. They may have some sort of joke. They can provide extra pieces to the story. You may run into someone being bullied and stop it. Afterward they give you something for it. They may offer a rewarding side quest. Sometimes they just give you things or money. That's more common in adventure games. You might just help them find their pet. They may have a code for you to say before you can proceed beyond them. They may be guards blocking off certain areas. When you are ready you may pass, or may have to sneak around them and find another way through. There are those of different professions: shop and in keepers, blacksmithing, alchemy, priests, and they can own horse stables. There are characters of royalty. They may seem entirely harmless but if you speak a word to them they will attack you- like the Yiga from Breath of the Wild. They knew you were the fabled hero going against Gannon whom they served. There are NPCs that run mini games. Like digging for treasure or basically gambling on something. One good thing to do is to create neat ways of helping others in the game. There can be different conversations pulled up depending on who is talking to the NPC. For example if you are a merchant they may sell you something or if you are a scholar you can read between the lines.

24- There are trees, herbs, flowers, plants, hills, mountains, rivers, oceans, castles, towns, dungeons, singular homes, bridges, caves, fields, forests, tombs, graves, pits, wells, and other worlds. So where do you begin? Just begin with what you want to and build around it. Give every place its charm and breathe life into it. Go the extra mile and make each place a special place. It is in your hands to make a whole new world. So how will your civilians radiate with life? What is the best architecture you will design from building to building? Into greater detail how would simple pots look? What is the best personality for any given person? How would they carry themselves? Where would the story of all of it go? Where will the game take the player? If the player is in any given area will they enjoy their time there? Consistency sometimes matters. To make the best dungeon you can and make the rest similarly makes it all memorable and brings union to them all. When you see a shop you know it's a shop or if you see a temple you know it is a temple. However there are some things that should be different from thing to thing.

25- There are games that effectively turn the simple into an entertaining experience. Paper routes, the organ trail, finding San Diego. Point and click games of lesser and greater complexity. Some are very illustrious. A great idea matters a great deal. Simple ideas have often been the best sellers. Like Tetris for example. A lot of simple mobile games have become great sellers such as Angry Birds and Candy Crush. There are a lot of "fiddle the thumb" games on the platform. Atari compilations have always sold well- pre 8 bit games (NES) on 16 bit (SNES) or higher (Playstation 1) systems. So certainly simple games can sell well but they have to be a good game to begin with.

26- The enemies overtake the world politically, through magic, using a powerful item, one that is mystic, or formidable. They gather crystals of power, or they defy the gods and do what was warned against by those who know. Sometimes they were just simply born to take over. Being a greatly powerful being. Sometimes they cheat their way into power. Sometimes they inherit a kingdom of great power and decide to take everything else over. The power that they took may have transformed them into monsters. They crave power and that power shifted them into an evil being. They may have a person working for them trying to break free from a dimension in which they are caged. They could be alien visitors of a technologically advanced race. They could be a monster that comes back every 1000 years. Final Fantasy 10 had "Sin." It required a human sacrifice to quell. It always returned however. It was religiously sent away with a sacrifice. The one destined to sacrifice it built up a team that became so close they decided to take on Sin itself and defeat it once and for all. That was a brilliant twist to the returning power concept.

27- Boss enemies are often creatures of some kind: dragons, monsters, serpents, spiders. They can also be something more of a beast than a creature. They can even be robots. They shoot beams, spit fire, jump onto you, and attack in many different ways. They have weak spots. They are sometimes very difficult to defeat, but much easier given practice. They could be those you ran into through some part of the game. They just seem human. Then it turns out they are demons and enter into demon form to fight you. They could be based on dolls. You could say demonically animated ones. There is that annoying octopus Ultros in the Final Fantasy series. There is a way of giving enemy bosses character instead of just being simple enemies with no real thing behind them. I've always liked Bowser from the original Mario Bros game though. It was his more evil/ wicked look. After that he became much of a cartoon and sure full of personality- but kind of cartoonish personality. The main enemy may have been your friend at one time but he became corrupt and now you are after stopping him and his nefarious intentions. The last battle may be their redemption. There is a lot of creativity possible with enemy bosses. They can be fiery snakes, things that are neatly defeated with arrows, things

that require certain tools as is common in the Zelda series, or some sort of monstrosity you'd find in Metroidvania games.

28- There are very plain areas. There are areas once plain like home, but something bad happened there. There are rainy areas, dark areas, spooky places, gloomy places, social places, mysterious places. Try not to make any one area the "plain" kind.

And there are areas that would feel risky for the player. There are some that feel sacred, some that feel safer than others. There are some that truly make the player feel as though they've stepped into a new world. And what once was may change.

How you block characters from certain areas is up to you. It could be that a very powerful monster prevents you from venturing past it- until you have gained enough power to defeat it. It could be you need a raft or something to pass through. It could be that you need permission from the King. It could be that you need more energy to climb high cliffs. There are many ways to gradually open up the play area- if you want it that way to begin with.

29- There are boss enemies that are normal compared to others. The normal kinds are just regular monsters, you could say. The others are like an evil group of dolls, a demon wall that inches forward requiring you to quickly beat it. They change forms and such too making them better than just ordinary opponents. An enemy may gather power in one form and if you attack it during that time you will have hell unleashed on your party. They may counter certain attacks like lightning spells. They may suddenly enter into their true form- like a zombie or demon. They may call for help. Then you have more to deal with until they are all defeated. They may have Reflect cast on themselves so any magic cast on them will bounce off them and hit you instead. They might cause certain conditions like rendering your weapons useless- of one kind perhaps, like anything metal. They may be fire bombs you are fighting which blow up and kill you if you do not dispatch them quickly enough. There is the Tonberry. It inches closer and closer to you and if it reaches you then it'll kill you dead. There is the Cactuar and his famous 1,000 needles attack. Always does as much damage. There are random battle enemies that steal from you. Then there are those that aren't enemies at all. They give you things then vanish. Yet they were in a random battle. Sometimes you are on an island you went to on an airship. When you encounter an enemy there then a totally formidable enemy appears. The undead you fight can be killed immediately with a life granting potion.

All of these prove that any given enemy can be more than just ordinary ones.

30- Items can be glamorized to an extent. They can be gotten normally, just by coming across them. Or more difficulty obtained. They may have required puzzles to be solved or things brought together that were far dispersed. And the setting behind getting them could be enchanting like a sword in the Stone in a forest kind of way. You may be asked if you want a spiritual stone or an equivalent sword. You could have one but not the other. It could be a thing you buy in an auction. It could be a weapon or item won in an arena. The sword could be tempered and yet better. It could be dropped in a fairy pond and returned to you in its most powerful possible form. The magic sword can be found in a graveyard or some sort of strange place. The sword may be able to randomly cast magic. They may be things you have to prove yourself in order to have. The original Zelda had a magic sword that you can only get with a certain amount of heart pieces and that concept returned in Breath of the Wild. There are super forms of any given item. First there is a low dose healing potion then a medium to strong one and from there they cure not one but your whole party. They can be one time use attack items. For example, cast a powerful spell once through a lightning orb or something. Or a surrikan.

One thing is important and that is that items are used to bring the game together. That is their best purpose. Some items let you flee a battle. Others let you attract the kind of enemies you want to fight. Some may be the only thing that saves you in a difficult battle. Some stop random battles. If you are far into a dungeon then a teleport stone can take you out right away. If you want to tie the game together better than items serve that purpose the best.

Items can go far beyond just face value. They could be obtained in special ways. They can have energy and spells to them. Such as charging them for a more powerful blast. They could differ from one to another and allow you to do so many things you otherwise couldn't.

31- There are countless things an item can do. Far more than just slashing or shooting. Will the sword in your adventure game slash like in a slice or be thrusted forward? What special aspect can you give to arrows? Fire and ice arrows? Powerful light or bomb arrows? They can be used musically, they can give you further reach. They can make you feather light, they can adjust your stats. And, going into things like relics from a certain game, can cause effects like protecting your comrades who are low on HP or auto cast spells throughout a battle. There are regen accessories/relics that auto cast heal on your party. Some relics are simple status boosts or give immunity to certain things (such as poison or a blind spell.) Some make stealing items more likely. Some will let you absorb spells to your benefit, double cast magic or do multiple attacks instead of one. Some relics give you all new abilities or make previous abilities more powerful like changing steel to mug. They are certainly a great addition to RPG games.

It's always good to have a second option. It's always good to give the gamer different ways of doing things just in case something has been made too difficult or unmanageable. There is more than one way to skin a cat/ where there is a will there's a way. There's no reason why a sword has to do only one thing, or an item, an enemy's weakness or anything else really. Just as an old sword can be tempered, better relics and accessories themselves can be. Items too. Maybe for example you get a bottle in the game that carries potion and you can concentrate that potion or magically make the bottle carry as much as you want. Call it "the eternal cup."

32- There are many adjustments an emulator can provide. It is fascinating how they can make emulated 2D games run in 3D.. to an extent. And I'm sure I'll be better soon enough. They've taken Mode 7 and have sharpened up the edges. And recently they've begun work on auto translation for foreign language games. There are things like auto ray tracing coming forth. Further in time I would guess they will be able to auto create games with AI. That's already so to a small extent anyway. The world will be more thriving, more alive, more detailed, etc. Right now we already have more than we can handle. So naturally help through AI systems would be very helpful. Sega Genesis had its own FX chip. It was only used in one game: Virtua Racing/ SVP chip. More and more tools for making games will allow more and make things all so much easier. I really appreciate "NES Maker." There are some geniuses working behind the scenes all the time, fully dedicated to releasing something awesome. Some old games would have been great given just one change or two. Others were plagued with problems. They are good things to work on and sometimes are. Some systems are given portability such as SNES handhelds. Others just do the ROM and emulator thing. Clone systems are widely available. System mods allow for modern inputs or backlight old gameboys.

One of the things I am most excited about is augmented reality. They don't produce literal holograms but make them seem all the same to have holograms before your eyes. Video games have progressed science more than just about anything. It was because of video games that computers have advanced so far. The internet didn't need nearly as much computational power. It was an important advancement, maybe the best, but it was video games that advanced technology.

33- These more non-human characters come in very many forms. They can be angelic or demonic, can be monsters whose origins may not be explained, or they are. They can be things you find on Earth. And they could be things found on Earth but in a different form. There could be aliens. They could be based on old myths, stories and ideas from long ago. From more recent fantasy books like elves. Or a Grecian Goddess. They all can be presented just in the way the game maker desires. In making an adventure game you will be tasked with coming up with unique enemies. Base them on what you think

would be the best to have in the game. That could be a centaur, a slime ball, anything you can imagine. What is important is how they act in the game and how they interact with you. How they are taken down and their moves against you is more important than their form itself. Sometimes you hit them and they split into two. Sometimes they were never meant to be hit at all, they'll shock you if you do. Some will jump out of the way when you are trying to strike them. Some have a shield and have to be hit from behind. Some jump and bounce. Other things to work out include how many hits they take to beat from weapon to weapon and what they drop when you beat them.

34- Party members can be handed to the gamer all at once or gradually as the story requires them. They can be bonus characters. They can be hidden. They can be hired for a fee or item. They can be temporary, disappearing/ leaving suddenly. In Final Fantasy 6.. Gau only joined your party after you gave him dried meat. Cyan's kingdom was poisoned by Kefka so out of a revenge cause he joined your party- had nothing of his kingdom to stay there. Gogo was found after the party landed on a small island. There was a monster on it that sucked in the party during a random battle leading them to an area where they found him. They are good examples. The game had a lot of playable characters. If in case you didn't find any of them the game even showed you who you were missing at the end of the game. (And it is always good to show the player what you can get in the game so they will know what to look for.) Every character has their own abilities. The more fun and inventive the better. One does things that the others cannot and each add a whole different element as played- is ideal. In an RPG you just have to look at job classes by whatever you call it, "different ability types'" is sometimes more accurate. In a side-scrolling game things are more simple. One character jumps higher, another goes faster. In a racing game one goes faster, other has better control, some are harder to spin out of control. In a kart game certain characters are more likely to get certain power ups and have a default racer to outdo. In a beat 'em up that is maybe the most simple. Every character has their own best trait- faster, stronger, one magic or another, one weapon or another. In a fighting game they all have their own powers. Some of them magic-like, others just special attacks. It is important to balance them out so that no one character has too much power over the others. There is a lot of imagination involved in their design. It is a genre that requires special attention to that design if they are going to do well on the market.

Whether your character bonks his head, has speed as its appeal, is an islander like in adventure island, a cave man like in Joe and Mac, a plumber, vampire hunter, ninja, whatever else- try to outdo what was done before and maybe you'll even have made a great mascot.

35- One party member can know things the others don't. They can have their own talents. They can have you interact with the gaming world in a way that the other characters can't. So they can open the world up more by being able to take more from it. Getting into new areas.

Other party members can be switched around in a way that is more suitable for the player. In these cases two heads are truly better than one. Like in Castlevania 3: Dracula's Curse you can eventually get three new characters. One with magic, one that can climb walls, and one that can turn into a bat. Different elements of play were easily opened up by the programmer by including them. Mega Man had his robotic dog that allowed him to reach areas he otherwise couldn't- or fly past more difficult areas. What a lot a little can do!

When it looked like you could go no further you made friends with an airship captain. The forces of light are behind you after all and working against an evil trying to befall you. Sometimes two characters join forces to cast a spell against something blocking the way. You may have made a wealthy friend that is inspired by your cause and decides to help you out, if only for an adventure. And he has a great ship to take you across the sea. Sometimes a new character makes the game both fun and easier altogether.

36- Each character can have it's own theme. While many games just gave music for every player currently being used other games will have their own music while they are being used. Each player can have it's own areas, in which they lead you to and in which they know everyone there. Certain music sets a tone. Like the sound of mystery starting to play. Music that begs for your involvement. A rush into battle music. Boss music, etc.- Whatever the things are happening in the game each have their own style of music behind them. Making good music for a game may be the most difficult thing to do in making one unless you are a natural talent. Sound effects are just perfect for some games like Ninja Gaiden (especially the game over sound.) Some are quite magical like in Mario Bros 3 when Mario is falling from the airship with a wand. Tetris on Gameboy had a perfect tune for what it was. I used to write good music- but it was all sad sounding. I didn't even notice that until my friend mentioned it. While writing music the mood must be focused on so you don't drift too far off from its intended mood. Classical/ instrumental music is still alive and well. It only went into movies and video games. People buy records of them, they remaster old video game music, and download them all the time. That's how much the music in a video game is appreciated. Some of these great composers though really just reformed old obscure music. It was an intention for the title screen in The Legend of Zelda to have Ravel's Bolero, but it was still copyrighted. And thank goodness! The original Legend of Zelda title screen music beats that any day.

37- Some games are uneven from character to character.. unbalanced, being much weaker than the others and so never used. In that case space was just wasted. Some characters have that one special ability but otherwise are useless. And in such a case the player does the same thing again and again with it. It can work sometimes, though. Like in the original Teenage Mutant Ninja Turtles NES game where Donatello had the best weapon. You could choose between the four turtles at any time in the game. That just left Donatello being preserved. Some players may want to challenge themselves by picking the weakest character. There can be times when the weakest character is the most essential. There can be the strongest fighter in a fighting game but that's okay if both players can choose the same fighter.

38- "There's no accounting for taste." You never know if a character you made is the best for all gamers. Someone may even like who you think is the worst character you made. Sometimes only one thing was missing: like a major part. Then in a new game their story is fleshed out more in a way that makes gamers like them. Sega used to make fun of Mario and the Gameboy's simple technology. You could even say that there was a lot to be made fun of there but the two did far better than Sonic and the Game Gear. There were a lot of characters in games made to be "cool" but were just laughed at. It was a risk to couple the new Gameboy with Tetris but it turned out to be the best thing they did. Nintendo takes a lot of risks. They are always testing the water. Some sink and some float but it has served them well. If a character in the first game does poorly then they can be taken out of the sequel. They aren't missed until they are gone. Bringing them back, they are sometimes even appreciated for the first time. A departure from form is one of the worst mistakes. To have this beloved character be transformed into something indistinguishable can undo its fanbase. It's like your favorite musician that tries to get inventive and releases songs nothing like their previous ones. Their fans don't like the change, though. It's like the video game Street Fighter 2: The Movie or The Legend of Zelda: Link's Adventure, and for some, Super Mario Bros. 2 USA. There are many examples of it in fact.

39- Some special items require a meter of some kind to use, such as a magic meter or just as a point system (like a weapon used takes one point of 20 uses.) Sometimes an item can be used non stop until the player gets hit, and so loses that item or weapon. And some items can be used more if another item is gotten. For example could initially be used, at most, 20 times, but now 30. And some items can be stolen from enemies. They all have in common restrictions to their uses. Sometimes a special attack costs energy. Sometimes one power up has to be gotten before a second better one.

40- The environment can shift from night to day. It can shift in weather. It can bring up things not there before. Some games are built around it such as simulation games. In them you can plant things, build your own home. The towns have very smart AI that brings it all to life. People change objectives in them. The game is adjusted according to what you do. And in games such as these ask yourself how they should be adjusted. Is it intuitive? Realistic? Predictable enough? There are games that split you into good or evil. Depending on how you play the game you either go down the light or dark path. Entire world shifting can be light and dark, balance and ruin, or time shifting. After every blood red moon all of the enemies you'd defeated return. One small thing can open up a large area. In the game it just looks like a cave until you enter it. That could contain a large area beyond what is just a little spot in the game. There can be an underground place that is as large or larger than the overworld. On the map it looks like two small houses but that takes you inside a large town. So a lot can be done with a map. The map is just a thing of representation for larger things.

Speaking of maps- they come in many different forms. The oldest of them were just dots on a rectangle. They may have given you some basic ideas like where the boss in the dungeon is. Sometimes information on the map is not given until you've come into that area. The player may have to climb a tall thing found in each region to activate the map for the surrounding area. They may have to do so in other ways too like there is a map area to access in Metroidvania games. Mode 7 was capable of making lovely looking maps. Maps can serve a purpose like auto-transport. Of course they are essential for knowing where to go. If in doubt a map can be pulled up and an arrow points at your next destination. Compasses are an accessory for maps. Sometimes they just tell you how to get around and other times they literally guide you with an arrow before your character. You follow that arrow. That is where you are supposed to be. That can be the best possible help for a gamer. Sometimes the map is just a screen showing what is coming up like in Castlevania and Ghosts and Goblin games. Sometimes the map shows different regions you choose from and go there one at a time according to what you want to do first. That is, a simple map with numbers 1 to 5 or however many. There are Super Mario Bros 3 maps- these are very well done. You have treasure rooms, secrets to find, a cloud lets you skip over a level. If you are in a two player game and beat a level, selecting it again will let player one and two battle like in an original Mario Bros game (not to be confused with Super Mario Bros.) Many side scrolling games came to include them afterward like Donkey Kong Country and Joe and Mac.

41- Racing games can let you buy car upgrades or new cars altogether. They can have you zoom around cities to greater or lesser realism. They can be based on the future, or just have a rocking and rolling theme. You can drive in cars or trucks. Go karts or tiny micro cars. They can have weapons, shooting or just throwing stuff. The tracks can just be a regular road or like a roller coaster ride.

In some of them you run out of gas. Some give you nitro gas for select boosts. Grand Theft Auto had you steal cars and just zoom all over town sometimes running from the police. Racing games are among the oldest of video game genres. While the Atari 2600 couldn't pull it off very well there were still people that liked them. Spy Hunter had a neat concept. You are basically in a 007 kind of vehicle with missiles and able to make your enemies spin out of control with oil slicks. Sometimes you even went against a helicopter. Sega made some excellent racing games. They had awesome car-like cabinets too, and one that was like a motorcycle arcade machine. It has always been two peas in a pod- giving the player a steering wheel peripheral for their racing games, and in arcades cabinets that were like real vehicles. Sega's Outrun blasted forth in what was called sprite scrolling and resembled 3D fairy enough. Sometimes a movie lends well to racing games such as Pod Racer from Star Wars Episode 1 or Batman games with the Batmobile being put in. Racing games are often included in genres other than racing games. Chrono Trigger was an RPG that had a racing game in it. Dragon Quest 11 had a brief moment of racing a horse. If racing goes beyond vehicles you could include Mario 64 or going against the jogger in The Legend of Zelda: Ocarina of Time. The Super Nintendo had a great library of games for sure and Mario Kart is its fourth best selling game. Mario Kart is a game that has very often been imitated. They shouldn't waste their time. It is altogether obvious that they are riding the coattails of Nintendo when they do it. Besides, only Nintendo has enough characters to pull it off. How far Sonic or Donkey Kong or some other franchise can go into a Kart game is far too limited. They could make all new characters for a new Kart game but that would be even worse. It would go against the point, the charm, that Nintendo created when they included all of their beloved characters in a game for the first time.

43- Some games change based on the actions you take. The player lives under some sort of karma system. To do good brings good, to do bad brings bad, but sometimes good can come from bad. Sometimes a wrong choice can be dire. It can have great consequences. And the game can be adjusted by how it is played by benefiting the player who does extra things. It is likely to do so may be difficult but possibly worth it. A game can give you a number of different endings according to how fully you play the game. It can take you on an entirely different path based on what you do. New open world games are becoming much more choice based. Octopath Traveller lets you choose between 12 different characters and the start of the game is based on who you choose. It was done in such a way that you get 12 games in one. There is such a thing as having too much on one's plate. It is an important part of game making to allow the player decisiveness. Sometimes an NPC bugging you to do a side quest is annoying. It is like a man that suddenly asks you to move his stuff into his new house. He offers you something nice if you do. You can get something nice like that anyway, in a more fun or leisurely way, maybe. Maybe you can but you aren't sure. Besides, you had plans. More

important things to tend to. Yes it is like that if only in a more subtle way. Maybe the game should just give you nice things according to what you do instead of pre determined and outlined side quests. That's not at all to say that some of the newer ideas out there aren't good. It's nice to change your look more, to pick your appearance like from a magic tailor or something, or just based on what you buy. It is great to gather resources throughout the world of the game. To kind of wander off into nowhere and find precious gems on large stones was a great thing about The Legend of Zelda: Breath of the Wild. Now in Mario Odyssey you become the Goomba or whatever else by throwing your hat on it.

44- The future of gaming, and its evolution- New downloaded content has become a thing. They can add quite a bit to what was already there. Games are fine tuned in such a way too. The gaming worlds are expanding greatly. With them more choices are available to how you will play. Way back when you could play two player games or four if you had an adapter of some kind, now you can play with dozens or hundreds. Just one little thing made such an enormous leap- the internet. The internet is making it where you don't even have to leave home to get a game. Some games are really cheap in fact. Systems are doing away with the optical drive. I predict that soon enough they will be done away with. We went from wired controllers to wireless controllers. That goes off of just two different things: optical drives add to the price and scratched CDs/ failure of the optical drive- the lens gets dirty or something. There is one thing more important than these and it is that optical disks cannot hold as much content as memory/hard/SSD drives. If augmented reality glasses do well then that technology will do well with video games. If the tech of that advances we may not even have big VR things, doing the same on the small glasses instead. It is like this: we haven't traveled to Mars yet but when we do we will be going there in style. What a new console will look like is unpredictable. I'm sure a lot of us try to guess. Then the system comes out and it is incredibly different to what we thought it would look like. Close your eyes. Imagine you never saw a Nintendo 64. You still have your Super Nintendo. You had it for a few years now. Now imagine what you think Nintendo's new console would look like. Open your eyes and see what it really is. It's purple. Kind of has two columns in front. Very curvy. Has four ports, etc. Man we were way off! As of the time of this writing the Xbox Series X, Playstation 5, and Nintendo Switch are the new consoles. I never thought the XBox Series X would simply be a rectangular cube or even be called The Xbox Series X. I admire its simplicity though. Nintendo is doing what they always did best: portable gaming. They know that price is more important than advanced hardware. That is something that is becoming more and more true as systems only have a short time left before their games can become lifelike. The Wii remote came out of nowhere too. So did the thumbstick. The future of gaming is to some extent the past of gaming. When it

came out the Super Nintendo Classic was the best selling console for a brief time. That's something that I've already covered so much before.

45- Some items like weapons can be enchanted or cursed, forged or blessed. Modified to be stronger. Having put together from other pieces and as strong as those pieces are is as strong as the item or weapons become. Final Fantasy 8 had the cursed lamp. If you use it as an item then Diablos will appear and by defeating him you obtain him as a summon. Zelda often had items made better by throwing them into a fairy pond. It's always a pleasant thing in a game when you have what you thought was the best thing to be made even better. Some games have a forge system. You combine parts and hammer it out to improve items. Sometimes you have to spare parts you find to be able to make a better thing because if you do so too early you won't have what you need later. In a more platforming kind of game your regular weapon can be made better. Such as a longer whip than before. In a racing game parts for your car can be improved. In a mech kind of game you can get more powerful weapons for the suit. In an RPG a sword can become more powerful as you level up. Final Fantasy 2 (NES) had it where your weapon gained power according to how much it was used. You would be best with swords if you used swords the most. People didn't like the system though and Square abandoned it. Betrayal at Krondor required that you polish your swords, and swords break, which is another disliked thing in games.

46- Some box art is so bad that it makes the game a failure. They say don't judge a book by its cover but people always do. Also, certain broken pieces can do the same for an otherwise great game. If you see something broken or needing to be fixed then don't fail to do so. A good product performs well overall. No one wants a car that can only go 20 miles an hour, works great except it chugs gas, left headlight isn't there, door is hard to shut, crack in the windshield, and likewise a game can be good save for one bad thing. Too much ambition can lead a gamemaker astray. That is when there is too much to deal with and not enough is known about how to put it in a workable frame. A minor but game breaking example of that is how the character jumps. They jump in a neat and untypical way- but it feels awkward.

47- Some games try to bring realism into it according to regular reality. For example you have to carry food to survive. You can only walk so far before you must rest. Like based on human limitations. You can only carry one sword, just like regular people. Maybe two. And they don't let you walk regularly in armor. Sometimes even the food you carry in these games spoils after a few days. The real world is for non gamers. The fantasy world is for gamers, not the non gamers. Games are at best a great escape. That's not

to say that all real life things shouldn't be represented in a game, but I would say that most shouldn't be. Yes in real life if you are hit by a bullet you are dead, but let's just pretend that we can survive 20 bullets. It isn't like the gamer is saying "why didn't I die? A bullet just hit me." People question fantasy very little in fact. We watch whole movies never once thinking it is all fake. Yet there are actors there with real normal lives entirely apart from the movie, entirely pretending. We are easily convinced. Lifelike isn't the way to go. That just makes it harder to pretend.

48- Games are often created from real life activities. Simple ones. Like fishing or hunting, playing sports games, and playing poker. A paper route. Most commonly they are based on sports. While these games quickly become "shovel ware" they have a good audience. My brother won't play anything other than American football games. They are good as leisure games in almost every case. They are games you can expect to beat in 20 minutes. Maybe Monopoly, Skip-Bo, Uno, Black Jack, Hearts, Chess, Connect Four, Life, even Mousetrap, Risk, Checkers, and so on and so on. There are many examples. Gambling too- slots, roulette, poker. Fishing and also hunting. A large number of sports. As for sports they aren't trademarked so feel free- just don't use official teams or athletes. These kinds of games can also be added to regular games. I use the term "real life activities" loosely. Whatever you see and do in real life though can be made into a game. Who knows, there may even be sports left out there which haven't been made into a game yet. It's Monopoly without the mess. It's Basketball without running. They aren't terribly time consuming. They are games for the non gamer.

49- Some game money comes just from hitting a thing: a block, a pot, blades of grass. Some come after defeating enemies. Some come once a game day. Some are salaries. Sometimes the money is hidden. Some games give you a whole career to make money. And sometimes it comes from things sold- those things you bought earlier from the same place or another, or just found it, or earned it. Money can be hidden in grass you hack away at. They can be coins that don't have to be circular, too. They can be hexagons of different colors and different values. You can be auto paid just by doing the right things in a game- a good and underused idea. Some blocks give you one coin, some can be hit over and over again to give you many more. Special coins can be hard to reach but worth it. Some coins are found in barrels or pots. How will your money look in the game? It can take many different forms. It can look like a gold coin, circular or diamond-like, could look like a pouch of gold, or it could just be a dollar sign. There are some NPCs that just outright hand you the money like from a thief who says "it's a secret to everybody" before giving you some of what he stole. I guess there should be a reason why some person in the game would just give you money, after all.

50- Some games have added value. Just an extra touch. And put all together they add up well, even *very* well. Too much of one graphic isn't good. Too much "sameness" isn't good. Water that doesn't at all move, it is just a blotch of blue. It's better to show the sword strike and possibly change colors and such. One of the best things you can do is change discouragement into encouragement. Give them more than what they asked for. Aim to impress, strike a mood, dazzle the eyes, Some great examples of game intros are: Ninja Gaiden 2 (NES), Mega Man 4, Wanderers from Ys 3, many Legend of Zelda and certainly most Final Fantasy games. It depends on the genre you are creating, but each genre has its own examples to be inspired by. I don't mean copying them so much as mixing them and putting in your own touch. Every player plays for the end of the game story. Further in the past there were some that were good but most of them were just way too simple. They weren't much more than credits being shown. Some games gave you a second quest after beating it. Whatever you do, do in style. Even if it is just a name creation screen. The Legend of Zelda: A Link to the Past had a neat name creation screen. Change things up a bit. Have one level a side scrolling level and another an auto scrolling screen. Have one on a train and another on a tower. Always have that one thing that is totally different and stands out from all the rest. Pay attention to the trees, the houses, and certain other things you draw out. Let imagination take prominence. A bad thing in many games is that the sprite work or polygon work looked like it was drawn by a five year old. Simple changes can make a big difference. In Mortal Kombat just giving Scorpion a different color than Sub Zero went across just fine. It was deemed more important to preserve game elements for other things in that case. Nobody will argue that the blue candle looks the same as the red candle. Color is very important to human vision. If you want to add a little more to the music then you can have it played in such a way that sometimes a different melody randomly plays. Most importantly save the best for last. Have at least a second thing for the most important of things, each better than the one before it.

51- Come up with a list of games you wish to take influence from. Like, perhaps, eight games that you'll be best inspired from. Then watch videos about them online, read strategy guides to see their contents, or play them. I only know what I do from many years of doing these. I have watched video game videos every day of my life for the last eight years. I wasn't studying or anything. I just enjoy them. Studying for a game maker can be the most fun that studying can be. Whenever you see a good idea you want to use, write it down. It doesn't have to be a video game either. It can be movies or books if you prefer.

52- 2D side scrolling games/ platformers can have the player riding a skateboard, even a little dinosaur or a rhino. A little boot, a mini car, etc. Or the player could be on a whole moving train. Could just be moving bricks.

Sometimes when they ride a skateboard it feels pointless. The fun of a skateboard is on loops and things, not just going forward. Sometimes game makers feel like a game element will be appreciated more than it is. They are like apples and oranges however. You can throw an axe now. After all, Mario just had a fireball. This guy has an axe to throw. But they both do the same thing. An example of an improved idea is a flute instead of a warp pipe. That would be what you could call midway better. The best warp idea I know of is in The Legend of Zelda: A Link to the Past. The thing surrounding the flute player on the tree stump. Beyond that even unto the Dark World mirror. As far as I know Mario has never warped to a dark world or did much more than just be lifted away elsewhere.

Things to ride in a platforming game can be like Blaster Master inside a mini tank you can get out of. It can be a go cart that you hop into. The game can also give you yourself different speeds like in Sonic. That can be running or dashing. Enemies themselves are sometimes the platform like riding on the shells of flying creatures. Joe and Mac lets you ride on terrordactyls.. I think.

53- There are ideas too much the same to be appreciated. Then there is a whole different way that the same ideas are done and it is refreshing. For example in Super Mario World you shoot out of a pipe. In Donkey Kong you shoot out of a barrel. In Super Mario World you could only go around on Yoshi. In Donkey Kong you could ride many different things. If you are going to use a pre-existing idea it is often better to do so differently enough so that it stands on its own. In a manner of speaking there are twins and there are cousins, there are fathers and mothers, what you want to create are grandchildren. You want to evolve what was there before. Generations pass and some are like old musicians playing old tunes, others are very connected with the times, some still listen to 80s music however, and they are both young and old.

 They are going to have to face it: nothing gets better than Tetris when it comes to fun puzzle games. The question is: how much fun are they trying to pull out of a puzzle game? They can only do so much. Are they looking for the exhilarating story of an RPG or its adrenaline pumping difficult battles? It's just a puzzle game!

54- Gamers have certain things to escape like a prison or cage. A town or other certain area. Perhaps an evil ruler and his kingdom. Or the planet itself which is dying, and food is being brought back and forth to it. A black hole to escape *into* or *out of*. Maybe even a galaxy itself! To escape from a ship in an escape pod. Or just from a place that's about

to go ka-boom. Some of them can be coupled with a timer. The way you escape a prison may be that your comrades break in to free you, going against many guards. You may have dug a hole. In Dragon Quest 11 you had a prisoner across from you who was waiting for you all along. He knew who you were all along. He was told you would arrive. So with divine intervention he successfully dug a hole before you got there and you escaped together. Then sometimes the guard is tricked into coming into the cell. When he does then he is overtaken and you escape. It could also be that a teleport stone was smuggled in. Maybe the prince or princess disagrees with your incarceration and decides to free you. Sometimes you are on the run. That can become a "you will not escape again!" kind of thing. Why you are on the run to begin with might be that you are hiding a powerful thing you don't want the king to have- or a magically powerful person, a treasonous knight or magician. You are keeping them safe or you yourself are that person. You could be a prince from a conquered kingdom. You escaped its devastation and now they are looking for you.

55- The player may be a victim seeking justice or restitution. Maybe just be after saving a person. May want change. To correct the wrong. Or just may be motivated toward wealth. Or to get all of its bananas back which were stolen. Whatever it is it is the purpose of the gamer themself. You could be a part of the king's knights which come to disagree with him on a moral basis- the king is too power hungry and destructive, even towards his own citizens. That's the way it was in Final Fantasy 4. What's more the king tricked him into blowing up a whole village. In Final Fantasy 7 you are trying to stop the planet from being destroyed by a very environmentally harmful corporation. Things like that are based on Gaia theory which Final Fantasy often incorporates into their games. The game can also have you trying to save a person. You might be trying to find them before the king does. You may be trying to warn them not to return to the kingdom/ dictatorship where things have become dire. They could be locked up and you save them. You may not even know them but decide to save them from execution. Fighting an evil ruler/ dictatorship always makes a good background for a game. Think about it: in fighting games (Shang Tsung/ Bison), Bowser and his minions, Sonic, Mega Man, Ninja Gaiden, Castlevania, Final Fantasy, Dragon Quest, and many others have them, too.

56- Weapons can whip, can slash, can go straight, can be thrown, can be tossed like a curve, can shoot flame or ice, can be magic wind or a magic made quake, a lightning bolt, even an eruption for a very powerful effect. Can be called down as a meteor, and so can relinquish a few enemies or a chunk of the world, a town, in good or evil ways.

Some games have inventive weapons. Rygar has a rope saw blade thing. Mario had a bouncy ball in Super Mario Land. A ninja has a shuriken. Batman has bat shaped ones. One weapon is a claw hand like Wolverine or Vega from Street Fighter. You see

the claw hand used in many games and movies. The more inventive a magic attack is the better. That means going against the norm to do something creative. Like "Pearl" ("Holy" originally) in Final Fantasy 6 for just one example. Mega Man has a wide variety of shots to choose from. They are unique forms of bullets or whatever you would call them. I have to wonder why they haven't made a good 3D game for him yet considering that. The axe throw goes in a North East direction, the dagger goes forward, Holy Water goes on the ground, and it seems like the makers of Castlevania paid attention to direction. Some games have weapons that are impractical. Really bad games have the main weapon that way. Some are just not neat enough, might just be an orb you throw and that's all you get. Instead of Holy Water Arthur causes a fire on the ground. Like the same way you use Holy Water in Castlevania but in Ghosts and Goblins what you toss brings up a flame. There are time stopping items. There are invisibility items, like the star in Mario. I like the flame surrounding Ryu better. If anyone needs an invisibility item it is Ryu!

When they gave Link the sword in A Link To The Past they decided he would swing the sword instead of thrust it. That was a good choice too. In fact the game wouldn't have played or looked the same without that. Some complain that in Castlevania 4 that the whip is overpowered. It could strike in any direction and was the best weapon to have, so much that all of the others were pointless. Though I disagree, some say the same about the Mega Buster in MegaMan.

When they went into 3D they had to consider 3D things. In Zelda games the bats were no longer around in a two dimensional way. They were now all around you in a 3D space. So they made things like trigger hits. They took advantage of the new 3D space. For example bombs could now climb walls.

Weapons should serve their purpose well. Should be fun to use and usable. There should be a weapon for every time and place. The same just as well applies to armor, shields, and items. If you can, make it all come together well, and make it so that one thing lends well to another.

57- Items can freeze the rival, slow them down, speed oneself up, shift time, dimension, space, warp the rival, or send them elsewhere. Final Fantasy 6 had a spell called "X-Zone." It was too powerful to be used in most places. It really worked on very few enemies. The spell just defeated the enemy instantly by sending them to the X Zone. There was one enemy it worked well on though. They were frogs near a wealthy town that gave you the most Gil in the game. So the magic turned out useful after all! Teleport stones are one of the best items in some RPG games. After going through a dungeon or area of some drawn out kind it is very good to just use one to get right back to the entrance. Haste has always been a good spell in RPG games. They make you faster at everything as the name suggests. Casting slow makes your enemies act slower.

Sometimes a game has a day and night cycle. Often at night time there are harder enemies but better enemies for leveling up. And there are things in the game that will let you go straight to night. Such as a resting place that asks if you want to wake up in the day or night. Also, different things happen at night in towns. More places are closed or locked up and you may want to choose to wake up in the day.

58- Sometimes you take your enemies power just by defeating them. Sometimes by swallowing them. Sometimes you jump on a turtle and throw its shell. Sometimes you steal the rival's things. At best there are modern Castlevania games. Better than that in my opinion- is Bloodstained Ritual of the Night. In it you can gain the power of anything you defeat after a certain number of times. Whatever you defeated you gained its power. If it was a fairy then you will be able to have one fly all around you like BEAT from Mega Man 5, or you got the magic power from it. In older games we couldn't possibly pull this off, tech wise. You could get 8 new guns in Mega Man. Now there can be hundreds. Not gotten from just bosses either but from whatever you beat in the game. Mario Odyssey used this idea, just differently. You possess whatever you throw your hat on.

 Then there is taking enemy power with RPG beastmaster job classes. Whatever you capture you can summon after that. This is played out in different ways. Sometimes it is just an imitation ability. You use an enemy against itself in that way. It could be that once you learn the monster's ability you always have it. In Final Fantasy 6 things were very specific. You had to have Gau and could only take the monsters on his continent. You leap into the monster you want to learn. You fight around awhile on the continent and eventually (quickly enough though) Gau returns. He can now use the power of that monster. The beasts on his continent are highly varied. If you are lucky then a really powerful one will appear so you can get its power. Bravely Default 2, a Nintendo RPG from Square Enix, had it where you had to weaken an enemy enough before you could capture its power. It was limited to how many times they were captured, meaning that you could only use its power by how many times they were caught. If you catch them once then you could use them once, if five then five, etc.

 Then we can't forget Kirby. He gets the power of anything he sucks in. In popular opinion it is a great thing to include in any game!

59- Power ups can make you a beast of some kind (like a wolf or bear.) Or a creature of some kind (like a dragon or spider.) Or just larger. Or give you power. The ability to fly. To move faster. They can give you an advantage. But there are power *downs* too. Like making you an imp-pig or reducing your abilities.

 One thing done in games is that you are secretly not human. You are maybe a fairy and fairies are hunted down, so you have to hide the fact. I've seen that very thing

twice in fact: in the movie Legend and in the game Bravely Default 2. The character may not even have known they were another being. Like Terra from Final Fantasy 6.

Mario gets bigger with a mushroom. That is a good enough explanation. We all know that mushrooms are strange things, so why not? He gets even bigger in New Super Mario Bros. In Altered Beast you become a Beast after getting so many orbs. You suddenly then have a lot more power. Many RPG games have limit breaks or by whatever name, a meter that goes up until you can unleash much more power than regularly. Sometimes that is so when you are low on HP. Sometimes it is just a given, a once in a while thing, sometimes it is according to a meter that is always slowly increasing. In changing forms you can become a bat like in Castlevania 3: Dracula's Curse. The idea there is that in a different form you can do different things. In a different form you can be more powerful. In Metroid you can turn into a ball and roll around getting into areas you otherwise could not. In The Legend of Zelda: A Link Between Worlds you could even become flat. By becoming flat you can cross into narrow cracks.

When you go into a different dimension you may take on a different form. No longer human but a half human half rabbit like in A Link to The Past. Sometimes just by going into a certain place your form changes. Dr. Jekyll and Mr. Hyde on the NES is regarded as a terrible game but it sure had a style! With tweaking that game could be made into a good one. In that game when you die in human form you enter into Mr. Hyde form. The most simplistic way of changing form is just by changing characters. That's an obvious one but some beat em ups make you play the whole game based on your initial selection whereas Teenage Mutant Ninja Turtle: Turtles in Time lets you switch between the turtles in the middle of the game. Likewise in the original NES game of the franchise you could switch between them in the middle of the game. Most side scrolling games don't allow that. Super Mario Bros. 2 was close. Before the start of the level you can pick a character. Most fighting games make you stick to the player you initially chose. Being able to pick a new character on the fly makes games much better yet it's a thing underdone.

60- Mini games can be added. They range from the simple to the complex. From card memory games to difficult puzzles. They include card games and games based much on luck or skill. They can be a "do at the same time" thing or a fishing game where you need to catch a particular thing. They can have you digging for something or playing a long Melody on a musical instrument.

In side scrolling games they usually come in the form of bonus rooms. They go as far back as Super Mario Bros where secret pipes led to coin rich areas, or vines up into clouds with the same. Later they would have you collecting letters. Like those that spelled a thing out. Once all are gotten then a bonus room would start. Super Mario land had tricky platforms at the end of every level to reach a bonus room. A game like Super

Mario Bros. 3 had it where if you beat optional levels you could go to a bonus room after. Some bonus rooms are hidden behind walls- invisible ones, maybe ones where you had to burst through on an animal you were riding. Some are hidden in other ways, and are just out of place. Some games made it seem like if you jumped into a pit you would die. Yet if you did you would fall into an area with a special item.

Mini games can be in gambling form. To pick one of three things. Two contain nothing. Three contain something great. Like the spin around cups hiding something where you have to keep your eye on the one with the best thing. Some are claw machines that you have to let down and grab what you want the right way. There are card games of all kinds. There are match three. There are match based things. You match as many things as you can as they quickly change. Those are like a slot machine in one form or another.

Sports things may be among them such as racing to win, baseball, or whatever else. Mini games can be puzzle based. They can require you to find a hidden thing with a shovel. They could have you hit things with arrows. They can all be timed and reward you for quickness.

61- Some RPG games would have you taking notes to review your progress or just to be able to remember a certain thing you'll be asked for later. The town's people can indicate where you should go next. The map can show where you need to go. Before the game starts they can give you a general idea of where you've been and what is coming up. A fairy or owl could give you advice (hopefully not as annoying as Navi.) In a platforming game they can give you a good idea of how to play the game on the first level. In a racing game they can give you an opportunity to practice. In a fighting game they can too. If you need to learn more there can be menus available for that. Often in modern games the load screen will list some good advice. With the fullness of modern games there is a lot to learn.

If nothing else works, the internet will. We used to use strategy guides. From the early days of the internet online guides were available. Most of them were made by everyday people. They allowed free downloads of them too. I remember in the late days of strategy guides they'd be too lacking. They'd say "go to our website to learn more." A gamer doesn't even have to read to learn more about their favorite game. They can watch specific videos about them.

Some games however have become such hand holders. Sometimes you aren't even likely to remember it all. Efficiency of button uses should be more of a thing.

62- Some RPG games give you a larger part in improving your stats, as you wish them to be. Though some only let you improve your stats by defeating enemies in the game. It's always great when you can pick and choose what stats you increase. Take the speed stat. The higher it is the more quickly you can act. Where it once took a minute or so from character to character now takes seconds. The person you raised it for acts a few times for every one time the others do. Some stats are incorporated into weapons. Like Aim and Strength. The stronger you are the heavier swords you can wield. The better your aim the better you are with arrows. In their own ways these open up the game. Singular stats can be improved in a number of ways. The first and most common one is just by leveling up/ getting experience points. Much more than that is possible though. It could just be an experience orb you find that requires no fighting. It could be gotten through side quests/ errands. Armor and shields increase defence. Wands increase magic attacks. Magic robes increase magic defence and all of these can be very intricate. Accessories in particular increase specific stats. If you want more stats per character to increase you can do the old trick of killing other characters off to take what would have been their experience points. Magic can temporarily increase stats. Like casting a strength spell on a character.

63- Some games will have you asking "what?!" And others may bring you tears. Some will make you angry, either with unfairness or insult. Some will give you a sense of wonder. Others will have you acting precisely, requiring your full attention. Some charm. Others are mysterious. Some are involving. Others are just plain interesting story-wise.

As for setting the right mood, maybe the best way to go about it is by setting many moods. A game diverse with feeling has a lot of soul. Some moments you laugh, some you cry, some are happy, others are sad, and they all help out the other. That's not to say that some games aren't better off evoking just one mood or maybe only two. In some games happy feelings don't belong. The whole setting may be apocalyptic or something. Some games are just amusing and charming. They have magical moments in them at best. Some games did good with the setting but unfortunately weren't good games otherwise. I would list The Immortal (Sega Genesis), Dr. Jekyll and Mr. Hyde (NES), 8 Eyes (NES), and Dragon's Revenge (Genesis) among them. 8 Eyes had this cool thing where you stop by a table and living skeletons give you food. The Immortal gave you the feeling of being in a strange and unusual place. One like "how did I get here?"

The last enemy boss is always so sure that you can never defeat him. As a result he doesn't really bother to try. You are just annoying flies getting in his way. He doesn't want to waste his time on you. Some stories are timeless. They will always be among the best gaming literature, to coin a term. It may be someday that people will remember these stories more than any book. If you want an example of the scariest enemy bosses Castlevania is the perfect place to turn to. For depth of stories and plot there is Final

Fantasy. The Legend of Zelda: Breath of the Wild made Gannon more ominous than they ever did before. He truly felt evil in that game. Zelda games have always done really well with setting up the story from the title screen to the first part of the game. Final Fantasy 6 rolled out a wonderful story from the beginning leading the player to eagerly play it.

Setting a good and powerful mood can be difficult to pull off. It requires a number of things to come together well. It sometimes requires subtlety to pull off. To not overdo a thing or make it too obvious. Some stories are sad and others are just ridiculous. They are if they go over the top. Also, you have to like the character to begin with to care about them. Just as any good story does they have to build up the character. You have to get to know them if you are to care about them. It's the feeling that something might go wrong but it might not that makes the player feel like they are taking a risk. A game that is entirely easy isn't at all exciting. The relief of beating a difficult enemy boss is the blood of the game. One good thing to do is to give the player hope for certain things. If two characters in the game should fall in love then make that happen. If a "dead" character should be brought back to life then make that happen.

Involve the gamer- make main enemies truly detestable and worth fighting. Make some of what you give them truly prized. Give them a good sword to carry. Have them think 'that's the thing they wanted all along,' not just with items but with the story as well. make sure that jokes really are funny. Give them an interesting plot. Put into the game good twists that they never would have guessed. Some twists never could be guessed. Why would you ever be sure of certain things? If that can't be answered then you can be sure that the twist will be a surprise.

64- Flying games, they can be: a pilot simulation (Pilotwings), side scrolling, in 3D, mission based, just finish level based, real life jets, alien spaceships, based on sci fi movies, or any number of other things. They can include life within a ship like in Star Trek style, they can be a strategy game too. They can offer the player a lot of power ups and usually do. To have more powerful guns, lasers, or missiles. They can have you fighting creatures in space such as in R-Type. Or they can be a war recreation game like 1943. They can even be what they call a cute 'em up. Like a candy land sort of game. Among other games I can't think of a genre more self-explanatory.

65- Sports games include all the games humankind ever came up with. Among them you find: wrestling, golf, soccer, bowling, tennis, football, basketball, pool, gymnastics of all kinds, racing, baseball. Some done more than others. There are possibly some sports games that have not been made into a game.

Likewise card games from hearts to rummy to poker and blackjack. Casino games, too, usually including slots and multiple gambling choices (usually requiring the instruction

not to use the game as a real life gambling device and so not a two player game. Among the others are darts, chess and checkers, all pre designed games that are publically of free use. As long as you don't associate them with real life teams and athletes and the like.

The mechanics in these games are important to work out well. The translation of a sport into a video game must be good, too. After all, you are not doing more than controlling what is on a TV. Naturally some sports come across as video games better than others. Certain things have to be come up with in making a sport game into a video game. Golf for example could put in wind. The gamer is told the direction and power of it. It could use mechanics based on the terrain- high terrain, flat, or sand traps. It can have a meter that you try to whack the ball at just the right time. Those are just some elements to consider in making a fun golf game.

Intuition is a good thing to implement into a video game sports game. That's how we get better at sports to begin with. Like in the saying "practice makes perfect" by doing something over and over again we intuitively get better at it. In a video game that can be that doing certain things certain ways succeed more than others. Whatever the player learns to do better naturally might be better than by technique. The pieces of it all just come together with repetition. That's the way that Punch Out! was.

You might give the player a good guess as to what the other players are going to do and how they are going to act from team to team.

Sports games can also go off the regular course having some kind of gimmick to them. For example futuristic baseball. As for other things there are tournaments, plays (like in American football), licensing (although modern hackers get away with making Tecmo Bowl of the NES have modern teams), and nice touches. By nice touches I mean to have the audience roar, for the electronic scoreboard, for weather effects like a snowy field in American football, and whatever detail improves the game.

66- The end of the level could have the character shooting forward in a star. Could open a door and go in.. or enter a painting. Can jump on a flagpole. Can have you touch an orb. Can be a circular flash of congratulatory graphics. Just be a finish line, sometimes with a victor's ceremony. In Teenage Mutant Ninja Turtles: Turtles in Time the turtles would lean down, jump, and shout "cowabunga!" In Kirby's Dreamland Kirby would do a little dance at the end of a level. If it was a castle in Super Mario World Mario would demolish it after beating it. Some levels have beat the level music at the end such as Super Mario World. Some have nothing at all at the end of levels. They just go straight to the next level.

67- There could be a magical herb mixture or pill you take that you don't really know the effect of. You may be given a vague description on its effects. Enough for at least a good guess. Then it had raised one stat but reduced another. And with experimentation you find a mixture that balances it all out. Some weapons or items are "cursed." They would be very powerful with the curse removed but not until then. Final Fantasy 8 had a cursed lamp with Diablos inside. By using it as an item a fight with him is brought up and turns into a summon demon for you if you beat him. Sometimes a treasure chest will have a monster inside. Sometimes the game tricks you into thinking someone is your friend but suddenly they rob you blind or attack you. In The Legend of Zelda: A Link to The Past there was a girl inside a dungeon that asked you to save her. So she follows you around. When you enter into this area of light pouring in she turns into a monster you must fight: the main boss of the dungeon.

67- How 2D games are made from a movie they usually have a lot in them that had nothing to do with a movie. But sometimes they do it very well. Keep in mind what lends best to a game, as coming from a cartoon or movie, show or old story. Looking back on so many 8 bit games like on the Nintendo Entertainment System so many of these games had little to do with the movie. They lacked imagination. They just turned certain things from the movie into a powerup. They represented the movie poorly. Many were just as rushed as ET was for the Atari 2600. It wasn't limited to the NES by any means. I let my brother pick a few games for his birthday from a catalogue one year. He really wanted Beavis and Butthead for the SNES. I knew that wasn't going to go over well but didn't argue with him. Some games did a great job with their license. Gremlins 2 for the NES had music that was inspired by the film and in a good recognizable way. The game was fun. It had many of the Gremlins there as bosses. It just had one big flaw and that was its tricky overhead jumping from platform to platform. TMNT: Turtles in Time was as good as a TMNT game could get. I would be hard pressed to find anything wrong with it. Licensed games often have enemies in the game that have nothing to do with its source such as the original Teenage Mutant Ninja Turtles game on the NES. What's worse than that is that some of them wouldn't belong in its franchise to begin with- like aliens in a fantasy world. Superman 64 just has you flying through rings basically. What else would Superman do? It seems like they couldn't come up with an answer to that. It reminds me of ET for the Atari 2600. ET stretches his head upward to get out of the pits. That's the basic premise. They had the excuse of limited space at least. They originally wanted ET to be a Pacman like game (a clone in other words.) What ET has to do with Pacman is anyone's guess. So is why ET can float up in the air by stretching his head upward- has nothing to do with the movie in either case. As far as many of these games go it would have been better if they thought outside of the box. But they had Mario on their minds and basically made a Mario game with certain movie characters. So they go

around collecting things just as Mario would, only they are collecting something from their movie instead of coins.

68- Some games not only brought characters together and bonded them together one by one, but they devastated the world, causing them to separate, making you a symbol of hope, searching for your old team to save the world from utter destruction. The topic here is world changing events. Like Link when the wizard Agahim sent him to the Dark World. The world turned into Darkness sort of thing. In this case the enemy has won, at least temporarily. It could be seen in Final Fantasy 8 too. There comes a point in the game where a magic so strong "compressed time" the warping of dimensions could be seen and the effect was really quite bizarre.. in an impressive way, too. It is a way that the bad guy can win, grealy win, but not totally. Like in the cartoon Samurai Jack, Aku was just about to be destroyed by Jack when suddenly Aku tore a portal in time open and flung Jack into the future "where his evil is law." It could be that only the team of your players escaped the great devastation and lived to fight another day. It could be that someone opened up the gates of darkness and evil poured forth taking over the whole land. It could be that a virus or something made almost everyone into zombies or caused something more like Stephen King's The Stand.

69- A little bit on the future of gaming: AI is becoming developed inasmuch as it can make games itself, partially, though not *yet* entirely on its own. VR is on the horizon. More in depth games are being made, more and more. Games are connected through the internet. The whole field is being mastered. But there is still a lot of interest in old games. In their original forms, or as remastered. As I've said earlier emulators and mods are able to auto improve games. Like magic they can make graphics much better, automatically.

The future should be considered to stay ahead of the curb. The people that took a chance in putting an arcade machine in a bar came into a fortune. Games were often singularly made. People were making machines of them within their garage.

Now that technology has developed and become cheaper we find people easily making clone machines. Portable ones, sometimes. And collecting tons sometimes, selling them, which is illegal. I don't care about it's lawful status but I do want people to earn their own money, not from the things others have invented. It is a good reason for copyright I believe. Not to digress too much but if a person worked their butt off and spent millions of their own money or more to make a good movie for others, it is just totally unright for another to sell an illegal copy of it!

So to be a part of the newest thing it helps you to know where things are headed. While AI cannot *yet* make its own games I can easily predict it someday can. 2D games to begin with, onto much more complex ones. We have AI conditioning for new games. Perhaps AI can improve greatly on our old games someday. Honestly I see no reason to say why not.

To make this software that either makes games much better and different enough to not be a case of copyright infringement, or to create all new games on all it's own, would be a good idea. Suddenly many thousands of games could be produced globally in a month.

There is software that lets you make new games, and that software is better than it ever was before. And as I've said before don't worry too much about format. People are looking for new games for their old favorite systems. And it's news worthy to some.

Apart from game making there are console mods. They change the hardware making them more diversified. And there are those that fix old hardware which isn't that difficult, usually. Think things like soldering in new caps. Or swapping out a screen. Or unscrewing an old broken part and screwing a new one in. And these parts are available online, specifically.

Sooner or later games will be incredibly immersive, broad, and what I'd call *a second reality.*

Some games are just redesigns of other games. This can be tool based as a software that lets you take an old game file and remix it's elements. For the greater talented it can be code based, having all new elements and being modified more thoroughly. And sometimes they will put a pre existing game onto a new platform.

70- Beat-em-ups can have the player choose the strongest, the fastest, or the one in between. One character can have a sword and the other one a bo. One could have one special attack, another a different one. One may have one spell to cast, and another a different one. Characters can be swapped out after they are defeated. And random weapons on the stage can be picked up and used, to great effect. It can be based on just a series of streets or in some time warped place. It can be a mystical place of dragons and beasts or just the streets. Vehicles can be jumped into and used, or creatures, or a horse. Enemies in them can drop items that you can take. Some things when stricken explode while others burst out hitting your rivals.

 The pace of a beat 'em up is important. Try to not have the player linger on one enemy too long. Also, let the fight be fair. So many games make it too difficult to land a punch. That has often been a problem in poorer beat 'em up games. Give the player a style of fighting. Make it not too simple such as just punches and kicks. As much as

possible make the style of fighting as one that becomes better with practice. Neat effects go a long way such as being able to throw your enemies toward the screen, magic of special case use, and dash attacks. It is good that there are areas to fight in that are neat and different from the others such as fighting is a rising elevator. At the end of a level in a two player game tell the players how well each did- it inspires competition.

If you have the licence then beat 'em ups are a sure fire way to go. If made right to begin with they will make a good game. Simpsons, Xmen, TMNT, have all gone well over into the genre. There is a premise there to begin with. Character designs lend well to it. Wolverine has his claws and heals fast, Donatello has his bo, etc. More importantly people can readily identify with them and choose who they like the best. Even if Cyclops' ray eyes are a bit overpowered the game can let you choose from different characters on the fly. That's a thing lacking in certain beat 'em up games: being able to pick a different character in the middle of the game. It is one that should always be included, however.

As for the setting there are an incredible lot to choose from. You could have it on crime filled streets. Those could resemble the 80's, 90's, or whatever period (80s would be more like Streets of Rage with punk figures.) Could be futuristic. Could have you go back and forth in time. Could be a dystopia. Whatever you want. You could make a setting that was never before done. The music written for it should be rhythmic. Streets of Rage is often cited as having some of the best music to ever come out of a beat 'em up or any game for that matter.

71- On mixing genres or styles: 2D becoming 3D, Over head becoming side scrolling or platforming, becoming a shoot-em-up, throwing in a puzzle. It is a thing as old as games, the quest to mix genres and do it well. To take what is traditional but question why can't other styles be put into it? Some are such hybrids as to be distinctly their own genre. Final Fantasy 10 was the one Final Fantasy to be loaded with puzzles similar to a Zelda game. Some things are a given. You just have to have the Batmobile in a Batman game. The game otherwise is maybe a platformer or something. If you get far enough then you can race along in it, and that's a rewarding thing. Act Raiser for the SNES mixed a god simulation with a side scrolling game. Some games mix two genres and others 3 or more. Some games make every level a different genre. Some mix on demand. Such as in Dragon Quest 11 you can move over into 2 or 3D when you want. Some are just brief genre swaps. Like in the original Zelda and in Zelda: Link's Awakening certain dungeon rooms switched from an overhead perspective to a side perspective. So the effect can be subtle but it has its charm. Racing is commonly added to games of non racing genres. There was one in Chrono Trigger. That's nice because it is easy to pick up and learn. Besides, racing games are just fun. Many games also throw in card games

using special cards if you ever want to play it. Adventure of Bayou Billy suddenly had you pick up the light gun in a level. Then there are the graces of 2.5D. I think it's good that 2D hasn't been thrown out of the window.

72- Some games let you change the appearance of the game, the world and characters in various ways. The on screen character in some, such as in RPGs, the character getting a new suit or new color. The weapons on 2D RPG games are either seen as different from sword to sword or sometimes not seen at all. Some games let you compose the music you want to for the game you are in. Sometimes when you change something and come back it is still changed. Sometimes it isn't, going back to its original form. Sometimes they do after an allotted time. Other things are schedule based. The game can have its holidays or particular people in the game have certain schedules. There are seeds you can plant in some games and after a while things will grow that you can pluck and use. Some trees bear regenerating fruit. Some games even have you going back and forth in time and what you had done in the past has an effect on the future. It is a good way to change as many things as you want and change them back if you have to. Then there is the dark world thing where what you do in the light realm has an effect on the dark realm or vice-versa. You may be told to come back later for something while the witch makes your potion for example or while the black smith works on your sword. Just like waiting for a package in the mail you are excited to have it arrive. They have all been a product of our time now that so many details can be added to new games. It is the process of game making where you give the game its own kind of life.

73- There are many examples of how a game starts. It could start with cinematics, a visual and/or text based story. The player could wake up one day in bed and find something bad is going on. They may be entering into a place they were told not to. Some games just start you off on a level. Some find you outside and being told it is dangerous to be there so take this weapon. Some have you find that something was stolen and you need to get it back. Some have your loved one needing to be saved, as s/he is calling out to you. Some find you disagreeing with the king and the course of their kingdom. More common with new games, you are given a brief or sometimes lengthy tutorial. And some first levels are just made to give you an idea of how to play, though without instructions. Some have you building a very specifically generated character. Others just give you a choice on where to start.

There are games that go over the general story very well and very graphically well too. The title screen itself may just be the main character playing the level like in Super Mario World or even the original Mario Bros. Some are cinematic- Final Fantasy 8 flooded you with abstract imagery. Final Fantasy 10-2 was a music video sort of thing.

Ocarina of Time was simply a dream Link had before the game started. Some games change the title screen stuff based on how far you have gotten in the game. Games have simple title screens at times but pulled it off well. Secret of Mana (SNES) spent a lot of the game's resources on the title screen alone. Arcade games had to pull you in so they represented the gameplay in different ways. Mortal Kombat went over all of the characters you could play as. They told the player the story behind each.

74- As far as becoming more powerful goes.. One game has you grinding for greater power, defense, or whatever it may be. Another just gives you power ups sporadically- enough to get you along. The power ups give you the ability to take out things further along and that can make the game much easier, so long as you have it. Getting hit carries the cost of losing it. So it goes that it becomes important not to get hit and carry it along as far as you can. Then some power up might be seen in a tricky area to reach and the player has to decide if the risk is worth it or not. Some games have you preserve your weapon ability. All the while looking for boosters for it. Among weapons some of these are hidden. Others in plain sight. One game has you buying things for greater power and others come more freely. Those that are bought can pull off different things. They can be a balloon that saves you from a pit. They can make what is difficult in the game easier. Those don't have to be just enemies. They can also include flying over difficult areas, shortcuting, and surviving poisonous/spike areas. An animal ride or vehicular ride may give you more power to just rush through things or at least get through them faster. A new spell can be most inviting. So much as to make it the current focus. The random battles are known to be much easier once that fire 2 or fire 3 spell is learned. Some have you collecting things for greater power/ greater health. Others require you to have skill to use them right, or knowledge of your opponents weaknesses. That weakness can be based on what weapon hits them the best. If they are too far above you to strike with your sword then you should get the upward flame power. Whatever helps you overall and you have a number of different power ups to choose from. One may be better overall, even the best altogether- better keep it as long as you can.

The best power ups do what you want them to. You have good control over them. They hit where you want a thing to be hit. The best magic is the most visually stunning. It is also good to have magic that is more than just attacking or healing but more into warping the fight around. The worst power ups are hard to control. They aren't so straight forward. Then when the time comes they are needed, they fail. The best powerups do a variety of things. The dagger thrusts forward and the axd upward and over for example. Other than that nothing is off the table.

75- Random battles can be very frustrating sometimes. They are sometimes reduced with certain items. If the player goes into an old area, one they left long ago and became stronger after, they may find those old and pitifully weak enemies there getting in the way, without any benefit for beating them. Each area in old 2D games may have had 4 or 5 different random battles opponents. Though in some RPGs there are areas that have dozens and dozens while elsewhere just that 4 or so. Some items stop the random battles as the player chooses. The creatures in them can appear in front of you, in a sideways manner, or above you, or more vertically. They may have minimal movement of none in older games, but for older gamers that was enough. Summoning a spirit can provide a bit of animation as added value. And swords of all types, magic and things, provide animation that isn't otherwise there.

 The debate over random battles is a thing of the day. Back when 2D games were limited in space the best option for programmers was the random battle. It takes a lot more space to fill a game with on screen enemies then it does to have them in a random battle format. So that is why random battles were made to begin with. They can be frustrating for sure. At times when you are trying to get somewhere several come up and you could do nothing but fight them. Even escaping the battle was a nuisance. They also created confusion in dungeon-like areas. When the screen changed while you were trying to get through them you forgot where you were. So naturally new games addressed these things. They made the "random" battle show what enemy was around on the playfield. If you made contact with them *then* a random battle would come up. Sometimes in games they had it where the weaker enemies would run from you. Since not so much experience could be gained from them they already served their purpose. Some games made it where you could fight one enemy after the other, compressing the time it took to level up. Some RPG games go in quick mode so you don't have to see the magic being performed or whatever while you are just grinding. Some let you auto fight. The question is, is leveling up even worth it if it is made super easy? Isn't it now just pointless? It still takes just as long in its own way because what you could do in an hour you can do in a half hour, so why not do that for an hour?

76- The setting of a game has countless possibilities. Among some that have been used are the places of Dracula, a land full of robots, an alien planet full of mystery, a medieval type setting full of magic, fantasy, a world of toys, the African safari, lands of the gods, a future world, space, places taken from movies and books, shows and cartoons.

 Even these can be varied among themselves. Like the gothic style of Castlevania or the one in Ghouls and Ghosts. Monster in My pocket was a game where you played as your favorite movie monster. Micro Machines had the neat concept of micro car racing. Lego games have been made based on Star Wars and were well received. Cuphead went after a very old cartoon style. Popeye was meant to be the original

Donkey Kong- which Donkey Kong was based on King Kong. There are games based on cartoons, so much as not really being needed to be mentioned. There are games based on toys. There is Marble Madness. Pacman wasn't really based on a slice of pizza- who knows? It could have been. But it's a nice story. Personally I think that Pokeballs were based on fishing bobbers but I don't have any proof. As for Pokemon, that was based on bug collecting. Zelda was based on Shigeru Miyamato's childhood ventures into caves and other mysterious areas.

Tetris was based on an actual old game that came around long before video games even existed. It went so perfectly into a video game, luck would have it. Frogger is based on the simple idea of a frog going across the street. Could as well have been a chicken. Why did the chicken cross the road? It did because I wanted it to win. Then they take frogs and have them catch flies for the game instead. Then they make Yoshi have a frog tongue.

77- A common occurrence in games are: dropping a letter, someone crashing the party, someone intervening, a challenge being presented, a trick being played, someone calling for help, saving others, gradually becoming more powerful, taking a chance, someone somehow surviving or being brought back, being betrayed, the sword in the Stone, being a part of prophecy, being underestimated, waking up in a new place, falling though surviving, having friends you never knew you even had, a sudden disaster at night forcing you to awake into calamity, something being more powerful than it was once thought to be, and the game not being over when you think it is.

It has been said before that "good ideas are timeless." Why are there so many good vs. Evil movies? I can't really claim to know. People want that thing to be conquered for all good love, hope, and humanity. There can be a lot of detours in the game meanwhile. Some have them as space fillers. Others have them as interesting twists or exciting side adventures- ones emotionally evolving maybe, or maybe just worth doing. If the player gets what they are looking for then nothing else can fail. Predictable and shallow plots without any substance, without any challenge, are as awful as Final Fantasy Mystic Quest.

78- Slight adjustments to the game can be of great effect, and things not there before can be too. Like changing one enemy into another in a second quest. Or the colors of a character's clothing. Or a light world to a dark one. Picking a name I guess you could say. Going somewhere but now it has changed. A hole is there now. A statue now there that gives you power or access somewhere. Turns out there was a moon. Turns out you can go there. A sword is now there. A new kind of coin. You can get things with just that kind of coin. Land goes dark. Sun comes up. Trees grow a bit. Things get rocked into

messes. Swords given new power, or arrows. Clouds shift a bit. Some of these can be easily done but leave a good impression on the gamer.

It is good to give things that extra touch. Whether it is a twinkle of the charged sword or shifting the appearance of the character midway through the game- even if it is just a different color of clothing. After all, the gamer has to look at the character for quite some time before the game ends. It can be caused by a seemingly random thing. That is to set up the game to do something when conditions are met. It can be that the music changes just a little every now and then. To implant a melody that randomly plays along with its regular form. As far as conditions being met goes there is Reptile from Mortal Kombat. Players adored him- although he was just a green colored ninja very comparable to Scorpion or Sub Zero.

When Mario ate a mushroom all he really did was get bigger but players appreciated the effect. In The Legend of Zelda: A Link to the Past, The Master Sword doesn't really look different. It is just a stronger sword. So the programming for that is simple. Yet it is a highly valued thing in the game. When the time came it was tempered, a simple sound effect was made for it and the sword turned red. Yet given the little sound and color change it felt like a much more powerful sword. You could even say it felt different altogether.

Here are some simple ways that simple but effective changes can be made: a thing larger or smaller than before, making something longer or shorter than before, changing the color, changing the sound, changing its effect, changing its form a little, changing or adding to its direction, and making it faster or slower. You can also double something or triple something. Like having a shadow of yourself in Ninja Gaiden 2 or making something come out in twos instead of ones.

79- You find an inventor who has great things. You find a new player that has the ability you need. You find someone that has a lot to say or a good thing to give. You find a person that can give you a lot of power or someone who teaches you a lot of good things. You find a person that tells you where to go next. You find a new opponent or you find a new friend. You find someone that wants to buy something of yours. Sometimes the more people that you help in the game the more help you will get at the end of the game.

Sometimes they have an airship or other sort of needed vehicle. You might have to trick them into helping you. You may be a person of royalty and those things are at your dispense. They could be interested in your cause and lend you what they have. They could just be an old friend who lends their vehicle to you. In Final Fantasy 8 they went into an airship lost in space. There it was just floating in space with its crew overtaken by monsters. You defeat them and now have a new airship.

You may have to prove your worth before they will help you. Maybe you are a bad person- a bad person of the king trying to change their ways. They then have you prove you are on the right side now, the side of good. They may not be sure if you are the chosen one so they send you after certain things that only the chosen one can get. In another instance they may help you but only if you help them first. That's usually by getting something for them or passing something along. Then there are times where they can help you out but only halfway. There is another person involved who you have to reach. For example you get a recipe for a new potion from someone and someone else makes it. You get a mushroom from someone and someone else makes mushroom potion out of it. They may help you because you freed them. They may just help you because you paid them. They may help you because you led them back home over the bridge and through the hills. They may also help you or give you something because you defended them against a beast or dispatched one for them, saving their village. In a more of a shooter game that would be taking over the militia that has taken over a village.

80- Side scrolling games sometimes give a route to take. Like upward on the map, downward, or through the center. RPG games get you about 3 places to go to before you can go to the next 3, more or less. Simulations give you one area of the grid to work on, and places in different areas of it. Some games let you wander around until you have access to new places. Overhead adventure games let you explore different areas, sometimes all at once, other times when an item allows it.

Different routes can come from every level having a secret exit or at least some of them. Sometimes the player is given the option to take an upper or lower route in a side scrolling game. Some are map based. You can play optional levels, usually that reward you with something if you do. In an adventure or RPG game there are an assortment of different things allowing you to go to an area you otherwise couldn't. Among them are: a raft, boat, hoverboat, ship, airship, flying on a large bird before you get the airship. There was even a castle once that travelled underground- a techicle marvel that was unprecedented.

Tools can get you there too like a hookshot thrusting you through an area you couldn't otherwise pass. The game maker just needs to answer the question "what is a cool way of making it from point A to point B?" An ice wand that makes lava freeze? A magic sword to break through the barrier? A blast that creates a hole? A rocket launcher that does? An ice spell to cast on enemies freezing them so you can use them as platforms. Or casting a fire spell on an evil tree in the way? Making lists of things like these is easy enough. My suggestion is to make as large a list as possible and use the best ones.

Of course many games have you collecting the three spiritual orbs or crystals or whatever else before you can get further in the game.

Sometimes you need a pass card showing permission from the king to pass through. Afterall the area beyond is dangerous but the king knows you know what you are doing. Those cards can be counterfeited too. They could be fake IDs as well. Likewise you can sneak into an area you don't belong by posing as a soldier. Sometimes it is that you are sneaking in through the back door or underground sewer. As for shooter games there is a lot of sneaking into places unseen.

Some levels are hidden altogether. Some of them collected together into their own little world. As for RPG or adventure games there are often places the player can go to that are hidden. Unless they are looking for it they would never even know it was there. As far as maps go there is more than meets the eye. There are underground areas sometimes. There are caves with deeply winding paths.

Since every gamer wants their own kind of level or area to play in it is always good to provide a nice varied amount of levels to choose from.

81- One fighting game has a lot of blood while fewer don't. Some are only made to shock but have very little appeal. Some incorporate a more wicked tone, not just in the violence of the players. Such as in using background imagery to set a certain feel. A gong sound at the beginning, and very good voice acting. Some fighting games have very uneven fighters, making some useless. Some have been based on absurd things, as most would agree. There are combination attacks in some. Some are based mostly on them if they are different in any way. Some have you fighting as dinosaurs and clay creatures like a snowman. And there's one I know of that has four or more playing on screen all at once.

My best advice for making a fighting game is that "controversy is dead." I was watching a WatchMojo video a few days ago. They are people that make a large number of top ten videos. They covered "games that have aged poorly" and Mortal Kombat was high on the list. I think it opened my mind up to the idea of it being a game that aged poorly. The mechanics were always kind of off in the game. There weren't any combos in it. It was well received (and badly received) for its blood and gore. At the time there was nothing like that, for sure. These days though every controversial thing that could be done has been done. My friend once told me "controversy is cheap." They really ran the rooster in the series from animalities to babalities.

Fighting games went into 3D with Virtua Fighter. At the time it was a marvel. It's hard to believe that now. Rare went knee deep into making a combo based game. That is, Killer Instinct. It was a good game too except for one thing: the fighters were not relatable. They were cool characters but when it comes to fighting games relatable

characters are more important. Fighting as a skeleton works in theory but not in practice. Street Fighter 2 got a lot right. They looked into just how attacks would work best in a game. They came up with the idea of button codes causing special attacks. They had human characters like Mortal Kombat. The music was there. Picking players from different nations made it feel like a worldwide tournament. Subtle combo effects were there. Each character clearly stood out as unique but still human- other than Blanka, whatever he is. There is the arm stretching of Dhalsim, the swift movements of Chun Li, with the chance of playing as and learning about 8 characters- something that shouldn't be underestimated in an arcade game for its time.

It was far more than just getting points now. It was fighting. People liked watching others fight more than they liked watching other players get the most points. Just like in grade school whenever there was a fight everyone would rush to it and watch it. Maybe less pronounced than that- but with more interest than just getting points for sure. Two player games were more competitive with them. The other player was no longer trying to out race you or whatever other two player games offered. Instead they were trying to beat you up in the game. Losing to the other player in a fighting game can actually make a person angry. So if there is any question for why fighting games succeeded it is for those reasons.

82- Consider how one game in a series did very well while it's follow up or subsequent game utterly failed. Like a game that was originally overhead while it's sequel was side scrolling. Or the ugly game in the family. It was just too weird to ever be appreciated. Consider that innovation often just went into places that no one wishes to be. Making a cartoon out of a previously realistic looking character. What looks good on paper may not at all be good. People don't want these differences. It is like when your favorite band suddenly goes with a new style. They think their music could be a great new style over their traditional form. Maybe if they had started with that second style to begin with then they'd be more popular. People just can't recognize them after that however and detest the change.

Sometimes an idea has run its course. In fact after the fourth game or so there is little new that can be added to it depending on how deeply the programmers have dived into the idea. Mario games still sell, sure, but they aren't making numerous toys and cartoons or causing a phenomenon like they once did. It was all over the map at one time. He can fly now, the Mushroom Kingdom had such awesome new inhabitants. These platforms did this and that and now there was Yoshi. Unfortunately it has come to the point of "more of the same." While something is new it has the greatest appeal but there comes a time when nothing new can be added to it.

Make your best franchise have games few and far between. Trust me, that's the best way. You *want* people to forget about it for a while. When it reappears there will be

much applause and a great reception. It is like dating. You may think you should be open and ever talkative but it's counterproductive to do so. I can add to that the "Parable of New Coca Cola." New Coca Cola was thought to have a better taste but nobody liked it. There came a point of it being detested and the people demanded to have their old Coca Cola back. So Coca Cola returned to their original flavor calling it "Coca Cola Classic" and the people liked it better than ever before.

83- Some games are about making other games, such as a single level for old and cherished games. These people play and share them via online. There's a market for that which surprisingly hasn't been considered. People that made these old games that are loved to this day have yet to make their own () maker game. Mario Paint lets you write music. As a musician at the time that was the best of two worlds and something I was looking for in software form. Though it wasn't anywhere close to "Print Music." I remember it as far back as Excite Bike. The game lets you create your own track. You would make the most ridiculously difficult track for the player. As a kid you want to make your own game. It was a dream of so many of us. Mario Maker gave us that chance. RPG maker was before it and allotted the opportunity to create an RPG. PC based and android based game makers are more and more available. Some are just ROM modifications "hacks" of older games. They get into making a previous game much more difficult and serve as speed runs to the most dedicated of players. Some of them are "randomizers." They take power ups and special items and put them into different treasure chests. It makes any speed run faster. You could get the most powerful weapon very early on for example. There are certain objectives in them to beat the game and things are largely left up to chance. Some game hackers just want to take a game's flaws and correct them. Then there are those that either just port them onto other systems or improve their graphics.

84- There are games that were mimicked in their approach yet just not as good as the thing it intended to copy. They often come across as strange and ugly renditions. They may have been much different however, enough to totally be its own thing. And perhaps they made a better game than the inspiration they pulled from. But then comes the sequels of their sources and they throw all the others out of the water! It makes you think *why hasn't anyone been able to do the same thing but that much better, before they did?*

It can be good practice for the game maker to take any two ideas randomly and mix them into a good new game. For example Pac Man and Bomber Man. Doesn't have

to have bombs to blow up the ghosts, but something else.. The mastery one finds by doing so can improve your game making dramatically.

Copycat games are a dime a dozen. I don't know what people are thinking when they make a kart game based on the Sonic franchise. Do they think that franchise can do just as well as Mario one? If it keeps on hinting "This is just Zelda" then the gamer will only feel out of place.

85- It is good that the player rests as the character rests, fights as the character fights, and feels the emotions the character was meant to bring over to the player. If a joke is in the game make sure it is really funny rather than just some dumb cheezy thing. I could tell that the last part of Final Fantasy 6 was not worked on as much as the earlier part. Suddenly there were dumb jokes and other things that suggested to me they were tired of it all. I was just a kid playing the game too. If there is a thing that the programmer cannot handle then the torch should be handed to someone else. Even if it is just one small seemingly easy thing the programmer may either not agree or is just too exhausted at the moment. Sometimes it is like a band that was not at all popular until it got a new vocalist. Games have turned out that way before too. They took a chance on someone and that paid off a great deal. They found that what one game maker was doing they were better at something else they were doing and so the company shifted his task over to it. Sometimes a company calls on another to make a game for them such as with Nintendo, Rare, and Donkey Kong. They told Rare that they could make any game for one of their characters and Rare chose Donkey Kong. Donkey Kong Country became the third highest selling game for the Super Nintendo, too. As for Super Mario Land and Link's Awakening they were games not at all worked on by Shigeru Miyamoto but turned out great. Unfortunately it is also true that the wrong people are hired sometimes. Untrustworthy companies will hire anyone that can get them a few quick bucks, especially on licensed games.

Some companies are steller. You can count on them having great games. They take pride in their work. They work hard. They have good members in their team. There can be exceptions to the rule, sometimes a few exceptions, but overall they have made games that have become classics. Nintendo is said to be over innovative but at least they have tested the waters, they are about the only that do and are certainly the ones that do the most. Who's to say what will succeed or not on those terms?

86- Some games could take ten years to solve on one's own. It used to be a goldmine itself to provide strategy guides and hotlines for them. You could carry an old portable device and have that game for ten years before you'd figure it out. That's one part of longevity and replayability. Back in the days when arcades were prominent they made

things very difficult to get the most coins in their machines. This carried over to older systems too. With limited space in the game they had to squeeze more play out of it. So without even a continue sometimes the gamer had a lot to work on to beat the game. Now save points are everywhere in games. Emulators have save everywhere features. There was actually a time when long drawn out passwords were a thing. Some are more simple than others. I think if passwords can be simple as a game is simple enough then they should be used over battery saves.

 Anymore there is so much that can be put into a game that we hardly know where to start. We are always thinking up new ways to best fill an increasingly limitless space. However if we are just working on a simple kind of concept like a Metroidvania game or new Ghouls and Ghosts game then replayability is easy to come by. Give the player more: more magic, more areas, more characters, more items, more abilities, more more more. If they have run the gamut on what can be done then there is always more downloaded content or a sequel. The sequel itself can largely run off the same engine. There are remakes too. Those that have better graphics. Even those that are mostly remade altogether like Final Fantasy 7 Remake. Sometimes it is the same game just with some added dungeons to go go like The Legend of Zelda: Ocarina of Time Master Quest. A lot can be done to old games. They can be brought into 3D from 2D. They can be coupled with other older games into a compilation. Once a company has a few classics then they can be a revenue for a long time to come. Those can be put onto plug and play systems. They can be ported over to any new system. Even all in original form with not a thing changed- in fact some people simply do not like changes to them.

 The life of a series can be rolled out slowly but still sold well. Street Fighter 2 for example had many many new games based off of the original game. All of those are called Street Fighter 2 (with this subtitle.) The second reiteration let you play the four boss characters that were previously unplayable. Shortly after they released it again just with a few new characters altogether. This went on quite a while and they all sold well. When the time came to pull out the big guns they made "Xmen Vs. Street Fighter."

 If you don't pull off a successful game at first then maybe its second title will. That in fact happened with Mega Man and we all knew where that led. It is always possible. Any draft can lead to a good thing if its basis is changed well enough. The important thing is to find where the good game begins and where the bad game ends- as far as that first draft goes.

 Some games fooled you into thinking they were other games. Some are entirely obvious but Battle of Olympus for NES was thought to be a successor to Link's Adventure.

87- Game preservation and collecting: Passwords have the advantage of never needing a battery. Is it at all possible to create a password system which can, these days, in these more complicated games, work? It depends on the complexity of the game. Passwords using more characters than just numbers or letters. But doing so would never require a battery or limited period flash saving. Then again battery changes in old carts is the most rudimentary of gamer electronics. CDs are subjective to disk rot where moisture has crept in between its layers. Tapes decay. No need to worry though- there are always reproduction carts and things. Sometimes your cart just needs to be cleaned. Sometimes it is more serious needing trace repair. Games have become the most highly valued collectible. Naturally so. Of course someone is going to want to collect them over comic books and toys. That's not always but mostly always. People are putting them into thick plastic cases and having them graded. A lot of people prefer old game manuals over comic books. Sometimes the cheapest option is getting that game that has permanent markers or worse all over it. Some look as though people tried to take the sticker off but only succeeded halfway.

I used to worry that if I made a game what I was making it for (what system) would become obsolete. That turned around though. People really started talking about old systems online. They developed fan bases for very old systems one by one. Some of these most of us never even heard of in our childhood. Now making games for them isn't uncommon. What's more is that so many systems are both being repaired and modernized. For example the NES 72 pin connectors- new ones are being installed breathing new life into them. It could just be a new optical drive put in. Sometimes a new and better screen for the portable stuff. Sometimes just given modern ports so they work on modern TVs. These are done by people that just have fun doing so, and there are many people doing so. My point is that whatever system you make a game for should be just fine- should be appreciated and a thing to talk about online. It may be just what people were looking for.

88- A game may have you interacting with the environment in a point or click way. It may have you on a world map giving you more selection as to where to go. You may interact with the people of the environment. You can interact with objects apart from the character sometimes, such as with magic. You can in a button mashing way, or a mouse click, or a number pressed, or the A button. You may twirl a stick or rotate a disk. You may use a glove as a steering wheel. You can use motion detection in some. In others you rotate a thumb stick.

Some need more buttons than others. Some become over complicated because of it. Some just have too many menus on screen. Some would have you mashing buttons you'd never figure out on your own.

And retro controllers are being reproduced to this day.

The question has long been asked "what would be a better controller to use in games?" Sometimes the answer was obvious: a steering wheel for a racing game. Sometimes the answer was just something that made more sense. Oftentimes it was just appropriate for the new hardware. The D pad for example. It could be said of the D pad it was brilliant. Where was it? Well it wasn't with Atari games. Until more complicated games it was nowhere to be found much like the thumbstick and 3D requirements. Game controllers are an interesting topic and something deserving of a lot of thought. Going over them helps me fall asleep. Most of the time they are rather unimaginative. Have three action buttons instead with no other changes or do basically nothing new at all like with the Turbografx 16. Well, they had turbo buttons added to it at least. For a while they had numbered buttons like an old phone would have and an insert to go over them. That really never catched on. Seems like a good idea though. With how unpredictable Nintendo is, so are most of their controllers. Sega came onto the 16 bit scene before them. They must have thought a little thought and decided "we'll have the controller have 3 buttons instead of two." The truth is though it is a nice controller and more than three buttons wasn't even necessary until fighting games became popular. It wasn't a flat controller either- if it was then it just wouldn't have been any good. Skipping ahead to playstation they went against the flat idea. They were probably thinking a 3D game deserves a 3D controller. Nintendo 64 sure had one. We at first were not sure what to make of the thumbstick it presented. You could see somewhat similar ideas on very old systems. They were quite funny too- you don't use them with your thumb. They are tiny little arcade sticks that are pinched. I believe they are what inspired the thumbstick. Sony took the idea and made two thumbsticks instead. If Nintendo is a lion then its competitors are vultures. They'll feed just the same. Not much more difference came until the Wiiremote. It was a novelty- a good novelty- but one that wore out quickly. Maybe it is that people don't want to fling their arms around and stuff more than they just like to sit down and punch buttons.

 As far as peripherals go: You can't mention them without mentioning the Power Glove. That could have worked out if the technology behind it wasn't so expensive. It had to be dumbed down to stay at an affordable price. The Sega Master System had 3D games via 3D glasses and I hear that they are actually impressive. There are arcade sticks like the NES Advantage. Nintendo was always about choices. Controllers sometimes have turbo buttons which just pause and unpause the game very quickly and for some games it is actually quite effective. There are a number of things you would have to see to believe- a sewing machine peripheral and a sonar for the gameboy for example. There was this controller-keyboard hybrid too. Like a really long controller that had a keyboard in the middle. Gameboy had a digital camera peripheral- the smallest of its kind at the time. As for gameboy they also had magnifying lenses, ones that lit up to both see the screen larger and play at night. There was the activator, the powerpad, light guns, Super Scope 6, mouse controllers, the game genie, and the pro action replay. In fact many more and most of them were bad, very bad. When it comes down to it I would

only list the lightguns as being any good. Arcade sticks are not a choice way of playing. Game Genie things ruin a game. Steering wheels don't go well over into a game. Motion control isn't as good as button control. As for things like steering wheels and fishing rod peripherals we just don't need things to be that "real." It isn't enough to put us in a state of further realism for any given game.

89- Social conditions in games designed around social based gameplay include criminal behavior, farming, errands and tasks, the regular lifestyles of people, collaborating, and fighting in a war. They connect you with some characters specifically, and a handful of them throughout the game. While the others have personalities, just less to say and do. Some side endeavors are present in them which allows the player how to progress in the game. There are some that employ you. Some that request any number of things from you. The opponents in them are modern or past-wise, or fantasy based. Coalitions may be present and certain interactions causing each own result.

 Social based games in an online way include Clubhouse Games. That game really is like a clubhouse. There are a large number of card and board games you can play in it. There are video game board games all new or traditional. Of course there are shooter games. There is Grand Theft Auto. Mob based games too. There is Mario Maker where one makes a level and another plays the level. There are racing games and there are online RPG games to name but a few. Some of them get most of their money from players themselves paying real money for in-game things. The appeal of them is that you can play against a human player at any time. Another appeal of them is that they are full of human players instead of NPCs. They can add a touch of humanity to them. They are people you are really talking to instead of predetermined things from a computer. In an online RPG game you grow with the other players. You team up with them and they can be people you really know in life. Just like real life there is give and take.

90- Choices in a game may include which route to take, which enemy or stage to face first, which weapon suits them better, what to spend more time on, what to not bother with, who to employ, who not to, who to build up, who to not use at all, and what to buy, seek out, and what not to.

 The best choices for an RPG game to include are what job class you want, what abilities you want to learn, what character according to their abilities you want to play as, the direction of magic and abilities, and the capability of raising stats as you want to. In a fighting game people get attached to one character while another person becomes fond of another. Any game that has a large number of different characters should have one for every kind of person. A game can either be linear or not. They may predetermine the route you take. For example doing things in order or doing what you want when you

want. In them if you do more you just get more. RPG games may only let you go to one town at a time. Some may do something like having a tomb or cave near that town allowing for the visitation of three places at a time.

In a fishing game the player finds their favorite little spot to fish and chooses among a number of equipment to use to catch the best fish. In a racing game you may let them choose among a number of colors and parts for the vehicle. In a game you may let the player determine their whole wardrobe. Sometimes it is that whatever armor or clothing you buy, find, or earn changes up and mixes your appearance as a side effect. Some choices are no doubt made. People never want but one powerup. That can make the better one just liked even more at least, if it is less available. The others are just in the way in that case. Other games balance them out more. Many games make different power ups for different situations. In one case one is better to use but not in another case. I would say that the best choices in a game include how powerful the player wants to be, taking them where they want to go, giving them an opportunity to find or discover what they want to, and offering them the chance to play the game they want to play.

91- Games may progress in a way that is natural or brutal, and some don't need "progression," or sometimes it is only needed sometimes. There can be interludes and pauses in the game which let the player rest a bit. Some games are fast paced. Among games, Ninja Gaiden games are the best at it. You had to keep moving. You couldn't stop for an instant. Then there are leisurely type games. Those are any games that can be picked up and finished within about 20 minutes. Games like racing games, gabling/card games, Guitar Hero, and sports games, are leisurely. They require no dedication to them. Ghosts and Goblins can be thought of as fast paced too. Some games are "focus intense." Tetris is a good example of that. The pieces just fall faster and faster. You could include Pac Man and Space Invaders in that for the same reason. RPG games go all over the place. Some moments are slow going, other moments incredibly intense while you are fighting a major boss, and so on. You could say Mario, Adventure Island, Joe and Mac, are all medium paced. Sonic, naturally, is fast paced. Even when Sonic enters into water he has to quickly get out. There are precision based games. Those include shoot 'em ups where it is you are being maraded with bullets. Then there is Contra and Silver Surfer for the NES where you could only be hit once before you're dead. Some racing games are fast paced. Some are both based on quickness and precision such as F Zero. In some of them bumping into another vehicle once will spin you out of control.

Games more or less require focus. They more or less require precision. They can have you restless. They can be played much more slowly than others or they can rest in between. In all these things it is important to know what you are requiring of the player and if they can pull it off. More importantly if they can *enjoy* pulling it off.

92- What makes the best villain? A lot of people liked Kefka. He was maddened by magic. He was infused with the power of magical stones known as espers and as a result became a madman that would come to nearly destroy the world and all of its things. He was a grand scale enemy doing things the king above him could not. He gained yet more magical power and brought about the near destruction of the world. Sepheroth is not too far away from the same idea. Oftentimes the villain has a vendetta against some power above them that twisted and deformed them or their loved one. They are almost anti-heros or are. The player can agree they are right to want revenge but also that not everything should be destroyed in the process.

Another kind of villain is one of an ominous power. They could be an alien race or something of a demonic form coming to overtake the earth. They'd maybe arrived from a different dimension. They may have been a thing released every 1,000 years. You may have to find them instead of them coming to you. Such as Mother Brain on Zebes. With new games and better graphics came more imagination. What was once a simple pixel set was now fully animated and larger enemies but that started as soon as Super Metroid. Not many games had bosses so large and animated at the time. Now Castlevania games have evil sounds coming from evil things from hell. Comparing the original Ganon from The Legend of Zelda to the one in Breath of the Wild the difference is drastic.

Bosses before the greatest boss are just as important. I really like the Four Fiends from Final Fantasy 4. The doll demons in the game too, and the dark elf. There are evil elves to be made! And evil fairies. Horror stories may be used to help you. Myths of demons too and what they do. So many cultures have them.

Some bosses are psychotic, others tricksters, some have sought power, may get it, some have stolen their way into power, others were born naturally powerful. Some are mystically powerful. Others have learned magic to get them there. Some have been around for ages, others have gotten there recently by some sort of accident. Some were good but turned evil. Some always were. Some are just lucky to have power behind them like an army.

93- On some levels rain. On some, snow. In some there is wind. Some platforms are ice. On some levels rocks fall and tumble. Some levels go dark and perhaps need an item to bring it light. Usually the wind helps you along whether you are gliding or jumping. The icy areas may require thicker clothing. With thicker clothing though you finally have the freedom to go there all you want. In the meantime it is fire after fire. A lot of side scrolling games turn off the light. They may flash on and off making you move forth slowly or just guessing where the platform is. In an adventure game or RPG you might

need a torch or flame magic. In the heat of the desert you may get exhausted. As for lava filled areas you might need ridiculously large armor to withstand it. That is unless you prefer a magic robe for your game.

Day and night cycles are another thing. The bad things come out at night, naturally. The gamer then has the chance to level up with different enemies. Unfortunately all the people close and lock their doors during the night because of it. Clouds may appear out of nowhere and with it a thunderous storm. Hopefully not in a frequent and annoying way but more of a special event. These are all too simple really to get far into. Whatever happens in your game happens on earth weather wise. The only question to answer is how it will affect the player.

94- Some platforms shake, others crumble, disappear, move up, move down, swing, or defy gravity. Mario has gotten really super specific with them. A lot of what was new about their newer entries were platform differences. Some are like flat mushrooms that are like trampolines. There are those things that if you land on them you will leap far up. They come in different forms from game to game. There are sometimes ropes to climb and other times you can just climb the wall or wall jump. People have a good opinion about wall climbing/ jumping. It is such a good addition to a platformer. Instead of a vine to climb a rope, a chain, a ladder, an elevator, many things are possible. Some platforms tilt downward like a teeter totter. You raise the other end and quickly enough leap from it. Feels like a circus sometimes. In fact sometimes games have you walk across rope. Sometimes it is the same thing but with your hands. Instead of the ground below to fall onto there is burning lava. Super Mario World had a skull platform to ride across the lava and there were skeletal dinosaurs coming out at you. Well done!

Other things that were cool include bursting out of a barrel in Donkey Kong Country, pounding downward on bricks to break them, anytime an enemy is the platform, taking the lakitu's cloud, and invisible platforms leading you into a new area. Sometimes you can go over a whole level by reaching the upper platform. Sometimes you can press down on the controller to fall through the platform you are on to the one below and sometimes the other way around going up through the platform above. There are stairs sometimes. You can either go through below or above them. Sometimes one will be more difficult but have a nice power up. Contra had a bridge explode. You didn't die. You just fell to the lower level. Kid Icarus was ever upward in its design.

95- Some items have a meter that counts down. When at zero it stops working. While some spells count down from 10 to 0, at the end of which the player dies. For example "doom" which causes a counter above the characters head before they will die. They are

items or spells that are ten seconds or so long that when reached zero are spent. That could be a ring of special power, for one.

96- Some spells are really good at letting you toy with your enemy. Others just attack or cure. It hasn't ever been a thing gotten far into, though. There could be spells made just for that. Spells that change the enemy into something else, that you can force spells out of, that lets you turn their own power or kind against them, that you can steal things from that they need, or whatever else lets you toy with them.

97- Mastering a game can be from a few things or many and sometimes from a very large amount of components. It can be as simple as jumping the right way. Maybe attacking the right way too. Or it can include a little grinding, or a lot. It could require a lot of attention. To be precise. To find better ways, quicker ways to get the job done. Or it may just be from difficult levels that require practice.

When there is a definite amount of something it will help the player know what they are missing. The player knows there are seven dragons. Defeating them all will give you the greatest weapon. Or they know that things go up to a hundred. That their HP goes up to 9,999 and their level can go up to 99. The title screen may show what is in the game that can be found. There could be a missing slot. They know if they had everything that spot wouldn't be empty. The end of the game may show what was left to be found, like characters. After the game is won the player may be told what percentage they completed the whole game. 60%, 100%. They all help the player know what to look for.

In many games you don't get the true ending unless you beat it in the most difficult setting. It's fair enough- at least you get practice using the easier setting. You can get stats at the end of the game. These are nice to include. For example how many enemies you beat in the game, how many lives you lost, things like that.

Some gamers are total completionists. They are not satisfied until they reach that 100%. Some speed runs are based on it. Other players feel free to skip around. Both are still possible and after the gamer completes the game at a low percentage they may just want to go back to it and try for a greater percentage, even a 100% completion. As for me, Final Fantasy 6 had me replaying over and over again just trying to find that one missing esper. Espers were worth finding. They were the best part of the game. So what corner of the game was that hiding? I just had to know. Super Mario World gave you a secret exit per every level. They let you know how many levels you beat and how many were left. This is a simple thing to add to any game but very impactful.

98- A game could allow you to insert code like a built-in code modifier giving you some idea on how to do it. In other words the code can reprogram aspects of a game much like a game genie but without the glitches and game breaking elements. I think it is a good idea. I have never seen it used. It can be so large that a code book could be made for that game. The code doesn't have to alter actual code either. There could be both-code input that changes actual game code and codes of predetermined use. If you want different music then there is a code for that, for example. It can be so extensive as to change the very nature of the game. Call it "smart reprogramming" something easily used and learned. Treasure chests or bookcase books could include codes within them.

99- Here are different ways that a player can jump: they can jump very high, half that much, some bend their knees when they jump like Simon Belmont, some jump realistically like in Prince of Persia, sometimes a platform causes you to jump up, sometimes different selectable characters will jump differently like Luigi jumping higher than Mario, some spin when they jump like Sonic, some flip like Ryu Hyabusa, and in fighting games every fighter has their own way of jumping. One that stands out is from Wizards and Warriors. The main character in it kind of jumps sideways. It serves the game well like "get out of my way." It is like how Blanka kicks in Street Fighter 2.

 Beyond the movement is the gravity of it. The best thing to include is the ability to change your mind mid jump. That stops your momentum and can prevent you from being hit or missing the right landing. Some jumps are heavy like in Castlevania. You pretty much must make a perfect jump because there is no turning back (literally.) Some jumps have no gravity at all. They are super high like in Legend of Kage.

 Some games throw you back if you are hit or else stop you dead in your tracks. Like Ryu Hyabusa in Ninja Gaiden 2. The majority of deaths can be boiled down into getting hit off a platform in that difficult game. Some games let you jump from wall to wall. Oppositely, some games give you invincibility while jumping like the screw attack in Super Metroid. Games are ruined graphically if there is no jumping animation given them. It looks so strange when the character just kind of motionlessly arches. It can't be left out what the jumping does, either, meaning it is not too difficult to land on things or get around that way in general. To be able to use weapons while jumping, too. Those must all be considered in making the jumping within a game be done well.

100- RPGs, platformers, side scrolling games, beat 'em ups, overhead adventures, first person games, strategy games, you name it, they all have their own way of using magic. To a certain extent each of those have their own way of using magic. Adventure games are more field based. If there's something in your way like thorny vines then you have to set them ablaze. If an area needs to be crossed then even lava can be frozen. RPG

games offer you an evolution of spells. They can be very impressive graphically. The library of spells has increased dramatically in RPG games from where they began. Enough that it is important to go over all the new and old RPG games you can to see your options. Beat 'em ups have spells sometimes. There is Golden Axe where you get a few uses per level if not just one. So a big dragon head comes out and sets your enemies on fire. Ghost and Goblins Resurrection has added a repertoire of magic. Just as good games do, you can choose the path of your magic. In this case it shows a tree and the branch of what you learn can go in many directions. Magic can be learned by scrolls- that was about the oldest way too. They can be learned just by regularly leveling up. They can be forgotten spells the old wizard suddenly remembered. They can be taken out of spiritual stones or books. Sometimes the game has it as a thing found. Sometimes you have to learn them, other times they are entirely optional. Super Mario Bros and the world of it in general is based on the evil sorcerer Bowser. Many don't know that but that was the original story to things. Bowser's kids are all wand wielding magicians in Super Mario Bros. 3. The original story goes that Bowser turned the people of Mushroom Kingdom into bricks and things. In Super Mario World there was Magikoopa. They are shape shifting magicians so maybe it is that Bowser himself is human.

Sometimes magic in the game isn't magic but technology, but does the same thing. By whatever name it is just as much fun to use and gives you power you wouldn't have in real life. Magic doesn't at all have to be used only on enemies It could be used to burn a bush away with a magic candle. It could light up a dark room, help you find things, even let you transport to another dimension. RPG games have become very strategic because of magic and certainly more than with anything else. What was once very straightforward has become a thing of finding and exploiting weakness, casting slow and haste, upping defence with shell or protection, casting the right summon, and floating against earth quaking enemies. There is greater and greater depth to RPG games because of magic. Finding summons alone make up a lot of their games.

Fighting games and magic is inseparable. They could be shape shifting into any other character or just fireballs. Naturally Mortal Kombat went with a flying skull fireball instead of just a ball of energy. In Kid Icarus if you are hit with something you turn into an eggplant. Egg plants were just the right choice. They are as strange as mushrooms are. Anyways, if that happens then you will have to backtrack to a person that will remove your curse. Ghosts and Goblins did that very well. If you are not careful you will turn into either a baby or a chicken. The spell wears off but in the meantime, well, how humiliating! Link himself will turn into a bunny if you are not careful.

101- Ideas for weapons can be taken from old stories of magic, wizards and fantasy based things. They can be the weapons the Grecian gods used. They can come from

tales of Dracula and weapons effective against vampires. They can be modern weapons. Guns of all kinds, clubs, grenades, missiles, chainsaws, etc. They may revolve around ninjas, samurai, or former wars. The Ninja or Samurai have a sword, the Viking and the Pagan their own thing. They can come from more obscure sources like what weapons were around long ago but mostly forgotten about. A ninja character can have throwing stars. Even popular soda brands have come up with video games and weapons for them. Such as Cool Spot and his neat little hand gun. That was like pretending to have a gun in your hand and far as that goes. There are games with every weapon under the sun. Sometimes the game will call for unique weapons and other times not. Things that are tied to weapons call for their weapons (ninas with a throwing star) and made up characters will just be given whatever best weapon you can for them. Mario doesn't use a toilet plunger (I don't know why he never has.) For a side note there could be a more life-like Mario game as opposed to a cartoon one and maybe a parody of sewage and crap. The crap falls down on him and "Moma Mea!"

All new weapons can be made like in Rygar. Sometimes the weapon itself makes the whole game what it is like in Bionic Commando. Stories can also revolve around certain weapons like they do with the Master Sword. Whatever the most powerful weapon is in the game is, build up a lot of hype around it. One possibility is to have a sword of all swords that take in every other power of the game so long as you can draw it into it- or a crystal of serious power doing the same. A living crystal perhaps that can destroy any enemy of the game and do great things for you automatically. Whatever you would give the most power, make it truly powerful indeed.

102- People have flown on carpets in games, on clouds, airships, spaceships. Have flown around within a tornado. Have just flown themselves with their body. They've taken rides on enemy and friendly characters/creatures, and with shoes that had wings on them. How else are you to get to the upper levels or roam across the game map? Often the first airship wasn't the last. The new one was faster or had a gun or something. Mario games provide the best example of how you can fly in a game, at least among its kind of game. There are helicopter hats, riding as a bullet bill, and the more commonly known ones that just have you going upward like a plane would. It is an underused idea in RPG games that you can fly yourself. They always require an airship or something for that. It would be easier to just take off and land with your body. Another idea is that a summon could pick you up and fly you where you want to go. In fact summons could transport you in general. Maybe an early summon horses you across the land while a later one flies you across it. Some things closely related to flying are gliding, floating slowly downward in different ways, shooting out of something, or you could say jumping so high it essentially gets you to the same place. There is a kind of jumping like in Metroid where Samus jumps, pauses midair, goes higher up, pauses again, goes up further, etc.

103- There are countless *types* of people that are played as. A prince from some land, a dragon or Dracula Slayer, a beast instead of a human, or animal or creature. A robot of some kind, an elf, a soldier. *A dolphin. A plumber.* As there are so many choices, take the time to determine the best choice(s) for yourself in making your game. All new types of main characters can be made as well. They only have to be loosely based on what they are, as well. It often creates a whole game around it. For example Castlevania is all based around classic movie monsters. You could add Mega Man to that to a lesser degree. Everything there is based on cute robots. They are like songs that write themselves. There is still a lot of creativity involved. There could be a lot of space to fill. Some game maker's are happy to- some prefer to in fact. Those that want the whole world of the game to come from their own mind are such people. That doesn't prevent the whole basis of the game being predetermined in order for it to be good. Some take a more general concept and form a pretty unique world from it. Ghosts and Goblins is seen as such a case. It's Ghosts and Goblins or Ghouls and Ghosts, I guess. Cup Head took its premise from really old cartoons. From cartoons in their heyday. Some came from liciened ideas- from Wizard of Oz to Terminator. Of all comics, books, movies, shows, even music bands like Aerosmith. Some racing games are set in the future. Some took the Micro Machine brand and made it a racing game. Marble Madness was just a racing marble. There was just racing when it came to some. Some used monster trucks, others motorcycles, and some aircraft. and some certainly were the first of their kind such as Mario Kart.

With fighting games they have been based on simple martial art tournaments, they could include the more demonic or sinister, they could be future based, have just things of myths like skeletons and werewolves, clay animation, have you fighting as dinosaurs, you name it. Simulations have been building up a city unto the highest population, creating a theme park, The Sims, and god games like Act Raiser or Populus. Then there are strategy games going forward and backward in time, space based, military based, among others. The biggest idea that comes all at once is the setting. It is where the game maker starts unless they are after something entirely new.

104- Traps along the way include falling spikes, rotating fireballs, bricks with spikes around them (more imaginatively) beams shooting upward and downward and sideways, dripping poison, and skull marked bricks you cannot touch. The image on them indicates that the player will die if s/he does. Sometimes a great monster or just powerful thing is in your way. Like in an adventure open world game where the programmer wants you to get stronger before you go there. If the game maker likes they can also make it where the player can sneak around such a thing. Treasure chests can have monsters in them. Monsters can be just regular looking people out in the middle of

nowhere. The moment you talk to them they change form and attack you. Whenever you are in an RPG and find a monster just sitting there ahead of you you know to quickly up your defences and save your game before you continue.

Sometimes in dungeons you are going along well but fall through the floor. Sometimes that is desirable, other times not. In fact sometimes it causes a lot of backtracking. Then there is the wall hand that comes down on you, grabs you, and takes you back to the start. Super Mario Bros 2 (in Japan) had it where you thought you found a warp point but it was a warp back to the first level. There were also a lot of invisible blocks in that game that caused your jump to stop and fall into lava. That's called trolling. It is when you take a cheap shot against the player.

Other traps include quick sand, pit falls, being cornered, grabbed, and being frozen or paralyzed.

105- More imaginative ways an enemy is made are the ones that come out of coffins, the ones that follow you when you aren't looking at them, ones that are more than just attacked to defeat but must be done so in a more particular way. Like one piece then another. Some have been made from a ball and chain idea. These take the game beyond just plain.

One game has it where the enemy will leap out of the way when you try to strike it. Another will break itself into doubles when you attack it. One will shock you if you hit it with a sword instead of an arrow. Enemies can follow a pattern like flying towards you in a wave pattern. Enemy bosses always have patterns. They minimize the movements you can do in order to both strike and avoid getting hit.

If you want to look at just how many different kinds of enemies there can be, you don't have to look further than Super Mario World. It had football characters using balls against you or charging at you (Chargin' Chuck), sumo wrestlers stomping flames below them (Sumo Bro), the dry bones, magikoopa, dinosaurs, the wiggler, twimp and twomp, jumping piranha plant, and the bob-bomb among others. Not that I am suggesting copying them but it gives an idea of creativity being used.

RPG games have been known to have the most ridiculous of enemies. In Final Fantasy 7 you fought against a house. Dragon Quest took a more cute-evil look. You could say they were more cartoon-like if that cartoon is Dragon Ball Z which in fact has the same artist. A cartoon animal design of enemies can be good. Donkey Kong Country had lots of them. Some game makers want to create all new kinds of enemies much like Zelda games do. Some are based on fairy tales including fairy tales themselves. We all know what a goblin, troll, and dragon is. Some go for a monstrous demonic look. They are just made to be as scary as possible. They can take up more than a screen in size.

They have moaning heads attached to them- like souls they took, or are something like a skull headed spider, for example.

One of the things that makes an enemy more unique is by how they attack. It certainly doesn't have to be just a weapon in hand or magic they use against you. It is how they use their weapon against you that makes them different. Likewise how you use your weapon against them and what it causes make them unique as well- more imaginative, different than just attacking them in whatever way and they fall dead. The third thing to consider is how they behave. The fourth is how they appear. So there are four things to consider in making an enemy: how they attack, how they are attacked, how they behave, and how they look.

106- Types of spells are numerous. The most often used ones are based on fire, water, and air. Then these kinds of attacks are based on one of them. An air spell can be a tornado spell for example. There are those ultimate spells you get along the way, but then an even better one toward the end of the game. Don't forget summoning spells. Then there are spells that modify stats temporarily. Some weapons have spells within them. In overhead adventure games a book or wand is sometimes used to cast one.

Some would say there is gray magic- which is magic not necessarily good or bad, it just causes an effect such as Haste. There are many classifications then just black, white, or red. Red is to have both black and white just usually in weaker form. There is summon magic too. There is beast master magic that teaches you the power of your enemies. Shape shifting magic and a lot of other kinds can be put into a game. Sometimes there is one spell and only one that is white magic yet it attacks. For example "Holy" in the Final Fantasy series.

Graphical effects of spells are important. Like if you cast death you can see The Grim Reaper pull your enemies soul from their body- which is neat. Death even cackles when he does it. A higher fire spell can look like a fireball falling down on your enemy. The first lighting spell was like a spark. The third was like a boom as though lightning had struck right in front of you. Some go out of their way to look powerful. Unfortunately it is the spell you always use but takes the longest graphically. You can bring up good graphical effects without mentioning summons. They are impressive cinematics.

Adventure games are more likely to have wands or books of magic. In a game focused on swords and arrows it feels quite neat to throw a fireball at an enemy with a wand. Ice otherwise, and the effects they have with them such as freezing your enemy solid. There was always something neat about freezing your enemies, such as Sub Zero does. In whatever case magic in games should be wide scale effecting a number of things if it is there at all. It doesn't at all have to be only spells either. It can include wands, capes, rings, accessories, be put into swords, arrows, or keys.

In fact to make a list of those: *magic to jump higher or fly, magic to find things, magic boots or gloves, magic glasses, magic hammer, magic swords, magic shields, magic necklace, magic orbs, magic to teleport, magic for speed, magic lantern, magic statues or idols, magic of invisibility, shapeshifting magic or form changing magic, magic bottles and potions, magic fairies, magic beings of all kinds, magic tools of all kinds, magic help of all kinds, and magic effects of all kinds.*

107- One town may be wealthy. One town may have nuts on them. Or just strange people, who are perhaps secretive, one may be the evil King's stronghold, another full of your allies or those that need you. One town may be hidden – on the moon, in a cave, underground. It is always good to make every new place different from the one before. It is not at all difficult to do either. A town can have the strange, a cave can have a prime enemy- like one telling you to go no further in a mysterious way. Another can house the thieves hideout. There is the bustling town by the sea where all merchants go. There's the grand kingdom that resembles the most royalty. There can be a town of magicians hiding their sorcerous secrets. This is just a small example of how very different one place can be from another.

As for different levels in a more platforming game kind of way: they can be split into forest area levels, underwater areas, cave/cavern area, ice areas, underground areas, the higher areas, desert areas, etc. That would be something more in the vain of Mario Bros/ World. If you take Ghosts and Goblins as an example then one level has you going through a kind of graveyard, another has you floating on a raft in a tumultuous sea, and another has you climbing ever higher on a tower. If Mega Man has an example then the boss at the end sets the theme, from airman to wave man. Of course one has you doing things in the clouds while another is underwater.

In an adventure game there may be a town or two. The original Legend of Zelda was more apocalyptic. There were no towns. There was a scattering of humans, all hidden. Overall it was monsters in the game everywhere you went. Link's Adventure had many towns. A Link to the Past had but one. There can be different environments in an adventure game. The place of mountains, the place of forests, for example. And different kinds of places like the graveyard and grand temple. Dungeons are a good way to make a small comprehensible map larger. The map doesn't end with the top. Later Zelda games would be split into themes just like so many other games: the water temple, the forest temple, etc.

In whatever case it is a most welcoming variety. They can be places that make themselves based on just a little background theme.

108- There are many instances where something was done as it wasn't done before. Most racing games were more or less the same. Then came the ones that did it a different way. Like a side scrolling motorcycle game with an over heat meter, making the jumps according to a right angle, and it wasn't something that was really done before. Or a fighting game that had four on screen at once each based on old beloved characters that a company had put together the previous ten years. And a go kart racing game that took a regular idea (racing) and made it entirely better.

Thinking outside the box, being imaginative, well-inspired but taking it beyond inspiration, being powerfully creative, those are some of the virtues found in the best game makers.

109- A game may have taken a month to program or many years. It may have been done individually, with friends, or corporately. The process may have been fun or toilsome. And one is true for one person but not another. The potentially best game may have been rushed and come to nothing. And some had been left incomplete. To make a good game the rule of thumb is "make a good product." Keep that in mind always. If it doesn't meet with high standards then the best choice is the choice of more work on it. The best route is the one well prepared. The better route is the one where problems are fixed before they arrive. To set out making a good product, to dot your i's and cross your t's. When you are sure that you can do something good and new then dive right in, work on it, and after an extent of perfecting it then release it, giving it as much fanfare as you can.

110- In one game you die by being hit or coming into contact with something you shouldn't. That is the most frequently used cause. Some will have you "die" by failing a mission or not meeting certain objectives. Sometimes they die when time runs out. Or it could be that a puzzle wasn't solved and they had to start over, try again. Poison may gradually reduce HP. Or consecutive actions expected to be memorized are not done right.

The many ways of game overs are good for the understanding of a game maker. The game over screen/animation itself could be made of varied quality. The sound effect or music for it should be given a lot of consideration itself. Ninja Gaiden 2 is my personal pick for the best game over sound. You could do a Mario if you like: Mario just falls off of the screen down below. You could do a Link spin if you prefer. Or, if you like, something more like Gannon's face and laugh from The Adventure of Link. The RPG game might say you were "annihilated.." or more simply "defeated." More brutal games show you were beat up or destroyed.. unless you put in another coin.

111- A person, place or thing in a game may have been taken from a pre existing movie or story. They are like a homage to them. They aren't really stolen. Just a desired reference to something they enjoy and appreciate. And sometimes one game pokes fun at another. These can be easter eggs. Those can be found in areas tucked away from others. If they are done differently enough then there is no concern for plagiarism. I remember one day it dawned on me that Metroid was based on the Alien franchise. That didn't immediately occur to me until I watched the movie for the first time (I was behind on certain popular films.) The Metroid drains your energy but the similarities end there. They do not at all look the same. Yet just taking such a basic premise a great new franchise was born.

Most creative people are that way because they want to do something of their own that came from something they loved. True fans of a thing want their own hand in it. Sometimes they want a direct part adding to a franchise directly. Other times it may have mostly been imitated. Sometimes not at all- it truly stands on its own in that case. Unless you are working for the company that your inspiration came from or working with a license, the best thing to do is to make the game stand out on its own. It doesn't have to be totally different. Just different enough to be differentiable.

112- Arcades may just need a little tweak to get them popular again. By who knows which way, maybe giving you a physical prize for beating a level. Maybe by making them more comfortable and leisurely. Allowing you to rent a kind of set up. More game choices. Whatever it is, it can't just be in the current form it is. You can stand and play them or sit and play them. You may even sit on a motorcycle kind of seat. But maybe we need more of a VR set up.

Then again arcades are making a resurgence. But in one's home—as kits ordered and set up *in the home*. If you can say they count then there are also the arcade stick plug and play games. They have classic arcade games on them that are played much as they would have been. There is no difference really other than the TV not being in a cabinet- but those can be made. MAME ROMS allow you to play whatever old arcade game you want to. There may need to be a gimmick behind making arcade games popular again. That can be VR, much larger screens, some incentive, or done with holograms.

113- Handheld games include LCD ones and can be as basic as just dots lighting up or simple calculator style graphics. Some games are very well suited for these, like card games and slots. The technology for them isn't as bad as it appears to be. It just isn't used to its potential. Is used instead cheaply. There's one screen. There could be more than one to make this technology more versatile. It may need different buttons. Not buttons in fact but dials and flip switches (the whole side of both sides.) Instead of

them trying to make it play like a home console would. They have gone out with the dinosaurs though given that new technology can easily give us something more powerful than say, the gameboy, having numerous games on them too. Or the smart phone to an even higher extent. LCD games may be going away and not returning. The best that can be done with them are puzzle games like Tetris or Sudoku. Slot games, black jack, to add two others. In fact Nintendo released two new game and watch systems to celebrate the anniversary of Mario and Zelda. The original game and watch was an LCD game. These though were games from the NES and gameboy presented on a modern little screen- not LCD at all. One day I found Organ Trail doing the same thing. It was shaped like an old Apple computer and presented the same graphics.

114- Wanting to take an old game and make it better? There are those that took an old game and programmed it in a way that you can play it using every cherished character found on the other games of its systems. There are some that are just modified to make it more difficult. There are some that added two players. And they either stick around or get shut down by the copyright holders of them. But my favorite example is called a randomizer. It takes special items found in, say, chests, and mixes them up. As a result you have to have a lot of luck, and progress accordingly. They usually make you beat the game much quicker, and so are used in gaming tournaments or speedruns.

Making an old game better may just involve fixing a thing or two. After that a broken game is a good one. Hacking games have more of a point to them if they are made more difficult or engender something new to them. Some are stylized after games on other systems like the Mario Land for SNES game. It was Mario Land if it was a SNES game instead of a gameboy game. Some characters are ported to other systems where they totally don't belong, such as a SNES Sonic the Hedgehog game. Some games are given a gimmick such as a battle royale of players just trying to beat the level the fastest.

There are of course remakes and remasters too. They change the graphics to a greater or lesser extent and can change things from a little to a lot. My friend liked Ocarina of Time more than any other game. I asked him how he felt about the new graphically improved Ocarina of Time time. All he had to say was "why would I buy that? It just has better graphics (so what.)" Sometimes a worse thing even happens: the remade graphics and sound are terrible. The SNES Ninja Gaiden Trilogy is easy to include in that. Many don't like the new pixel designs of graphically enhanced Final Fantasy Games. I personally didn't like the Final Fantasy 4 DS 3D game. The DS was just not capable of great 3D to say the least. When Final Fantasy 6 was ported onto Playstation I thought I was in for a lot of cool 3D cinematics. But no, just the title screen had them and even those didn't impress anybody. Then there are those games that were just ported from inferior sources. Such as a port from a lesser game from a lesser

system. The translation and other things on that particular one should have not been the basis. Super Mario All Stars was great. Enough for it to be the second highest selling Super Nintendo game. It gave you a bang for your buck. Four great games all remade well and at that time nobody could have played them without an NES. Even if they could, they would have been pricey individually. Then there was also the one that added Super Mario World to it. Then there was the Gameboy Advance series of Mario games. Unfortunately they added oddball voices coming from Mario. Mario said in a strange way "just what I need-ded!" whenever he got a powerup.

 Ports used to take a big hit when going from arcade to home console. For some this was fine. In fact Contra and Rygar are considered better than their sources. They weren't the same games really, however. Colors had to be cut, sprites had to be made smaller, levels removed, graphics downgraded, some like Dragon Slayer were not even possible. They had the daring to take a complex arcade game and put them into very weak hardware. For example Street Fighter 2 on the C64. They even expect you to get by on a single button and joystick sometimes. A favorite YouTuber of mine always refers to their sound effects as being farts and queefs. The port of Pac Man onto the Atari 2600 was a travesty. Other games like Space Invaders did well enough. Some like Pac Man only had the fault of the programmer to blame. Like Mortal Kombat on the Sega Genesis it could have been a lot better. Street Fighter 2 for the Sega Genesis was improved through a hack making some color and graphical improvements. A lot of people make graphical improvements or other tweaks for old games. Mario 64 is a popular subject for them. Naturally Nintnedo doesn't want it on PC.

 Emulators themselves are becoming so that they improve or at least change games. There is one for the NES that adds a kind of 3D look to any old NES game. There is a mode 7 enhancement that sharpens the pixels and it is quite impressive. That was the only fault of mode 7- it looked blocky. Then there is the area of nude mods or comical ones. As for comical mods they can do anything from making Link into a duck or blowing heads out of proportion. One thing is sure and that is that old games are being changed all the time. Usually for the better, sometimes not.

115- There are games made around just one concept from another. For example one game had within it among many other things summoning. Then a game was made that was based on nothing more than summoning. But also keep in mind that one game that is just one thing can be included into a game of many things, such as fishing. You could say that it was a beat em up kind of game that led to typical two contender fighting games. The point is that individual elements in games can be made into new games based only on that.

116- They've always tried to find just the right species of animals to make into a game character. Appearance counts a lot and so does personality. The choice of species doesn't matter as much. It does but style matters more. You could look at the way Disney cartoon characters act as far as personality goes. The elephants in Robin Hood look like something in Donkey Kong Country. They walk on two legs and happily move along instead of being presented in a more lifelike way. Animals of all kinds can be included in a game. One may be a sword fish that you dart around on like in Donkey Kong Country. What makes that good is not just riding on them but with their sword like face you have a weapon. A rhinoceros feels strong to move along with and can burst through walls. All kids like dinosaurs so they are naturally a good choice. Joe and Mac went with the dinosaur and caveman idea altogether. There are horses you can ride and also a camel. Unlike in real life you can ride just about any animal in a game. It could be suited for that if it has to be such as making a bird larger. You could even be like He-Man riding on a tiger. The game can have a thing of turning you into an animal like a wolf in The Legend of Zelda: Twilight Princess, or in Altered Beast in general.

117- Choices of names come across differently. Some are simple and regular names. Some are hard to pronounce. And to this day there are gamers that pronounce them one way and another person differently. Some names have a meaning behind them, like a link to something. And sometimes you choose your own name in a game. In Final Fantasy 6 an item late in the game lets you choose an all new game. In most modern games the name is pre chosen and cannot be changed because of voice narration. Sometimes however the name just isn't said during narration so the player can still pick their name.

The name of a sword gives you an idea that the next name one is more powerful. For example from copper sword to silver sword, to diamond. And that's so with just more than a sword, of course. There are spells going from Fire 1 to Fire 3. After that there might be something such as "blaze." Naming the enemies in an RPG game can be like taking one thing and putting it elsewhere. Like a Stingray fish from the ocean, placing it in the desert and calling it a "Sandray." It could be to mix two things that seem similar like a praying mantis with a reaper. There are things like "zombie dragons" and "fossil dragons." Some have names that don't exist. Some are just simple names like "leaf bunny." Then there are some given neat names like "Angel Whisper" that just give a name to what they do. And finally, some have regular names, just altered, like "cactuar."

We couldn't be expected to know the names of all of the enemies. So Super Mario World had what some games have- they listed and named all of the enemies in the game after you beat it.

Naming weapons can be based on what they do. They could be inventive instead. They can be generic if you want, such as just "iron sword." We all know that Donkey

Kong was based on King Kong. Where the word "Donkey" came from is anyone's guess- then again there may be those that know. Pac Man was initially going to be called "Puck Man." He looked like a puck. They didn't want the arcade machines being altered with an F at the beginning so they changed it to Pac. Mario and Luigi both have the last name "Mario." Therefore Mario is Mario Mario and Luigi is Luigi Luigi. Names in the Mushroom Kingdom are usually just what they are- that's their name.

118- Color is effective in making one opponent more powerful than another. From yellow armor to red, for example. Or to signify royalty with the color purple. And although programming such is far easier, it *is* effective. Colors in a game can be bright and stand out. *Too* colorful depending on the game's settings. But the worst thing is to only use a very minimal amount of them from place to place. AI may be as such that some day in a game it can have the sun set on the level behind you, which wasn't so before.

First the sword is gray, then it is red, and as such feels totally new though all you did was change the color. Many characters are just color swaps such as done in fighting games. A color swap can indicate what a certain thing does such as it is with Koopas in Super Mario Bros. Like in Mario Kart too, the green shell goes straight forward and the red one hones in on the racer ahead of you.

Some coins are blue, others are green. It is an easy way to indicate their worth to the player.

And there is a game where you must spray paint certain enemies. That is, Bart Vs. The Space Mutants.

Personally I always thought it would be a good idea to have color lighted buttons. Like one that lights up blue or green, yellow or red, and as you see things on the screen you can interact with them based on color. Like green text gives you more elaboration when you press the green button. Or a purple color on the screen has you using the blue and red ones. Or to go toward a green tree you press the green button. Or to buy an item from the shop just press the green one. A really good idea, I feel!

119- There have been games that were playable on just one screen. There were ones that just had you move from left to right. And 3D lets you move all around. There are even 2.5 D games. Games where you just point and click. Games that are played as movies. And games that made movies through rich cinematics. There had been overhead ones. Forced side scrolling ones. Vertical ones (isometric.) They even had an arcade machine that used a row of screen elongating it.

The Virtual Boy was based on pseudo-3D technology that would reemerge with the 3DS- Nintendo's 3D portable gaming device. The Sega Master System had 3D games that went with 3D glasses. The Vectrex used what no other home system did- vector based graphics which were more realistic looking in its way. Light guns added technology to your TV. The way they worked was by flashing a series of lights along the TV and what that light bounced off of was where the gun was pointed. It happened so fast that you didn't notice. In effect it isn't the gun that is shooting but the TV that is.

The Nintendo DS used two screens. It must have been a good idea because it remains the highest selling Nintendo console, currently. It was very useful to have the map on top and the game play on bottom. Maybe even better was having the inventory on top and the gameplay on bottom. It was based on something they had done much earlier- the game and watch series. Speaking of LCD games they engender a screen of their own. They've come in the form of watches. The Nintendo released literal games on watches were good games. As for Tiger, well, they weren't as good at what Nintendo was producing.

What's next? Can we depend on holograms or at least augmented reality. VR or further immersion in whatever way? Who knows but the successful pioneers are probably leaving the TV to go in that direction. Computer screens and things have all been said and done. The age when riches can be made off of arcade machines and these simple new devices known as video game systems are long gone.

120- Most things have been done in games that could be done, depending on what variations that any one thing was given, and so often changed. If you feel a need to be entirely original then you will miss out on the rich possibilities before you. They've done all the work. You have a lot at your disposal. And the opportunity to put things together the best way they could be, instead. WIth how much humankind has produced in forms of entertainment we could use for an eternity. Even if that must be with new spins, remakes, or alterations. I think there are a lot of new possibilities. Those will come naturally as time naturally evolves us. When more holographic theaters come about there will be an awful lot to remake. That'll go a great deal further than colorizing a movie.

My prophecy of sorts is that new technology will greatly change video games. Technology itself will improve game making abilities- like AI that auto fixes or changes stuff. AI could even auto compile a game if programming language evolves to that point. Things have certainly gotten cheaper. As kids we did not expect there would be ROMS and emulators. Now these games we so greatly needed were right before us. What cost thousands of dollars- a system, a dozen or so games, was now highly affordable in a classic mini console thing. You can have an arcade machine in your home at a reasonable price. We could find it hard to believe that someday these will be

available in PlayStation 5 Mini form. There comes a point when home consoles and games have such hardware as to be more than enough for any game one wants to make. There will always be those that try to go beyond its limit, though.

121- There are always random battles but you never find random puzzles or games. For example instead of wandering around for random battles a dots and boxes game is pulled up. Why do random battles have to be enemies in a dungeon and dragons kind of way? Sometimes in making a game the traditional way seems the only way, but it isn't.

122- The many ways of RPG fighting cannot be gone over quickly. I wouldn't even bother trying to cover all of them. I will just go over the best ones. RPG games should have more than just attack, magic, and item commands. There should be at least one more for abilities. Those can be learned through whatever way- through ability points the player spends, with or without job commands. Sometimes a character has their own innate abilities that the others do not. These can be like Sabin's martial art moves or Cyan's Sword Techniques. His sword technique is more powerful based on how long you wait. There is Locke also, who can steal. Locke's steal isn't the end of it: with a relic you can change steal to mug (to both attack and steal at the same time.) It is like magic changing to X Magic if you are able to get that ability. X Magic lets you cast two consecutive spells instead of just one. There are items that you can buy per type of character, too, like the shuriken which only the ninja can use. Ninja doesn't have to be a job class. It can just be what the character is if you like. Another command that can be put in is the commonly used Summon command. We all know what that is. The summons themselves can do a number of things. They can heal the party or raise its defenses and of course it can attack. Along with that they may include a number of things you can learn through AP (Ability Points) as long as they are equipped. One may be "zero random battles" for example, or "defense + 10." My advice is to not just gloss over these if you include them in the game. Balance is needed in them and inventiveness/imagination if they are to go over nicely. They can also be a way of learning a spell, just the same spent on ability points. In fact "spent" or automatic, whichever you prefer. They can teach you anything after so many points. If it is automatic then every thing in the list of things you learn is given a point. Some require more points then others.

The player should be able to cast magic on all enemies at once if they want to. That means that the spell is weaker against them all compared if they were hit individually. Bravely Default 2 had it where you had a brave command and a default command. To default was to store up power and when you select brave it uses your accumulated power. Sometimes games have it that the instance before you land a hit and press a button then the attack will be more powerful. There is the defence

command. Then there is the row offense/defence. The characters that are on top and most forward are the most offensive but the least defensive, and vice versa. There is the speed stat that determines how quickly your next action will come. It can be so high as to make their attacks come twice as fast as the others. That is a good stat to raise if one of your characters is much more useful than the others.

Going back to job classes- there are so, so many possibilities. To just name a few: freelancer, bards, ninjas, monks, knights, dark knights, black mage, white mage, gray mage, red mage, scholar, merchant, thief, summoner, warrior, beast master, technician, gambler, ranger, and dragoon. As always, it is good to know your options, to understand them at least a little, then put your favorite ones into your game. They don't have to be job classes either but just innate from one character to another.

..RPG skills can include stealing, using cards or slots, dice, coded button pressing, timer strikes (the higher number you wait for the more powerful the strike.) For a player to shift forms. For a player to jump and come down later upon the opponent. Many others too like having a pet protect you, taking the enemies power and magic, copying what your opponent does, the unique ability to summon, being capable of using more powerful weapons, absorbing magic otherwise harmful to the party.

123- Taking one thing and making it better doesn't make an overall game better. These things have to fit together better too. And "the more things change the more they remain the same." If everything is just a different version of the same idea then the game is just largely the same as it was to begin with. If a person just basically copies something it goes over like this: You made another Mario game? You should leave that to Nintendo. Only Nintendo has been able to make a good Mario game. That's just because anything else is identified as an ugly sibling. They have ugly "goombas," and odd looking mushrooms to avoid copyright infringement. It doesn't have to be altogether different to be an adequate well received game- Lady Bug was a nice Pac Man clone that did cool things Pac Man didn't. It reminds me of movies that are obviously trying to copy another. If you really like the original then it is difficult to appreciate the other one. If the name is generic enough like "Alien" or "IT" then they'd even try to fool you with its title. There was the ET rip off that nobody remembers (Mac and Me.) There are many examples, believe me. I think that cloning games is just shameful. They hadn't worked on anything but rather took another's idea for a quick buck and the moment we saw it we knew it.

124- Ask yourself how a real life thing is put into a game the best way. Instead of making it realistically adopted, incorporate it in a way that it is best as an element of the game. The game doesn't have to make sense unless that is its intention to begin with-

even then there is a lot of room for imagination. Many of the best games make no sense at all. Piranha plants coming out of pipes? It is better to make a fun and imaginatively presented world. There is a translation into the game world. The rules there are not the same. In that world all things are possible. In those games imagination can come alive and bustle. Some games call for a degree of realism, however. It should be determined how much and of what should be presented in a realistic manner. Some things are even more unfair than real life like swords breaking, and having to rest like humans do- even on a schedule where a day lasts about 20 minutes. So the real question to answer is when and where realism has its place. More than that, what is the best life and world for the player in the game?

125- The environment of a game can be made up of areas like the inside of a great tree, a graveyard with spooks inside, or a tomb, or a heavenly area. It could have you walking long down a path. There could be a hermit there. Or a person that direly needs help. There are lakes that dry up to reveal a path and places hidden within a large wilderness. There can even be floating continents. The topic here is unique or hidden locations.

These can be the result of having the right tool to get there as in Zelda. Link bombs a crack in a wall to find what is inside or hook shots himself over an otherwise impassable pit. A better example would be playing his flute in front of a fairy pond. With Samus from Metroid it is basically the same thing: newer weapons/abilities will open up new areas. An RPG may have a hidden location where it wasn't expected such as a staircase behind a bookshelf. Final Fantasy 6 had a brilliant one where there was a monster on a little island. He engulfed the players. The gamer thinks to fight this, to run if they have to, but it turns out that after you are engulfed you are sent underground where a hidden character (Gogo) can be obtained. That can be done differently in so many ways. You could encounter birds near a mountain. They look like they want to eat you or something. They grab your characters one by one and you think to fight back harder or flee. But then they take you up to the top of the mountain. It could be the same thing taking you underwater to Atlantis or wherever else. In a more side scrolling game fashion that's done by flying higher, hidden pipes going underground and things like that. Mega Man made it seem like a pit was a death trap but when he jumped into it there was a special item there. There are vines Mario climbs. Naturally you don't want to directly copy things as uniquely Mario as that. So instead something like a whirlwind comes up by hitting a block and that'll soar you up high to cloud land. You can have an instance where a magic staircase appears and climbing it brings you to a different place. There are creative ways you get you to other areas- those higher above or below in a side scrolling game.

126- Dogs that shoot out swords, an enemy with a ball and chain. I used to think they were dogs anyway. I'm referring to the Centaurs in The Legend of Zelda. One person says "kids like turtles and dinosaurs, let's make them in a game." Another says "kids like turtles and ninjas, let's make it into a cartoon." Trees that talk, skeletons with sword and shield, the sea monster, and a witch flying on a broom, are some commonly used ideas. In Mario games it wasn't a witch but a Magikoopa on one. The most common method and the most effective too is to mix things up. It is the dragon taking the princess for sure but it is King Kong or Bowser. It's a ball and chain- make that into an enemy. The Legend of Zelda: Link's Awakening turned that into a dog. So now we have a ball and chain that is a friendly dog. There was one more neat thing about it too, which is that if you stand in front of it for long enough it will break free of its chain and come after you. Maybe it was a dog all along! That was before Link's Awakening had it specifically as a dog. If you hit the chicken enough times the chickens from all around will gang up on you and you are almost surely dead meat. After you hit the turtle shell it becomes a weapon. The sun above looks like just a part of the background but then starts to chase you all around as though it has fallen from the sky. They are unique enemy effects and can be the best part of any game.

If you steal from a shop and return then disaster truly follows. If you land on dry bones it will fall apart but pull itself back together a moment later. Sometimes in an RPG the enemy steals from you instead. Final Fantasy 6 did this very comedically with a large bear. Sometimes it was thought an enemy was one but wasn't. In fact it gives you things. It was the one random battle enemy in the whole game that did. Sometimes it is just that one level or area in the whole game where everything is super sized. In Super Metroid there was a statue or two among many that would come alive. The others didn't. They were normally just as stiff and lifeless as any other statue but two of them came alive. It is another example where one thing among many was different.

What I am going over here in general is that some enemies have nice touches to them. Some were creatively made and are especially good with a thing or two that is special about them. Game Makers should bring special elements to whatever enemy they are designing. It is a thing that can be called more deep and less shallow, more interesting and less plain, or a practice to put in greater substance.

-Conclusion-

In all of these you should have a substantial idea of your choices. They can be added to personally, or just taken as your intuition suggests. Take your time and find the best things you can put into your game. Who knows what good things you can come up with when given enough ideas to work with? And I hope your game creation goes very well.

With so much that has been said I am sure you will have a ton of ideas to work with. Knowing your options and being given examples and ideas is the best thing I can do for you. The practice of this book is to take old ideas and make them your own. Some of the ideas I have given you are too generic to need to change. They are just commonly used ideas in that case used by one and all.

I am continuing now to give you some of my own ideas which you may feel free to use in this public domain book!

Part Three: Some Free Ideas Technology-Wise And Game-Wise

Many peripherals have been created from pads to stand on to circles to be in. From gloves to wear to just arcade versions of game pads. There have been cards you scan. There have been motion sending devices of all kinds. They are mostly scoffed at for being good concepts, but just not working well enough. Some worked fine, such as gun controllers for games. But the glove I refer to and many of the others could be improved by any individual and sold. That goes along the lines of making what didn't work well work well, adding to it what is needed to make it better.

As AI develops and software along with it the next great code modifier (those devices that reprogram the game letting you cheat) could be much more versatile. One could even be made that lets you entirely recreate the whole game.

Password printing on a card. Other kinds of cards are printed like accomplishment ones. Membership cards made. Like in a large game world to participate and be a part of a group gives you a kind of card. The story you make printed out. Imagery in the game can be printed out. Your high scores, too.

I imagine soon you could tell the console to do a number of things by your voice like on and off, reduce volume, and zoom in or out. It could add a helpful element to game playing. To just say open menu for example, "cast fire." There could even be magic words in the game. Microphones may become essential for a gamepad. You could tell the game to give you a certain weapon. You could ask for help and directions. At first

you read the things said to you. Then we had them spoken to us. Maybe in the future we can talk back. Just as AI is fairly good at understanding and replying to what is told to it that technology may be more and more added to video games.

As the world is mapped from place to place down to the roads of any city and with GPS there could be made a game of the world as a game. You could wander around the map looking for others or it could be altered in a way more suitable for gaming. The real world could be assimilated into a game. Could be *simulated* into one. These maps we have and pictures of places upon it can be more fully immersive in any given game or software. It could be that new consoles aren't producing consoles so much as social affairs. People may use them someday to do more social things- simple communication and exploration of the world and its people, then play games. There could even be a new console made based on that instead. It could have the bedrock hardware and software to focus solely on those types of things.

A whole library of in game books could be used. Like an encyclopedia. Letter S could contain Spells. Letter P could include Places. Letter S could have See. See would give you a picture, audio or visual of what you want to look at, maybe understand more. But the game is largely flipping through these books. Like a search engine it will make finding things easy. It is a board game of books you could say in video form. The games controller could compliment this well. They would have alphabetic letters and whatever else compliments this kind of game. Again- like an encyclopedia. Letters A-Z. T for Town, C for Characters. I think it would be neat as well to have its players doing real world things like put a treasure somewhere for others to find.

Ideas I've had for a while now include music that auto changes. Imagine about 20 melodies, short ones, that play in different order. They are kept well enough the same musically from piece to piece. But provide just a little constant alteration. And a special software built into a game, maybe placed on a chip, can auto change the game in subtle ways. Anything that can change but mostly remains the same. And lighted buttons as I said before, like a button that is a light of a color. The green light conveys one thing or another. If you are near the ocean you can press the blue light to walk towards it. You could use the power of the green crystal. Sometimes a special light comes on that is not often there- on orange for example, and by pressing it something special occurs. When one light comes on it may mean that someone wants to talk to you. Light based buttons could add a lot to any game.

There will come a time when you can take just a little video of yourself and make that image do whatever you wish. It's largely possible already. This can be used to put you into a game just as if you are really in it. This would be especially helpful for social kinds of games. And too for adult natured games. Be a star of any movie. Take one star of stars and make into us all *that* star.

You could have text prepared and have your image speak it without ever recording yourself. But someday too you could take text and give your own voice through a sample, in a similar fashion. In either case putting your own image and voice into a game should be soon enough possible. It is a long stone's throw away from a game where all you could do was pick your voiceless name.

And there could be themes you select from in having "yourself" do, automatically. The game could have you set up action and response.

People could largely program the game they are in themselves by that point. They would construct questions and answers for any passer by. A series of actions could be set up too according to the more likely reactions between you and others. You are like a character in the game sitting by a tree while at rest/ not playing. Anyone who comes upon you can be given a general idea about you and leave you a message to read later.

You don't have to be in space or on Mars yourself. You could be given a total recording of it you could enter. Or you could go there using robotic bodies. You could see what that sees and, if touch technology is ever made, "feel" the very ground of Mars. And through this make it inhabitable through machinery and Android like things we control from Earth. The Galaxy itself could be made into our game. Who says we have to go to these places in human form if technology makes the experience just the same?

An extremely detailed world-environment of a game could be created using the information pulled from certain websites.. the encyclopedic ones. As long as AI can know well enough how to create game world things from it. It would know the nature of a plant for example. Where it grows. How it grows. Physical qualities of it. Pictures of it. How the body uses it, etc. , if it heals or if it is toxic. And like weapons in a video game those that came a long time before. Precious metals, where they are usually found. And best of all old deities and their honorary and magical uses. Through the internet AI can understand the whole world. It can then replicate it as the game maker would have it represented. This goes beyond just Google Maps.

Compositions can be made by individuals to buy, claim or earn by the player. By those that can notate. And an orchestra could be simulated. Art too could be made by players and likewise sold or something. It could be an ebook. Some forms of creative work can possibly be shared within the game. They can be placed in bookshelves or shown as paintings on the wall. The music can come from a radio looking thing.

We haven't yet seen religious based "games." That is, a social type game based solely around one's religion. Whatever religion that may be. Heck, it could contain every known denomination. It could let the person create their own denomination or post a pre-existing one. In it could be Churches, sermons, Bibles of all kinds. Hymn music within them and a place to ask questions or have them answered.This is another example of a game not being a game. They could be online and made like a game would be made, programmed into software, but are more social gatherings. Going beyond that there could be areas of certain professions, communities (retro gaming communities among them), people interested in science or whatever else. People of all kinds can learn from others that way, explore the inventions of humankind, and things such as that.

Greater contact between players could result in real life errands paying in video game dividends. Video game money is worth a lot. There was a recent case of bots being used in a video game to collect special things later sold. While I am not suggesting anything that shouldn't be done- video games have things of great worth in them for dedicated players. Who knows what kind of commodity or economy that could become in the future. Some of it has been labeled as gambling. Transporting goods is becoming cheaper and quicker. There is consideration being given to bots and drones doing all that work with very little human hands involved in it. Online "games" can be a flea market sort of thing. The possessions in your home can be replicated onto the game if you want to sell or trade it.

And a money making based game is possible. They can include any profession that can be done for another on TV. Those include Tarot reading, teaching, preaching, and maybe even non-TV delivered sales could be added to that.

With more portable games a whole adventure can come from them. To be told to drive a certain place, to hide a certain item in a *type* of place. That causes treasure hunting. Or any game that incorporates real life into it. To do a favor. Things which do not put the person playing at any risk. A person could post what kind of thing they want. And that thing would be made for them. Something, maybe, emailed or posted online.

As for real life being blended into a game there was Pokemon Go. With augmented reality you can find pokemon based where you are in the world. Augmented reality certainly adds a whole other element to video games.

I imagine a game where you can sit at a theater or even take others to one with you. Or attend a pre-set up concert. You can have a shelf of movies. A digital format doesn't give you something like that. But in a digital room you could. You could set up one thing or another. You could pull the book off the shelf. You could buy rights to provide these to others. To allow access to them. Kind of like what the radio does with providing royalties. People are always eager to show off their things. There is an app just for that. The most liked kid was always the one with all the games. His parents had more money perhaps and it was only with him that you could play games that all of the others simply did not have. That's the reason why people build large collections, for the most part.

A device that beeps or shows texts, that being simple, or an email or online notification could be an extra feature of a console. A light may light up on a gamepad alerting you of something. Those can be color coded. The console itself could beep. Or having a small two inch screen kind of slanted upward could indicate to the player different things. Like a new game is available to order. Or in making digital software cheaper by providing advertisements. And it may just tell you when your favorite co-op player is available to play with you.

TVs have gotten rather cheap. Maybe consoles will come out that use two TVs. That would be very nice in fact. The second TV could be to your side. That second TV would do all the great things that the dual screen portable systems of Nintendo did. One for a map, menu, another for gameplay.

A card slot in a console, like a small one, can be included as an extra soundtrack for the game. And these can come with the game or bought separately. It could include bonus content. It would be a much cheaper way to do so than a disk peripheral or a large cart add-on. And another example could be it changes the effects of spells graphically, on an RPG. Could provide all new cinematics, any number of adjustments. On just a mini memory card.

And if you are going back to cart games, each cart could have a small slot for these.

Maybe even 2. Maybe even 4.. to get just the right game you want.

The longer and more often you play a game the more powerful and wise you become. Real-life being paused in that time. In the time you left things have changed. Maybe the world updates all the time. Maybe it has its own rules to bring progress. The players make the environment progress from straw homes to brick ones. And civility must be fought for. And Kings come and go. And Queens too. The world is made as the players make it. And changes as the people would have it change. It has its own secrets. It contains gems in one area. Deep in the ground. From which things are made or stockpiled by the richest characters. And gods may be present in the game. The greatest of players perhaps, or just programmed entities. Behind them is mystery, prophecies and all for anyone who would succeed in the game.

Maybe that's a possible game itself. To have in it deities that guide the way and can become friends or enemies, that are behind you according to how you befriended them.

We know the world we live in according to the physics in which it was given. With a lot of consideration all new physics could be created for a video game world. It would take a lot of very smart people to do so. That what goes up may not fall down. That the wind may not produce a twirling tornado but I stead pull upward. These are simple enough but to simulate a world with all new physics that come as an understandable formula, *that's* more difficult.

There could be a social based game that goes from caveman to jet fighter. And a time machine that goes along with it. And a simulated world that is made from previous interference from player to player. The game could indicate what happened in the past which needs to be changed. Call it "Contenders of Time." The player could guess the result. They could try and go back to change it. Or change something else in a reach of power. Valuable items that the player had could become worthless, for they came from a thing extinct. Or their jewels were gotten before they could have fallen into the hands of other players. I call it a *time skipper*.

On the back of a controller could be a distance reader. Like a finger is an inch away from it or two. Ideally you'd hold down a front facing button to use it (so it isn't accidentally used.) They could magnify things or reduce them in size. Making them closer or further away. Or pull something in in other ways. They could also swipe upward and downward. As well as rotate, roll around. Even better, the L and R buttons on top can read distance and speed of movement on the index fingers. That would solve a lot of problems gamers have to this day when it comes to camera angles.

There could be a preference button on the gamepad to press when the game is going as the player likes, to have them continue that way. Or a dislike button to do the opposite. A "more of this" button. A "less of that" one.

There could be a button to freeze things in time. A "set this" button. Or to "unfreeze that" button. A button to propel. One to slow down. One to shift everything. Another to send it backwards. A way to lift. A way to break. And as such the environment can be fully interacted with. So then a *plus* and *minus* button. A *remove* button. And commands such as that.

Classical music is largely in the public domain. When notation software becomes developed enough to play them entirely realistically, people will be able to reproduce them freely and in large numbers. Scanning technology can be incorporated into it. As AI develops new harmonies and styles can be added to that. When voice copying develops enough you could say a few lines, maybe a paragraph and have your singing added to it. Be it in whatever style you choose. Rock, pop, rap, metal, etc., And with the copying of your image "you" are on stage with whatever outfit you want. Says quite a bit about where things could go. It is another example of AI making a video game for you.

Include your own lyrics. Your own visuals or basis from them. Pay homage to your favorite movie. Have yourself put into a music video for it. The possibilities are astounding.

People could piece together musical themes in a harmonious way. For example one theme by Bach sounds much like one by Beethoven. The AI knows they'd go good together. So they mix forms accordingly. They may even adjust them in a more fitting way so that they fit into their own style (instead of Baroque sound with Classical sound.)

And much further along I'd assume there will be the possibility that AI could understand the instructions you've written down and put them into a game. Just by writing the book clearly enough for the AI to comprehend, it makes a game as instructed. Like commands that include "I want the title screen to have lightning and flashing text on it," or, "the first character you see says this." And (this) area has (these) things." And to help it along you may write down number codes for more specific graphics and the like. Programming language may evolve into more realistic and natural human understanding someday through AI.

Part Four: Creating From Different Genres

In an RPG:

Imagine a game where you begin with entering or leaving a place. The mood is set right. It could be a calamity you are thrown into. Things may seem peaceful on the other hand. You have to look around awhile for the game to shift into a bold new quest. Maybe you've triggered a kind of sword in stone moment. Or maybe you are cued to investigate something.

You may be funded by a King to help him (or her as a Queen.) You may start out already having money. Or you may have inherited it.

You can start as a person that was a soldier, or magician, or a wanderer/ vagrant, as a prince or princess, or just a person given sudden responsibility. You may have come into an area with a friend or two and in investigating something you feel an urge to look more fully into it.

The people are troubled. By something ominous. Or just seem to need a little help for something that turns out requiring a lot more. And if you like the whole game could be more easy going. In fact many games do just fine with only a little to say.

You may have found to go far beyond the expectations of you and seem to be more needed than they realized. You could be "the chosen one," and so a fairy greets you and sends you on your way, informing you that you are to be of great help to the people of that world.

As for the graphics you can choose to make just one image for a whole area, a point and click thing to go from place to place. Or the player can maneuver it in overhead or 3D. You *could* do both in case the player just wants to get in and out more quickly sometimes. Or as in some games the places are entered into side- ways. The people of the town can be created into the style of kinds. A merchant with his own suit. An armory labeled accordingly.

The way the character strokes matters a lot in how games are controlled better. Some have used swings, others, thrust. Some shields are automatic and aren't different from one to another. Others cover more area. I would say keep grinding and difficulty proportionate. But require a lot more for the better items. Give them what they need if they are at least doing so enough.

I've seen some NPC's (*non playable characters*) just stand. They don't move at all. A lot of them look just the same. And I've seen others leaning against the wall smoking with a

pipe. I've seen some erupt into a dance. And I've seen from town to town in some games that the merchant always has the same face.

Have a good way of showing things that seem "off." Having the player feel as such. It can be in different degrees subtle. The grass that can be used is the only grass that moves. And from there be creative. Perhaps that grass only moves in the moonlight. So then the player goes out in the moonlight and sees it moving, luck's it, and uses it.

And remember that players can actually do very well at navigating loaded inventory screens. It's when they have no idea what they are used for when problems arise.

Sound effects for one item or weapon to the next among others are an important consideration. The sound of getting money, finding something. But sound effects can also reveal the nature of something. For example to indicate where another piece is out. So if you hear the forest theme the other piece is there. And sound effects can potentially be used more creatively then they typically are.

Battles range from enemies on the regular screen or put into a random battle one. Or a mix of the two. Sometimes they show you the enemy upfront. Other times sideways. Some in 3D. Some are turn-based. Some RPG games have you maneuver in a grid when fighting. Others pull up a circle of four choices. They've been enhanced into patterns and time based) either push a button at just the right time or wait just 5 seconds, stuff like that.)

There are a lot of adjustments in these games to make the character just a little more powerful, to reduce weakness from specific things. To push forward in position for greater offense, and backward for greater offense.

Older RPGs wouldn't let you simply go up to someone and talk. You'd have to pull up a menu and say "talk to." Often the characters move just a little slower than we want them to. Some NPCs get in your way and you have to wait for them to move before you can pass through. Some show all of your characters like in a following row of four. While some have you see just one. And then there are RPGs that let you pick that one character to show.

Some random battles are so frequent that they ruin the game. Others just don't let you progress in any desirable way. Like the graphics for magic are all too much the same. It may have a boulder fall for an Earth spell. Level two is just a larger boulder. Level 3 of it is just an even bigger one. Or another problem could be that it gives you a choice to upgrade something but you just invest all the points in a single thing. No one ever really liked the idea that the more you use an arrow in your fights the better you become at it.

One game has you knowing just where you are going. Others surprise you with the fact you can go to the moon or go deep into the ocean.

There is a lot to be said about the relationships between characters. There is the one that is saved and comes to be protected. There are those that betrayed you. There are those related. Those you didn't know were until later. There is the protector. There is the one that has something you need. There is the one that had a talent or flying ship you needed or certain access. There are those looking for revenge. Those that became martyrs. Those that become romantically involved. There are those who turned out to be half mythic creatures or able to summon and other various things.

And these are just ideas to consider being a part of your game and their different incarnations:

A ceremony.. of a marriage, of a new ruler, of a sacred date.

A celebration.. on a sacred day, a birthday, a victory.

A "mythical" being.. whose power is robbed, sought out, or that's changed things.

An ominous presence.. that's supernatural, that can't be understood.

A legend.. of a person, of a creature, of a Kingdom, of a sword.

A lost love.. and where they went.

That treasure.. of legend, of great value, that's worth finding.

Orders given.. To slay, to find, to leave, to fix, to obtain.

A visit.. from a dragon, from a person, from a ghost, from a friend, from a King.

A Homeland.. overtaken, pillaged, a threat, destroyed.

A choice.. to rebel, to defy, to refuse, or to accept.

A decision.. that's hard to come by, or handed down from the wise.

Trying to find.. a powerful item, a lost friend, help.

An adventure.. because things are too mundane, ordinary, or following after a legend, to find treasure, or as imposed on a person coming of age.

And for these anything you can add to them.

I've seen some great ideas used that include listing all of the hidden items in the game on the title screen. Seen some awesome gold carts. Title screens that set the stage and the mood of it perfectly well. There are some RPG games that were incredibly diversified

in which you had hundreds of choices from weapon to weapon, armor and items, "relics," magic, and summoning. Stories that could really pull you in, even bringing you to tears. I believe in fact that the most overlooked thing in RPGs is the story. While some titles have a damn good story in every one made, others are simply bland. Not there at all, really.

So in all this give the player great tools. Give them great characters, great graphics, the best system of things to work with. Surprise them, reward them, give them great control over things—like the characters they play and the things they use and how they are used. Make it fun for them and have them involved in it as much as you are able. In the end, these are what matter the most.

A formula for a good side scrolling game

As I've said before: it's been seen that a great new idea came out. The first of its kind. It hadn't had a sequel yet. In the meantime company after company tried to do the same thing with more or less success. Usually to less the quality of the original. They didn't try to make something unique really, just the same differently. And as for the idea that was imitated, that good new idea for a game, it's sequel out done it's original in every way. It was their idea to begin with. And the creative minds that originated it were able to do one better. Those that were simply lacking in creativity could not.

A good side scrolling game should provide a concept to where the player is and what they are doing there. Or it can just be quirky, like a mushroom land with all sorts of strange things in it. Land of Dracula, land of robots, a theme of some kind gives cohesiveness. Don't worry too much about realism. In fact games are usually better without it (unless that is a part of the theme itself.)

Fun mechanics are a must—like those from enemies or things that make you jump, swing, rotate, ride and fall, spring, burst out, and such.

There are enemies that pester you. I'd avoid implementing them. Such as those that barge into the player at fast speeds. If you do have them then give the player ample opportunity to dodge them.

Some games or games had baseball sprites throwing baseballs at you. Sometimes they throw spears and other times cast spells of different shapes (rotating squares, circles, and triangles at you.)

Larger enemies can come in two forms: those that move around and those that stand still when attacking. The pattern of attack from them all should be predictable. And fun in it's evasion, so to speak. And fair enough.

One game would let you progress from one level to the next, only. While another gives you at least a couple of choices to go. Like to take the map upward or to take the lower path. Some lend well to replaying in order that all is found. Some are rich with many secrets.

Some ideas have stood the test of time and should be used. Use them the best way according to what you are doing. As it best fits together.

At the end of an overall level a NPC in the game may give you a gift or a title, a new sword or money, or anything else. At the end of one level they may be trying to get the highest score, depending on where they land. Or at the end of one are two doors. The top is harder to get into but if they do they get extra lives or something. And dispersed throughout are mini game opportunities to gain more equipment, lives, or whatever else.

Power ups can give you a new suit like leather armor up to gold armor, an outfit of some kind. Player sprites can also double or triple like a shadow behind you that makes one strike of the sword into three. Characters can get smaller or larger. They can become their opponent or just take their power.

Compile the best ideas from one to another, to many, making whatever changes you need for cohesion. Give enemy sprites the actions that lead to the player forming strategies against them. That must be taken out each their own way. And provide them curiosity over them.

As a summary it is hard to pin down just what makes a really good side scrolling game good. But these methods listed will go a long way. The player can understand where he is or wonder who he or she is in the game and where they are at. While it may be a world never seen it can still be an interesting one. The enemy sprites or forms can dazzle to more or less degree. The items can be good to hold and use. The exploration can be there in the right doses or just have the player lost. So maybe the best question to ask is would *you* like to be there? Would you spend a lot of time there? Or is it just too all ugly to begin with?

Collectathons should be avoided. This is where getting coins or something is really the only objective. A large variety of enemies is necessary for a good side scrolling game. Those shouldn't be too plain. They should have their own unique thing to them and are at best well imagined. Consideration should be given into what happens when you jump on top of them or use certain powerups on them. Some enemies move differently, have certain patterns, adding to variety. Depending on what kind of game you are making there are powerups/weapons needing to be created. It's good to let each one do its own thing- to go upward and over like an axe, dart straight forward like a dagger, drop right in front of you like holy water, covering every direction. Some may be slow but more powerful. One may not require item use expenses because it comes back to you. Given these the games weapons will bring themselves into usefulness in a natural way.

The best platformers

What game I can think of started this whole genre and took from a movie about aliens the best non-licensed game about a pre-existing movie there ever was.

By definition a platformer has you going in all directions. The player chooses their own opportunity. They can proceed minimally from one area to the next. Or explore everything before doing so, gaining greater power.

Some grinding may include going back and forth from one screen to another depending on where you are able to save. Some enemy sprites are made to rise up consecutively after they are struck down. In other words, they reappear right after you kill them. Some have RPG elements that make grinding essential.. more or less of necessity. While others just have energy refilling elements that require much less.

It's largely about what the player wants to see next. It's about them being able to proceed.

Maps are essential in them.

Some have you going ever upward, others all around, some deeper down. Some have you on top of a great castle, others deep into an alien world cavern. But there's no reason that you couldn't have things like an over world map in these and really turning a platformer into a more worldly adventure. Some have a mix of the two. Some have leveling up while others just have weapon and suit upgrades, and all kinds of mixes are

possible. While you may include towns or not and more enemy based areas is up to you. Whether it is a quest to save someone or a people is one choice. Another choice is leaving it all up to you, like you are an assassin ninja or on some sort of mission.

When you come back to a place and it wasn't quite like it was before *that* makes a good platformer. As does making the player more versatile. Making the enemies true enemies. Equipping you with items of interesting use. Items and weapons that improve your maneuvering and capabilities. Setting the mood. Keeping it intuitive. Things such as those make a good platformer.

Adventure Games

If I were good at making any game it would be this kind. Doesn't require so much story as an RPG. It is really simple really. You gain greater and greater access to the world or land you are in. Some items let you proceed. Whether it be to get into a new dungeon or to get through that dungeon. Hidden things. That's simple really too. If you burn this this will happen. If you play this here, that will happen. In short if you use this or that here a certain thing will happen.

Puzzles are common in these games.

Weapon upgrades, too. That you begin with the least powerful sword then the next one and the next and so on. Some weapons you don't even need to have to win the game. But they help.

You can dig for treasure, fish for treasure, hack for treasure, uncover a sealed cave, or any number of things. You can take just about any real world action and use it in these games, in one way or another. Like using a net to catch.. a fairy. Like lighting a lantern.. and what are those used for? That's right! Lighting up a dark cave!

The formula is different most of all according to the setting. It could be a mythical land based most of all on dragon and wizard and elf lands. Or it could be a tropical land. It could be an alien planet. Or sometime in the future. I'm sure if anyone thought enough about it they could base it on the real world.

I'd suggest most of all to have good fighting mechanics in them and the coolest looking enemies you could think of. Compared to an RPG the story could be much more minimal, but it doesn't have to be.

Think about what kind of health meter and system you wish to use. Whether it be a meter or whatever else. And what conditions you can add to that. How life energy is regained, what causes it to increase or decrease.

Other things to consider are the particular weaknesses of enemies. If you will include magic. What neat tools you could use. Could be a mallet or could be a microscope. The best thing you can do is create a list of real world items and neatly fit them in. There are countless possible possibilities. Like eyeglasses.. they let you see things differently. Or a mirror.. it mirrors your character elsewhere.

Whatever you have in the world you create can be used with the things that world contains. Like a boat to cross the water.

You can have a forest. You can have people living in massive trees.

You can cross by horse or horse carriage. Or a car. Or magic. Or foot. Or with special shoes. You can fly with shoes with wings. Or a large bird. Or winds. Or plane. The choices are yours.

What I would come up with first is the type of land or world the player will be in.

Personally when I'm playing this kind of game I don't want a ton of backstory. To go wander around a village full of people hinting that I'm the Chosen One.

Often there's a crystal to get.. like four of them. Or special keys, Greater Keys, a raft to cross, the weapon you need to defeat the Corrupt King.

Consider the layout of a village within them. You can have the merchant and the place to get cured. Your own home there. People with interesting things to say. Or helpful things to say. Or that you have to do something. Or that they have items they didn't have before. They can have inside them money and spell books and items that can only be gotten to with another item. They can have you perform a mini game. Can include gambling. There are many elements you can include within a town.

Graveyards and tombs, massive trees and caves, isolated homes and towns, the desert, the frozen land, the forest, the island, the castle, the lake.. in other words, real life places made special.

Enemy sprites don't have to just barge and attack. Nor all be human. Relatable is nice though, a familiar creature or animal for example. Even if those are sliced up. They can be statues that only attack you when you bump into them. They can be "stay out of my way" types, but otherwise harmless. The sprites can turn out to be friends. They can be followed to get to the right place. Like by color if suit you will know where they go, accordingly. They can be tricky in a clever way.

And I'll reiterate taking real world elements and placing them in your game. Like glasses that each have you see the world in a different way. That one pair opens up and presents things the other glasses do not.

All of this should be substantial advice toward making a great adventure game.

Continuing with (hopefully) brand new ideas:

(An Interlude)

Original Ideas

You can buy a tent that once you place it stays there. "Camping areas" where you can rest and recharge.

Different coins buy different things. Some are used for one type of thing but not another.

When you defend anyone they can be called on at any time to help. Or you can build a rank of people to help you who aren't much playable characters.

Sneaking into an army to spy. Or into some sort of area to do so.

Satellite images to peer down into a town or other area.

Characters that offer you a price to sell what is in your possession.

Merchants that build what you request them to from a very long list. The ability to have far more items, ones more unique and particular.

Enemy sprites can take your power up and use it against you if you don't get to it in time. Or according to many there you have to choose what will be your power and theirs.

If you don't find hidden weapons in a level then the opponents in the next level will be using them.

In one level you collect things, kind of naturally, and in the next level a merchant asks what you have for them, and with what they take you've made money or a trade.

You can limit your enemies' resources. You can reduce them to a point.

You can call it a platform strategy game when you go around acquiring more assistance or change the nature of one area in various ways. For example hanging "the eternal lamp" in dark areas. Or collapse a bridge. Or seal a door. Find the keys and bring them to a single character who will send others out to lock those doors.

You could say collecting certain things to bring certain things together. To obstruct your enemies and corner them.

Gives the player choices of how the next level or area will be. Like by checking off a list of things. For example, the level to be very easy or difficult. If you choose the latter you'll be better regarded. Tell the game you are faster money or what weapon will be contained somewhere, and then play the next level in a more customized way.

To find a cure for the king. To regain his stolen ancestral crown. To be sent to bring him a ring or do him honor. *To perform an act of honor and prove yourself a worthy knight.* Or these for a queen, of course.

One puzzle can be of a looping effect that you can't pass through without the right combinations of actions.

What special items you get determine where you go next. The harder they are found the better the next place will be. By collecting four of a kind that opens its own passage. To open all four doors, or whatever you get first you must then get the other three of and the other ones are then disqualified.

As an angel get your wings. Serpentine wings if you like. Those that you greet the most and help the most you may become. For example if you help a knight then you become one. Or differently if you help a dragon then you can become one. Or if you help a particular species then they will be at your disposal, one and all. Be it a dragon, an elf, a bear or wolf, or the dwarves.

"Visions" come up suddenly depending on where you are or what you are doing. Just like a nice cut scene that is cleverly put together. They tell you what to do for a reward. And you'll either follow after it or not. And it may bring the story together in an abstract way. One full of parables and metaphors and the like.

Having a wishing well and making wishes. Having a temple to pray for help. Be it a white or black temple. Memorizing words of spells like a paragraph long. Being given the right combination of action to complete a spell. Randomizing these to prevent cheating.

A magic casting calculator that is possible if casting numerous different spells as things are punched in. Not so much numbers though numbers can be used, too. One that includes things like elements and shows possible weapons on your person that can be implemented. And maybe all new spells can be produced and added into you.

At night time astrological signs—in the stars and their order, brightness and color, using the moon or moons to be told how to proceed or how things are at the moment. If a kingdom/ person is in trouble then a star may have gone dark. And maybe following a good star can make you wealthy.

Color stones or numbers that come up when certain things are around. They give you an idea of *what* to look for if you are near them or just if you are in any large place where they can be found. Will indicate if someone is in the town or not. If they are in the right place. Or just objectives, what you should come up with or places that have things you are lacking.

A point and click adventure game can be like in a loop that has only one ending. You don't die. You just have to determine the right order of doing things.

There can be the power to glance at an area. A limited one, maybe up to 5 seconds. It'll let you be more prepared, for one. Or maybe to better know where you should go. This power can come from different methods—an item or service you buy, or just available one game world day at a time. I think a good way to have this is as a crystal ball.

And can be used in more ways than that. You can ask to see where a great sword is or a piece of something you need, at lesser and greater prices.

You could adjust the power and appearance of an end level boss just by the course of actions you take. Certain potions can morph them into a weaker enemy. Can de-evolve them. Or that can be prevented. Maybe they've found an item you should have gotten first. Or a wizard wasn't stopped. Or enough of the boss's minions. Maybe you've obstructed their progress during the game and things such as that.

Having "The Underground" in the game (those whose secrets must be hidden) the player must try not to run across. Must try to stay out of their way. Night time monsters don't have to literally be them. Not zombies or vampires but people and dangerous groups. Or maybe you can be one of them doing everything you can to not get caught. Maybe the King just has a terrible curfew.

At the top of The Mountain of Storms you raise your sword, lightning strikes it, and is given greater power.

Spells go where the wind goes, as when an area is windy screens across from each other carry the spell more broadly.

The Special Sun raises the defensive power of "reflective armor."

Collect The Crystal Eyes placing them into six slots. They are taken from the regular game world onto an outer planet.

Collect The Magical Sands for The Magical Hourglass (s.)

Magical threads of a magical tapestry.

Being pursued, on the run. Chased down. Going into hiding. Evading those after you. Finding the right way around things and such.

Reflecting the sun as a power, given to a shield or sword. Using the sun to charge them.

Being given a throne as an endeavor. Fighting to be rewarded for one. That being the quest. Or a great palace as a reward.

The reaper is always behind you. Following you. And you must defy him, trick him, and outdo him. If you succeed then immortality awaits you at the end of the game.

Buying in-game a subscription of items. Things that are automatically added, reoccurring.

About Simulation Games

From piloting a plane to building a city, sim games are very broad in their scope. They can even include things like creating a theme park. As the more successful ones evolved, so did their complexity. A lot of time they have you doing multiple things at once and it is good to consider how much is on the player's plate at any given time.

Sometimes they require a lot of instructions. Some are easily enough understood off hand. But awfully overload you with more than just occasional instructions. It's so bad as to not really have you playing as being told what to do step after step.

If you want to make a game like this all you have to come up with at first is *what* you want the player to simulate. Could be a public place or circumstance, war based or

talent to gain, a private place, a business or otherwise. Could be mining or a logging industry. A construction or scientific scenario. A medical one. Perhaps stuff dealing with an epidemic.

Creating towns or evolving a planet, putting things into order or being as a god to primitive civilizations. Warping space and time, concocting new Laws of Physics, time travel, interdimensional travel. Holding together the people of the world. It could be based on society, too, such as steering one in any direction you desire, and to deal with things like riots if you don't take care. As such you make the Constitution and see what results.

It can involve engineering. It can be based on obtaining a great game or money (or both) or success in any form.

Could be based on other things such as:

Space travel, restaurants, a profession, a company, treasure hunting, investments, missions and objectives, new inventions, personal pursuits, testing, adjustments, components of these, elements behind them, creating the best way, learning from mistakes and being able to correct them.

So consider the best for the player to proceed and insert that within the game. What mistakes are truly mistakes. How to build upon what they have. What is detrimental? How the pieces fit. How they do not. And at the same time give them ample opportunity to learn and experiment.

3D Games

They can be based on hell, alien Invaders, zombies, a haunted city and it's buildings, an alien world, a war, a secret agent's mission, or nothing really other than an imaginary place.

There are missions usually, objectives to reach to complete level by level.

There is a whole world to delve into in these games. Particularly RPG 3D games are immense in their world. Some have very realistically portrayed a life in Tolkien style or whatever similar sources they are pulled from whether very uniquely or not so.

Different species like elves and dwarves, dragons and knights are within them. The player starts out taking a look at the world before him or her and the story starts to

unravel. What was once the first objective led to many more. By choice, deciding to pursue one thing or another.

The herbs growing and the branches of trees, the caves and the towns, the towns and the people, bring the world to life. Giving as many uses as can come from it. Hidden within the world are greater and lesser treasures.

The player must cooperate or defy. Align themselves with food or evil, as they choose. Sometimes they need help. Other times are betrayed by that help. And the other obvious assortment of things within them like enemies of greater and lesser strength, magic and swords, fighting, villages, Kings and Queens, towns, etc. The most important thing is how they are put together and what they consist of.

As is variety and the opportunity to explore, and so be rewarded for it. To build your character up. Yet not one thing changes too quickly for another. Not before the player had the opportunity to enjoy and appreciate it. Some degree of leisure is good. Especially if the game knows the gamer has been at it for hours.

Too much and not knowing what to choose, it isn't good.

3D Games should have a good camera, good controls, the best use of items (put emphasis on making them useful and worthwhile) , and quality in that case is better than quantity. But the quality is even better. Living environments are required for some. Other kinds of 3D games require it less. Storms and weather—go through the roster. Think about conditions caused by different kinds of weather. And Earth conditions to, whatever you like: volcanoes, earthquakes, and the like.

As in a 3D RPG some inspiration goes a long way. Old superstitious fears for example. Like a witch's Sabbath stumbled upon. And as I often suggest: think of real life things and how they can be incorporated. Whatever you got. Like mosquitoes in watery areas that hinder you with sickness. Or potions against them. Some are very well known like "the troll under the bridge" story. Or the "Sword in the Stone." But the majority of these stories have seldom been touched upon.

Concepts are often done one better. Or just differently, however the creator of it wanted to use it himself or herself. One is a massive spherical spaceship. Another is a cubicle one. And a lesser known one is about robotic arms that make more of themselves to the point where they make all of the matter in the universe into them.

I've played 3D RPG games that were simply too cumbersome to enjoy. Usually they tried to base it too much on realism. Like having to sharpen your sword. Or carry food. Or *having* to rest and camp out. Maybe looking for wood first. Being robbed or killed while you were asleep. Only being able to walk so far. Making you learn systems of magic. I stead of just casting it. Going up and down on a grid and around the corner. Some game makers really did seem like they wouldn't include anything that wasn't reality based.

Enchanting, Beautiful, Rewarding, Worthwhile, Incredible, Rich, and *Otherworldly,* are key terms that should be used in creating a masterful RPG. And have the story keep it all together. Keep it feasible and involving.

And certainly there have been more successful 3D RPG games that didn't much have it's own world. Like just a general world map to stroll around. Not one where the very branches of the tree could be made into a wand. Ones that just had very plain looking towns with a minimal amount of things to get there. Some story advancement, perhaps. Be it in the skins or a wealthy Providence. The random battles would have perhaps just a few enemies to fight from one place to the next. Still there are nice touches to the over world map like entering into a tomb.

The old ideas remained with them for most part but people still love these games to this day. There is a very strong market for old games.

Some games did not go over well into 3D. The original 2D style was even returned to them. Or they'd attempt to make it 3D only partially. The ideas of them were all designed around 2D infrastructures.

There is a lot less that can go wrong with making a first person shooter game. Good controls, idea weapons, a mission, a theme, is all that matters. That and good maneuvering. That can include ducking for cover or hiding somewhere. If these are done well then your FPS will turn out just fine, just as good as any other.

The tone that an adventure 3D game sets is important. Like having a stone door close behind you and the next area is made visible. It gives you a sense of one place to the next. 3D complements some things better than their 2D counterparts do. For example being thrust into the air after shooting a hook into it, being brought toward it. A sense of depth and height, of open terrain, most of all, is good use of 3D. Like looking upward at a castle wall, a very high one. Or falling further down. Just ask yourself 'what does 3D give you that 2D doesn't?' And use it effectively.

Going up in a 2D tower doesn't make you feel that high up. So the use of looking up and down should be considered.

In 2D games you go on top of a home and get something to just the left or right on it. And you only see the side of it unless you do an overhead view.

Because of improved hardware we have more options. An in game clock, day and night cycle, voice acting, wider areas, more detailed areas and the like. 3D Games are getting better all the time. 2D ones are, too. At least as far as possibilities are concerned. It's like taking an old canvas and being given new paint and brushes.

The world of 3D will move onto the world of VR. And like it is becoming with 2D, VR will do the same to 3D someday, I'm sure. There are emulators that can sharpen old 2D pixels, that can improve sound, auto translate text, and give a general 3D effect to old 2D games. For 3D games there are AI based programs that can improve the graphics.. effectively so, too. So any old game will be given new life and I'm sure that will continue to be so. AI may largely make new games from old ones, someday.

As long as the world is not too bland or difficult to deal with in a limited or overly complex way, your 3D game will be good. Make it fun and involving. Immerse the player within it. And much of the advice I've already listed for 2D games may be used in 3D games. As long as the translation to it is right. Whatever makes it best in a 3D environment.

―――――――――――――――――――――――――――――――
―――――――――――――――――――――――――――――――

Odds and Ends of Other Genres

You may have noticed I am not mentioning strategy games. The reason for that is simple, I've never really played them.

Among racing games there are those that stand out. They can either be realistic or not, more or less. Some will have you racing a car among others, passing by trees and cities. There are many themes that have been used in racing games. Using micro cars, carts that have cartoonish elements, Rock and roll music being played while you are racing, space based racing on spiraling tracks, among others. There is the overhead view. There's the 3D one, the over-head one. There's a side-scrolling bike racing game.

Among them are nitro boosts. Vehicle upgrades. Cars that are faster but turn worse than the slower ones, and the ones in between. There are weapons the vehicle may shoot out. There are oil slicks to avoid. There are speed boosting bars. And bars that fill energy, without which you'd crash. Or the same being done with coins. And there are racing games that have you in the air, flying planes and things.

Some objectives are to break records with time lapsed, others just to get to the finish line, by either surviving or in the top 3.

In fighting games, a one on one style of them, there are certain coded munching buttons to perform a special attack. You may have a weapon in some or pick one up. You have a number of opponents to fight before you get to the top. Some are 3D and require things like rotating the thumb stick as fast as possible. Roster of characters can be from minimal to very large. In some you can fly. In others you are grounded. In some your weapon only comes out when pressing a certain button combination.

They have their victory dance or opponent execution. Or making them into something silly.

They have hidden characters that only appear under certain conditions.

And certain effects like being able to change into all the other players during battle.

I would suggest changes from the regular as best you could. Letting the player gain power instead of beginning with one and ending with one. The middle of the arena could be safe, and the outside of it more dangerous. Being able to design your own fighter. Incorporating RPG elements. Things that heal, use of magic, being rewarded for doing especially well. Having it be point based.

Creating a team of fighters. When defeated you move onto the second. Like four of these.

Being able to set certain conditions.

Having particular weaknesses and strengths. Like being immune to certain special moves.

Recharging for power (as used often in other games) by holding down a button.

Largely there are elements in other games that have been largely ignored in fighting games.

You could have things to avoid while fighting, like something shooting out a beam sometimes (those incredibly powerful Zelda laser beam machines) or rocks falling down from above.

You could possess your opponent and become them. And they become you.

The breadth of the screen could be much further.

For double victories you could be rewarded. Like with a new special move. Or you may steal the opponent's power. Like in a way by making contact with a special move.

It is good to have the fighters be relatable. Fighting as non-humanoid and basically strange things are not relatable to the player. Body movement from character to character is also important. If you look at Street Fighter 2 or Mortal Kombat you will see right away that they all punch differently, block differently, and move around differently in general. It serves the kind of game well. Special attacks are different from one another. Some are somewhat similar and I would say that's good. Each playable character may have something special about them unique to them- for example Dhalsim stretches.

If you want to make a game where boxing, martial arts, a beat 'em up, and wrestling are all contained within one- well, that's something that hasn't been done yet.

About fishing games: incorporate them into overall wilderness games. Like having a log cabin and avoiding bears. Making traps, hunting, using nature. Collect what you need and make it a type of wilderness survival game. Go into town for fishing lures and food supplies. Sell your goods. Take advantage of early light. Boat down the river. Travel farther. Make friends. Speak to the town folk.

The fisher should have multiple rods and bait, lines, etc., And large areas to fish in. I like these games so I am mentioning them. But the overall concept of the outdoors could be used.

Pinball games—I've seen a few that were really good. My favorite is Dragon's Revenge.

Good puzzle games, card games, casino games. They all fit into what I call a "leisurely" category. Beat them within 20 minutes of starting. Chess games, and sports games too fit into that category. Among these free use ones a very large number of games could be put into one game. Dots and boxes, darts, bowling, baseball, other sports, board games, card games, and racing games, there are many. They'd either make sense together or not. Really it seems strange to mix some of these, but who cares?

Mini game games- Such as Wario Ware or the Game and Watch compilation on Gameboy. You could add Clubhouse games to it and Mario Party. Those do the same thing really. We've all played games that have mini games in them. Like in Zelda Link often finds some place in a mini game or in the Final Fantasy series it has occurred. Some games are based entirely on those. Remember those games in your childhood: dots and boxes, battleship on paper, sudoku, word finds, cross words, hangman, or tic tac toe? They were always fun. Video games give us the opportunity to play them all. There's no reason why many other things cannot be added to the type of game as it. You could put in slot machines and card games of all kinds. You can add bowling and other very simple easy to pick up sports. That's what Clubhouse games did and did it well. If done right it would probably go well over into an inexpensive self contained toy item.

Educational Games

These come in many kinds: teaching kids to type, ones based on history, math, or any other educational subject found in grade school. They could be for adults too, teaching things like music composition. The idea for them is to make education fun. As such they kill two birds with one stone. There are a lot of unused ideas for what they educate people with. Like religion for anyone that wants to learn more about their own beliefs or to consider starting off on that road. Or magic- from Wicca to more profane things. Or science, geography, human and non human biology. Educational games could have greater potential than what they find. It can use the term "educational *game*" as loosely as you want it to. If you know a thing or two for any particular subject then you may try your hand at making one of them. If you have a degree of some sort then all the better.

If you choose a software instead and a thing about piracy

By software I just mean non video game stuff as the computer program. There was no software I wanted more than I did a notation software- software that lets you write music. I looked everywhere for such a thing in 1999. I came across Acid Studio itself which was a great fun to use. It lets you gather together preset loops and put special effects on them like reverbs. I wanted something more along the lines of composing on screen. I finally found one a few years later (called Print Music!) eagerly ordered and eagerly awaited it. After that I got the newer version which had the awesome addition of letting you put your music in MP3 format. There is a market for non video game software. You could say maybe even a bigger market, who knows. Things range from video editing to slideshow making, word processors of course, a thesaurus in digital form, and a large broad list of other possibilities. Sometimes they find their way into video game domains like Mario Paint did. Paint is a software, there is software for animation, math, you name it. If any person needs help that the computer is good at

giving it can be made into a software. You could create a Tarot reading app, a Bible app if you prefer, or one of the Koran- of many books, a dictionary, an app to help you with learning programming language, there are unlimited possibilities. Some of them are easier to produce than others. Unfortunately we don't have good software making software. We have good video game making software but not software making software. In some cases however- if the idea is simple enough, we can make software on video game making software instead of a video game. For example if you are just making a dictionary or something that is easily done that way. You might have to find ways around certain things but that is one way to make software without knowing how to program with code. I went a little into Python. The precision, the exactness, was particularly difficult. I highly esteem anyone good at programming and it makes up the highest paying jobs and I see why.

Unfortunately it is also the easiest thing to rip off. So covertly so, with so many robbers. I had a friend who once said "nobody pays for software." Of course some do, but most just steal it through cracked software, torrents, and things like that. They never made an infallible anti-piracy thing. People have always found a way around it and at heart they are easy to get around. The NES had a simple lock out chip that Atari with its Tengen brand easily found a way around. There was this interesting one that depended on power from a battery. Any attempt around it would disable the game (the arcade game that used it.) The problem was that if that battery died the game would be unplayable (bricked.) When it comes to piracy it surely must be the one crime that everyone commits without giving it a second thought and simply because of the sheer number of people doing it it is just impossible to stop. Companies are even bold enough to create devices that copy games and put them on the wide open market.

They are ever hard at work making devices and finding ways around anti copy measures. Soon enough in fact they have produced emulators, methods to copy game data on a disk that can be used in the system, or for cart based systems to create a flash card to load the entire system's library onto. Even when the company puts together a well thought out system, getting what licenses they need to, people just hack them and put in whatever additional games they want to. We don't even need to mention roms and emulators that make a PC a system of all systems and games. Maybe a 100 year copyright is a bit much and things need to be figured out that treats both the consumer and creator fairly- but it isn't so simple as that. What about games that were abandoned? What about game preservation? What about highly imaginative hacks or recreations? What if the recreation is just open source? Should there be royalties? Some companies are very aggressive against even showing their games. If anyone records themself playing it on YouTube and becomes popular due to it they can potentially lose their channel. Some of it is more reasonable like posting the whole soundtrack online. I feel bad for those though that are just showing their gameplay and going over things like their favorite parts, reviewing things, rating things, having fun, getting popular from

it, only to have a channel they worked hard on only to be removed. It makes me think of them as uncaring corporate monsters. Insert your own morality here. I am no speaker on anyone's behalf.

Casino games

The casino games I've played have been very narrow and not at all graphically impressive. Perks for being a high roller and the ability to exist outside the lines of machine to machine Some little touches would do quite well like getting a better suit the more you win. Or carrying/buying a good luck charm. Getting psychic advice, using a horoscope. Following after the luck. Odds based on the machines that are yet to win, after being used many times. Having a bigger crowd around the more you win.

Going from the poor casino to the better ones.

As with game compilations we most often find compilations of old ideas—which is fine. But a more challenging pursuit would be multiple original games. They've existed before. And they make good games I would say. They are usually not original card games or something. Just a large assortment of mini games. Some of them are as simplistic as an LCD game. Maybe spruced up ones. I like to say: that to take an idea that was poorly executed and do it better is in the spirit of game creation—better still it is to evolve them. Many potentially good games just weren't done correctly.

But back to mini games: the best I've seen was a board game that did well into transforming the concept into video upon the TV screen. Like I say: if you are going to imitate a real world idea into a game, have it fitted into the nature of a video game. What you can do with a video game takes the advantages it brings over real life physical forms. Most board game video games are very generic, as they are just video forms of the pre-existing physical game. You *don't* have to make it a piece by piece copy. You *can* give it a quality, adding things to it that only video can do. What *couldn't* be done in physical form doesn't have to determine the limits of it when transitioning it over to a video game!

And to mention some of the things I forgot to mention: a more 3D based video game could have you betting on graphically impressive horse races or martial art tournaments, anything usually better on. Mini games are simple in their nature: like skipping rope, pushing the button to skip. Press another to skip faster. A lot of ideas may come from the old single screen or LCD based games—anything that is simplistic. Catch the falling thing, don't miss too many, button mashing, things like that.

Games of lesser tech:

It seems that we evolve backwardly sometimes. We had rather powerful home computers. They are big enough these days to pack quite a punch. But people went from gaming on their cell phones, and that's good—we will evolve with lesser resources. Making a smartphone game has its advantages. They can incorporate GPS on the go. They are wildly more advanced than portable systems not too long ago before them.

We have special gamepads that can wrap around our smartphones. Ones of lesser and greater quality. But more choices, for sure.

Assuming that your game design is based on small handheld devices like a phone you should ask yourself things like how you are going to use a smaller screen, and in which ways use portable gaming the best. We never before could say that we can play those old special board games in a car during a trip somewhere. And ask yourself too of other advantages, like GPS or microphones.

LCD games are often under used, quickly and poorly made then how they could be, to less potential. While they can't be expected to dazzle, some companies have made highly enjoyable games for them. Others just put together things entirely too dull. But that tech is highly underwhelming compared to what a regular small screen could do, as opposed to "calculator graphics." And So we have a small color screen capable of 32 bit graphics or greater. And LCD just went out altogether except for maybe poker games or slot amusements.

And people these days have very small computers, ones that don't even cover a whole hand, on which can be programmed, put together, connected to a TV, or used any number of ways. Some just emulate ROM games (which is cheating and spoils the fun.)

Games that are stylized after their own world:

Those in which you reside in a city, a world, or worlds. In which you are in some future world concept (i.e., a science fiction one) or act out the life of a gang member. As good as the AI in the characters are, it is as good as the game may be, or at least as in depth and versatile. Precious items are procured and forbidden tech is used, sometimes.

There are those in the game connected to each other and you gradually fit in among them. You are connected to them in pursuit of money or power. Or perhaps just to set things straight. There could be a dictatorship looming above you and you may operate in the underground. Or a corporation or certain group of people that repress rights. Special technology of all kinds could be used in the game. The player can be placed into missions. Side people can have you looking for things you need or want. People helping you may grow in size. There could be a whole world to explore. The character can choose their clothing in-town. They can go on errands. They can procure what they need to advance. They can prepare themselves for a trip. Can do recreational activities like gambling (whether above or underground) play sports, play unique card games, too. They may set up a little business. They may sell things. They may be asked to perform certain tasks. They can just look around the world and observe it. They want to raise their rank. Maybe the better they do the better off they are. They can take risks or play it safe. They may be trying to become the most powerful group. They may be trying to escape to another land. They may be going around asking questions to get answers. They may be hiding in a park. They may choose from any number of groups to join from good to bad and in between. They may be on an expedition to find a relic or undersea treasure. They could be assembling things for the creation of a powerful item.

The setting can range from a fantasy setting to a cyberpunk one. It can be futuristic, a dystopia, or an adventurous world to be in. There are games like Breath of the Wild, Grand Theft Auto, and the Elder Scroll series. The game Myst put the player directly in a mysterious world. The objective was to find out how you got there. The game could just as well have you wash up on shore not knowing how you got to this strange new land. Then there are the instances where you wake up and the game starts. Games often have you start out that way. They could be mission based games for a crime lord. You could be a part of a renegade team using illegal technology to be very specific.

The contents of the game itself provide a lot of uses for the player- things to drive, things to gather, places to go, people to talk to, etc. One little piece is made at a time with some repetition but hopefully not too much. The dialog doesn't have to be too long. Most people would be bored by too much talk anyway. Some things don't have to be too complex. It could just be a forest of similar trees carrying a kind of fruit like in an adventure game. The landscape could contain anything you find on earth: forests, mountains, cliffs, plains, deserts, snowy places in an adventure game. Large and tall buildings, cars, other vehicles, civilians, homes, and whatever great architecture you can dream up in a more modern game. In a futuristic game it is made up of the most awesome future you could present. That includes impressive technology and a style anyone could wish for in a future time.

Maybe the best place to start is by drawing. Draw out the strange trees and fruit, the way a neat home would look like, maybe one abandoned, various swords and tools,

neat people, creatures, enemies, potential friends, beasts, mythical things if it is relevant, strange areas, etc.

From there create a set of special things. Those can be especially helpful people or beings, especially mysterious places like a graveyard, one tool that stands out, that one best car or ride in the whole game, major enemies or obstacles and things like that. These are things that stand out and are worth more.

Elements of gameplay have to be worked out. A lot of consideration should be given to the story. How does it start and where does it end? What is the end betweens? How did the player get there? Why is he or she there? The purpose of them, who is there to help them, who is against them, who will they find, what are some more people to add to the whole thing are the life of the player in the world.

The main things to tackle are the overall look and theme of the game, the things in the world you can use and interact with, the story, your motives and objectives, with creativity involved and the game made to be good looking and good to be in in general.

A Mental Hospital Simulator:

I admit it's a strange idea.

Inside the Halls of the Asylum are the upper doctors you simply do not want to mess with. Below them are nurses that could inform your behavior to the upper ups. You have choices inside. Crazy people to talk with. There are fights to avoid or get into. There are times that would put you in a rubber room. And when the doctors are around you should be on your best behavior. Your privileges will increase. You can start playing basketball and other games in the gym. You can then walk through the lot when getting your food. And if you want to attempt it you can try and escape. Groups are there to teach you valuable life advice and you can either attend them or not. Some have you doing art. At the ring of the bell you take medication. Or other things. You talk to the doctors as persuasively as you can.. or be subtle.. And the objective of the game is to get out as early as you can. Riots can occur. When people are troubled enough. And if you do awfully enough in the game they will lobotomize you.

The game gives you funds, like once a week you are given money to buy things that can be useful in trading and things. To make friends. You can also call relatives to bother them into sending things over, in material or monetary form. Another activity is playing music with the crazy people, a guitar, a flute. Buy a stamp and send a letter home. You may get lucky. You may gain support. Or you may just get a little extra money.

If doctors are abusive you can report them. You can file a complaint. Then they may be removed and things could be easier on you.

If you are pacing (walking around) too much, you are punished. If you bother someone you may be too, especially if they warn you not to. So go about with these in mind.

Part 3: Miscellaneous Things and Additions to the Previous Things—

If we are going over past failures of games it is just because the product wasn't any good. Though there are those that were not given a chance. Retro gamers call them "hidden gems." Whether they just weren't up to par with their competition or contained broken controls, or just didn't spark enough interest, they never went far. Sometimes the port was just too far off.

As for hardware, most failures came from one of these: too advanced is too pricey, lack of support from game making companies, the composition had better controllers, a cart is more limited to a CD in the ways that really count, or the games for them were awful.

One side scroller will have you jump around and frolic, sliding up and down and climbing, bursting through barrels, Hopping on springs, throwing the enemy, while another just has you doing maybe one or two of these, and turns out to be very bland.

For some game making groups the process is a party. It is done in the joy of creating something good. And they have behind them people who know what they are doing. No one wants to be on a losing team. The losing team just wants to get something out on a deadline and are only concerned with instant, though by its nature temporary, success.

But let's take them and make them better. One by one. Breathing into them the life they should have had.

Game designers are asking all the time "how can things in the world be made into a game?" The first approach that should be taken is to realize *it's a game*. It is a game version of the real world that fits it in best as such. You may ask yourself what makes a world better and more interesting than Earth? What can we do and see there? What seems magical on Earth that we can include?

We do it all the time. We look around and think how we can make this all more special. The world goes by it's own rules. You won't find any book that can let you bring down lightning from the sky. That's why we have movies and stories of dragons and things. Don't have them here.

That's why a game having you be a rock star with a toy guitar was a perfect idea.

And as games become more immersive, smarter and more realistic, they may as well be considered a second reality. To be inside the android's head.

The different ways to produce a game are abundant. Many of the older styles were done by singular people. And these days game making software lets you make complex games fairly easily.

There are game making software to produce a game for many of the most favorite systems. You tell what you want certain things to do and where they will be for most part, even programming things in such as chance. To put text up where you want it and menus, and all else.

Then they can be put into a cart, programmed into a CD, a floppy drive, or just kept digital.

Here is a list of questions you might like to ask yourself:

Is the game entertaining enough?

Is it understandable enough?

Are the controls and menus easy to use?

Are the weapons and items fun to use?

Are the graphics appealing?

Are the enemies of a good design?

Is the player rewarded?

Is the music very good?

Is the game not too simple and plain?

Is it rich in content?

Does it lend to exploration?

Is it well connected? That is, are the pieces and components of it put well together?

Can anything be made just a little better?

Is what you have in it working, or should you cut it out?

Is the story a good and compelling one?

Does it evoke emotion the right way?

Are some areas just too frustrating to include?

Is any one thing in it able to be improved?

Are too many things thrown into one place where in others they are inadequate?

Is it fun? Is it involving?

It is like a good meal. The spices are just right. It doesn't burn a whole in your mouth. It isn't too hot or cold. It is served up just right and worth taking the time to enjoy.

If there is no reason to move forward and no wish from the player to do better than they have done before then repeated playing of it is unlikely. However, if they find interest in things like the items, the people and places, and given ample reason to go into the next place, they will find themselves there and enjoy every bit of it.

The earlier areas can be more leisurely. It can give the player a sense of how they should proceed. Of how they may learn to play. Or otherwise it just may be too much on the plate.

Unconditionally there will be different degrees of appreciation for your game. Even though the majority may love the game and it becomes a classic, there may still be some that detest it. Don't let it discourage you. Ask your critics what they felt could have been better and simply come out with a new version. Start with a draft, a rough start, and go from there. And remember: *two heads are better than one.*

Do quality control. As if you were a health inspector for video games.

Different Ways A Game Can Start:

1- You wake up in your bed. The people in town are expecting something of you like for you to visit the king. It may be a special day in your life. It can be more creative than that. In Final Fantasy 8 the game started after Squall and Sefer got into a fight and Squall was in a medical bed.

2- You are simply given a weapon and told to go forth.

3- In a simple game the first level is just a tutorial. It presents you with the ideas you need to play the rest of the game like was done in Super Mario Bros.

4- You washed up on shore.

5- You are talking with your friend. Maybe he or she wants something from you. Maybe they tell you that there is something you need to take care of.

6- The cinematics at the start say it all. This was really done well in Y's 3: Wanderers from Ys.

7- You are given a number of places to go to from the start like it was in Mega Man.

8- You woke up from a very long slumber and found out that you were put into sleep for your protection, as a future time will need you.

9- You and your friends are talking to each other and have decided upon a certain action.

10- You land upon a mysterious planet with your spaceship.

11- You and your friends are fighting something fearsome but right before you win that thing sends you back in time where you wake up not remembering what happened.

12- A fairy, parent, or some other thing wakes you up and directs you into a quest.

13- The game has you do a personality test that determines what kind of race you are (such as a dark elf or something) and that determines where you go from there.

14- You are on a pirate ship ready to smuggle your stuff or take some loot. You are ready for a diamond heist or something.

15- You are on a train to your destination secretly acting with a team against a dictatorship-like force.

16- You are in the midst of acting on an order from a king, perhaps an order you do not agree with.

17- The game briefly explains who you are and what you are about to set off doing.

18- You are a grown person now and ready to leave home.

19- You and your friend are going to some neat place following a rumor that something special is there.

20- You have passed out or been knocked out or something and your friend is nudging you to wake you up.

21- You are in the midst of a war trying to escape and urgently seeking sanctuary. Or you are a soldier in that war.

22- Your parents or mother knew you were being hunted down so she sent you somewhere else, a safer place, like at the door of an orphanage.

23- The game opens up with you in a class learning important instructions and from there certain training. You are maybe a part of the King's elite or something like that.

24- The game… throws you into the action, teaches you first instead, prepares you, places you into a town where you can learn things from its people, quickly unfolds, slowly unfolds, has an aura of mystery or a set of things to watch before you begin.

25- The game asks a series of questions to make out who you want to be at the start. First your name, your specialty, then they tell you where to go and what you should do.

26- You are summoned by something like a talking tree in The Legend of Zelda: Ocarina of Time or a crystal in a typical RPG. You could be summoned by a townsperson, a ruler over a Kingdom, or some strange force.

27- The game gives you a series of things for free. Like Pokemon starters or something that determines how the game will proceed.

28- You are visiting a place for the first time and things didn't go as expected.

29- You start the game in a celebration of sorts such as a carnival, holiday, or celebration (similar to Chrono Trigger.)

30- The title screen cinematics lead you right into the game. It could say things like "100 years have passed since then," or give you a back story on the things to come. In that case the more important things about the overall plot are presented- everything you need to know to have a quick and basic understanding of the game are all there.

Frequently/ Traditionally Used Ideas:

1- Vacated towns full of homes that you can enter and ransack. Some needing keys. Maybe not easily gotten into.

2- Lands full of mist and fog. Rainbows and night time stars, and the mystery of a star far away. Puzzled scientists and trying to make sense of everything.

3- The nature of the universe is changing and what was once a law of physics no longer is.

4- A monstrosity being formed by nature. By science maybe, or through a rite.

5- Being expelled from your Homeland but returning as a savior.

6- A rush to get to something before anyone else does.

7- The loss of a precious material that saves life. That keeps the world alive. A fountain, a crystal. Or a doorway that was once sealed but now has been opened, and monsters coming forth. Or them coming from another world or dimension.

8- To be tricked into setting them free. To be fooled into letting them loose, and now all hell breaks loose.

9- A greater ability to toy with your opponents. Casting spells that just screw with them. Casting spells that just toy around with them and turning them into whatever you wish to.

10- A lengthy list of spirits you can summon. Pages long. Having many to find. Earning their support. Having them evolve. Investing *them* with armor, spells, magical items and things instead of just you and your party. Making them more like playable characters.

11- More job titles than are currently used. Like a King. He can collect taxes and us above the law. A shape shifter, a spirit, a jinn, a trickster.

12- The story is sometimes split into more stories. You play the part of one in it's own area, then the part of a character in another.

13- And sometimes the world of the game depends on who you play with. Each character let's you do the things that you only can with them.

14- With some you play there's a different game. They can fly, or hover, they go faster, or are stronger. And with some of these comes some pretty intricate strategy.

15- There are cheap ways to diversify the game and yet they have a good effect. Like just changing colors or appearance. Or a slowly setting sun.

16- One good game had the great idea of chasing around ghosts on a horse and capturing them. Capturing things can also include funny looking bugs and the kind you

see everyday, or fairies. Or a jinn put inside a bottle. Or a spirit that you suck into a machine.

17- There is starting over from scratch in some games. That you and your team were separated. Or what you had was lost. Or that it was taken from you. Could have just been that after the player dies they lose their power ups. Or could be that the world was rocked with devastation and you awoke on a little island.

18- Fighting while you fall down a waterfall. Or going through the waterfall. Or a leap of faith. Where the river leads you after many bends. Or a waterfall at the base of which is a great cavern.

19- Having the stealth to move across safely. Sneaking in. Avoiding contact with sprites, including any eye contact. Passing the soldiers. Going about on roofs. The back door. An unknown corridor. A sewer.

20- Learning a new sword technique. Spinning. Shooting beams from them. Slashing. Multiple strikes. Piercing through. Targeting and attacking consecutively.

21- Scores and scores of magical fluids deposited in bottles. That raises health and magic. Or defense, offense, speed, that make you float. That enhances your abilities or changes your environment. Or just a jar of holy water.

22- Gathering in one area for The Great War. At a sky high tower. On top of a great mountain. On a great plane. The place rumored of where good and evil will meet for one last battle.

23- More quest for the sake of Greydom (or Graydom) than for good or evil. As such a quest not for the victory of good or evil but for the Gray. Becoming a Gray Knight instead of a paladin.

24- Have interesting boss enemies in RPGs always. Actually they *all* should be well drawn and animated. The players need to adjust their tactics in order to win. Have them change form and go along with a theme, like a wall moving forward that you must stop on time. Or that pesky arm that does you more damage. Or the enemy that changes its weakness.

25- Transportation: it can be a car or truck, a Jeep or motorcycle. A train or a bus. A taxi or a flying bird. A horse or an unearthly creature. Can be a space ship or jet. There are *many* possible forms of transportation you can put into a game. Even a magical portal. And a boat.. and a raft.

Shoes that let you walk on air would be cool. I don't mean to just let you fly up and down. But ones more used like an imaginary staircase. Or that lets you control exactly the direction you want to go in.

26- Story twists can include betrayal, an unexpected event, the tables being turned, an unknown relative, a trick, a self-sacrifice, an unexpected ally, person was possessed, had hidden magical gifts, inherited greatness, changed their nature, getting help that saved them from what was otherwise impossible, being lied to, conspiracy.

27- A build up to an upcoming thing is always a good thing to do. Stuff of legend. That great power. The Sword in the Stone, The Greatest Spell, The Lost Kingdom.. *stuff of legend*. Things most say are impossible but turn out to be true.

28- They all have level ups. Going from 1-99. But there could also be evolution with these in, say, every ten levels. By the time you reach 100 then, you've evolved to *godhood*. Every ten levels could give you a new set of magic or a new talent, or greater stature. You start at fire 1. At level ten it turns to fire 2.

29- There could be a library of games within the games. In areas of books and as such each town you go to will have its own special game to find, or a set. Simple mini games and stuff as things you can find like treasure in an RPG.

30- A search engine kind of thing within the game can pull up all kinds of information like where anything in the game can be found.

31- Species of healing plants, species of poisonous ones, ones with magical effects, one to feed summoned creatures, according to appearance can be collected.

32- You can rent out items rather than purchasing them. Or make deposits. Or trade two outdated things from your party for one good new item, as you were just going to forever unequip them anyway.

33- Changing the entire game world could be because the previous one was put to ruin, the new one was a more evil dimension than the light one, or the map could change from one set of levels to the next. Sometimes the player goes to the moon. Sometimes to an underground land. Or a cloud land. And in many games you just have restricted access until you find the right item to proceed.

34- Some magical items work on a timer. They last from a few seconds to a minute or so. Or until magical power is depleted. Some enemies cast a spell that leaves you with a little time to beat them in breaking the curse. Some curses have an I'll effect on you every step you make.

35- Cursed items are sometimes present. That when you open or use them a great monster is inside. Or that they *could* be powerful if the curse was broken.

36- Some magical rings work very well in casting auto magic. They adjust stats or have you protect those low on HP. They let you double cast magic and make two of yourself for double the power. They shield and protect or augment your power in some way.

37- There is a helper along the way. It could be a bird that flies up to you from time to time. Or a sage. Or a special message sent through telepathy. Could be a fairy. Some of them help the story along and have good advice. Others must think you are plain dumb.

38- You get a raft but later you need a boat. You get a hovercraft across ragged areas. You get a ship but it is lost. Or you need one that can go to the moon. You get one item that helps, but later you get one that helps the same way but more.

39- Things unexpected can come in the form of a treasure chest containing a monster, a powerful sword suddenly breaking and needing repair, a less common random battle, learning new spells based on level ups, a power up like in a side scroller that is only in one area of the game, being deposited suddenly with a lot of money, a city once hidden appearing from nowhere, or an area of the world below you that you had no idea existed.

40- At the end of a level, a battle, or area, different effects could be made. Sometimes you get extra points or a mini game depending on where you land. Sometimes you fall from the sky with a wand in your hand. Other times you just touch an orb and continue. And sometimes you leap and circular dots circle around you. A cut scene may follow it. A victory may include leaping up and down. The defeated opponent may just disappear, or dissipate into fragments with a booming sound effect.

41- Inventory can be on a limited basis or as stocked, still more or less limited. Some games let you have just one item at a time while others may give you a dozen, and some, hundreds. They may appear overhead or just in a sunscreen. Or just the screen before a level, giving you choices if you want to use one before entering.

42- The roles of the ones you play as can be, among others: *a protector, a wanderer, a treasure Hunter, one sent in a quest, one trying to save another or a group, an explorer, a reluctant soldier, just a person who wants to tag along, a person that has no else place to go, one needing help, one on a mission, a rebel, or a person thrown into matters above him or her.*

43- Villains come in all shapes and sizes. Some made have been entirely unique, some represent old ideas, a mix perhaps. And there is a lot to say about villains. They may have super powers. They may have an army behind them, a group, a gang, a cult. It has been about clowns. Like evil ones or just crazy ones. Some have been taken from mythos. Or old stories like Dracula. In video games they are often animals. A turtle, a crocodile, a toad, a pig man. And there have also been: powerful wizards, a Sorceress, aliens, super minds, scientists, and martial art masters.

44- They have an array of schemes behind them. While they are seeking or keeping total power you are sent to make things right. And while you may fight on a moral basis they do not. Some of them may be plain evil as a type of game has it. In other types of games you know little to nothing about them. They are just the last boss. Maybe they stole something from you. And are much just in cartoon form.

45- Their foes of yours can be legendary or other worldly. Full of great powers and inhuman. With a dash of the eerie and spooky. They play their part as their strange nature comes into play.

46- The primary villain can gain more and more power until it becomes godlike. Or be vested with a natural source of power leading them to use it in any bad way. They have the greatest magic, powers, weapons, devices, and vehicles. The most wicked appearance. The most intimidating one.

47- They usually have a particular way to defeat them. They may be weak to only one weapon in the whole game, or they are stricken in that red dot on them style. And sometimes go from one form to another, maybe having four.

48- Along the way they have put every obstacle in front of you that they could have. The level leading to them is full of all kinds of evil. It's to reach the top, go through a course of statements, and to deal with an enemy that cannot be changed.

49- Give the final boss a personality, dazzling power, a build up leading to him, her, or it, and transformations if you like, their escape from time to time, and great weapons that only they could defeat.

But if you are making a more simple game then a simple enemy will do just fine.

50- The resources of the land (or level, areas) can be stumbled on or only found with a lot of searching around. A merchant may be on a train or residing in a forest to help you along the way. And friends may return to you at an unexpected time. A pearl in the ocean, precious metals buried, trees whose branches make great wands, dust of magic power, herbs in the field for magical purposes. And these things can be taken and used as is or put together in a form of alchemy. In a swamp a sword. A stone in a rocky area that has power. Looking for a lost ring that though it is hard to find is powerful. A spider that weaves magical cloth. A dragon whose scales make a shield. Or a creature providing the same.

51- Something in the basement of a home. A key found in one place but used in another. Like a key to a home. A fallen knight in a field with a knight offering you his sword for help. An area of once a great battle where armor and things have been left behind.

52- A place of great power where certain spells can be cast but nowhere otherwise.

53- A fountain or spring can restore energy. And while some games have multiple ones others are scattered around. Some were just there where a programmer felt they were needed, but being in only one spot on the whole game. Fairies have been used to restore energy, revive life, too. Spells and items can restore energy. That includes dropped items. Some may restore it as time based. When an item used like a ring counts down to zero, that's all you get! Some after battle times restore it, or when you reach the next

level. Some towns folk do. Usually at an inn, buy not only. And sometimes you just talk to an NPC and they say, "hey! I'll restore your energy!"

54- "Leaps of faith" are sometimes put into a game. It may be very literal, like jumping from a cliff. You may think you'd die if you do. But it turns out you landed in a very special area. I've seen things being timed this way. You had a couple of minutes to get out then the game asks if you want to wait another few seconds. You want out. But if you wait then a former party member comes up to you and you leave together. That character would have not been playable afterward if you didn't. The game may ask "look around more?" As a hint that you are about to leave something behind.

55- Potions can come in purity. The purer they are the more powerful. And a few percent more or less can make a big difference. Whether it be for attack magic or for curing the higher percent of purity the better. And percentiles can be used to formulate your own concoctions.

56- Buttons can be used to indicate things through sound. For example a "yes" sound or a "no" sound, or a "you are close" sound plays when you press a button on the gamepad. Hold down L and R together, or justly button A, whatever you like. So if you want to know if you are close to someone or something, pressing a button will give you a sound, accordingly. One small theme of music per question answered.

57- Spells of great distance are not commonly used. But they could be used to affect the game from very far away.

58- From one game to the next, sequels have sought to do one better. There has usually been that characters have been added to it. Sometimes the same boss, sometimes a new one. E tea power ups and abilities were added to make the game more fun. The story may have stayed the same or was adjusted a bit. The playable areas were increased in size. The new hardware allows for far better games, or at least is the hope. But there comes a time when things have changed so much that they cannot be recognized as its own title suggests. And new ideas are just gimmicks that came from all of the leftovers.

59- Good games are loaded with extras. Things that are only in one part of it. But so many of them fill up the whole game. Like a third that at one point in the game could steal the guards clothes to sneak in by. Or that *one* time when you walked up to a stove and pressed a button it burned you. That *one* instance, that *one* time you could do something in the game but nowhere else in it. Like jump into a large boot and hop around or one enemy that steals from *you* when no other ever did.

60- Games haven't always been based on simply computerized graphics as we know them. Some were interactive movies. Some were vector based. Some were LCD or just lights. Some affected a virtual experience with mirror tricks.

61- Old styles of game making have far greater potential than before in terms of depth. Where it once had to cram in what they could, there is a lot of space now besides. There is room for far wider areas with more in them. Music can be orchestrated for it. And cart adjustments could have it fitted in to some extent. I think though it is better to have it somewhat plain. As far as the look of it goes, anyway. Cut scenes and graphical improvements made but they should retain the feel of the 16 bit era, 8 bit if you like. Some of these new games have in them some goofy voice effects.

62- It's really an art of balance contrasting one with another.

63- Most spells are based on the elements and guessable things like poison and healing. But there could be simply "color" spells that strike twisting lightning of colors. Say that a foe is mostly green, a green spell can be used on them. That is to say, the green spells affect the green things in any play area as the programmer would have it.

64- Among non typical kinds of games (and the typical are very typical) are games that would have you playing a guitar, raiding an animal, a farm, exploring the deep sea, going around photographing, games of an educational basis, brain power games.

65- Games that are transferred over to video games: like TV game shows, or Sudoku, some kind of card game, a number of sports, a board game like Chess, are all easily programmed but tons of fun, and do well enough.

Retro Video Game History:

Among one screen games are games that have you fighting in patterns. Tennis kinds of games were the earliest ones. And not always literally one screen. But based on just a few each of limited design. There was evasion incorporated. While enemies were either falling from the screen getting lower and lower faster and faster, or a thing or groups of things chasing you around in maze form. You fought for immunity all you could with a special item. There were safe areas here and there. There was a safe path, sometimes one that altered, requiring a bit of strategy. And to escape into an area that was safer was common. To reach the highest part of the screen. Getting help here and there. With enemies moving in different ways: up, down, left, right, diagonally and in circles.

Then came basic 2D going where very much more could be added to this. We then had the player going left to right, most commonly. Some very imaginative minds created some great games with these new hardware abilities. Games had music. Synthetic sounding, but present. And for the first time they could have stories. A new controller layout was needed. Save features became necessary. With them you could continue on your quest and play more in depth games.

The previous era of gaming hadn't any quality control over it and so any game could be released for them. Gamers got screwed over and the market was in shambles. Presenting them in a new way became necessary. And making sure that the games had a level of quality among them was, too.

They wanted better effects in their games. But the hardware was very limited. They'd try for environmental changes, pseudo-3D, things the 8 bit era couldn't do. They had little to work with but still came up with some attractive graphics sometimes. And as the game carts of the time were improved and the hardware was better known, better things could be done. Using every trick in the book they even made some portable games that still pack a punch to this day.

Peripherals became more ideal for the 8 bit era. The games were just complex enough to allow for them. Like them or hate them, some were a lot of fun. Others didn't work like they claimed to. There was a lot of motion sensing. Then there was the toy gun and games for them. Touch pads, multi taps, and lots of gimmicks existed.

As for portable gaming it has become possible to have *good* games that could be swapped out and changed.

Game making has become much more intricate already. You could have dozens of different levels each with many screens instead of just playing the game in one or a few. The graphics within them were more developed, and how the game played out from one object to another.

The 16 bit era came next. Many old ideas were reused and made incredibly better. Having more seemingly orchestrated music. Giving the player good looking homes and villages, allowing for more colors and details. The games themselves were bigger. The enemies in them could be far larger and more intimidating. And more controls were possible with new gamepads.

The arcades were breathing their last breath. Certain fighting games were still popular but little else. Those were moved over to the home consoles and the market with them. Fighting games were very popular at this time. And for a time RPG games shined.

The 32 and in some cases 64 bit era followed. But it was a rocky start for many. There were once popular console makers that just couldn't get in the market well enough to stick around. Carts were going out. CDs became the standard. 3D games were now possible. And the way to make them was of a brand new understanding. Some were very basic. Others were quite lush with environments and things. CDs offered more space and better music. And again a new controller was needed, most of all the thumb stick.

Some games went very poorly into 3D for the first time. Embarrassingly so.

Games were needing large teams to create them.

Fighting games moved into 3D. As did most other genres. To at least have a touch of 3D they felt was necessary.

There has never been a guarantee that any one company will be best in the market and remain that way. While 2D games were the expertise of one company or a few, those games may not evolve well. In the days of 3D first person shooters have reigned supreme. And those kinds of games were not even made in the past.

So the market was born and brought up with these. We are still in the 3D era. The gamepads are mostly the same. The games are more in depth but still generally the same in their nature.

$200 for an old 2D console.. and about the same for a single 16 bit system that included a game. That's *before* inflation. But now there are remakes of them packed in with dozens of games. With wireless controllers too. At what would once cost thousands and take up a lot of space is a hundred modern bucks and tiny in size.. like the size of your hand, and they could go much smaller if they wanted to.

Then there are rip off devices. Like ones loaded with ROMs. Having hundreds of games on them. Being able to hold thousands. Played portably. I do *not* recommend them because that takes all the fun away. Once you have everything you want nothing.

There is a very large community of retro gamers. There are many thousands of videos of them online from play-throughs to glitch expositions. And retro games are being improved these days due to new tech and software. Giving an almost 3D effect to a 2D game or sharpening it's graphics. So much graphical improvement to impress. Art is collected for these things. Shirts, dolls and things too. And some of those old games are incredibly valuable. Like the sought out rare titles that are sealed. Or games of which only a few dozen exist.

And new games for old systems are being made. Or else hacks and reprogramming of them. With modifications that the original gamers of them would have loved to have.

More About Making Good Games:

The process of making a game can be as rough a draft as fitting pieces together randomly as they are called for. You may go back and find that something could have been done better. Naturally you don't want to split hairs. Good enough should be left alone. Then, if you need to spend more time on something else you can. You may be

able to do it alone. Or you may need help. You can use a game making software or learn programming if you do not know how to already.

Work things out on paper. Save your notes. Use those that were the best. And be aware that although something may seem the best idea at the time it may not seem so later. So returning to your notes tells you that, think about it. Adjust it or change it to be something better.

You may decide to put it on a cart or a disk, as a file that can be used on a computer. Just a digital file or contained within its own hard drive. Our choices are increasing. Going back to old systems is perfectly alright. People to this day are buying them. There are things modernizing old consoles too and clone systems that actually play physical games. If nothing else there are emulators available that will let others play them. Online companies are available for mass reproduction and for game boxes and manuals.

The best games come from passion. Not from lack of desire. People have collaborated and sought the best possible experience out. The most suitable musicians were found and used and that made every bit of difference. Some things make the best difference. Like the theme of the overall game, the graphics, the items, and the mechanics. To be a good game it is probably going to have to be a labor of love. Strive to make a good product. Don't let the sun go down on a poor or inadequate game. Remember: once it is done it is always done- at least in that form. There can always be remakes to come and that sort of thing but when your product is done it is like it is alive. It will sell itself and give all of its goodness to the player based on how well you made it.

I always wanted to program a game. I've never been able to. So I did the next best thing. I created a book of ideas for others to use and hopefully come up with a great game from them. I've shown examples of how ideas were used before. And really just about any idea has been used before in some way or another. So I made it a book of choices. This is a public domain book because I am just after making a positive change in the gaming world. I am not making any money off of this book or any of my books (if you want an even better book my Game Maker's Bible will be finished soon.) I post the ebooks on many online sites for free whenever they allow it (and most do.) If not then I sell it at the minimum allowed price. I am not even getting paid for the paperbacks since I set the revenue goal at $0. The people making the book get paid a little. I don't. With all of this feel free to share my book. You can sell it if you want as well. You can also add to them and either sell or share them. My Game Maker's Bible is a book I would like people to contribute to much like an open source software.

Just the same if you are a publisher, just publish it.

For me early on I wanted to make a game. In my 8 bit days seeing what was there before I'd take to paper and try one better. My ideas weren't that great. I was only 10 years old. But one idea had potential. A major game company told me that they were interested in the concept. They sent paperwork to me to establish my own copyright. My idea was for a two headed skeleton. One shot fire, another shot ice. This was in the 8 bit days where general ideas were very simple. But when I got the paperwork I presented a whole new idea altogether- instead, and they rejected it! I'm not the kind of guy that promotes my material. I always felt that if my books were worth reading then they would do well enough on their own. I've considered doing silly things before like sneaking my books into libraries or placing them in different areas of town. Maybe I could sign my books at a bookstore! I don't think so. I mean even if I could that would just be pretending to be famous. 'Someday I will be famous and then the signature will be worth it.' Some people actually do stuff like fooling themselves into thinking the books they mail to 100 different places a month are suddenly going to be picked up, loved enormously, and boom! They're in! It would have been better if they spent more time writing then all of this time and money consuming self-promotion. Everything I've said here is also applicable to game makers and their products. In fact I think it is even more true for them.

I'd say "keep on a simple pace." Do not flood an area with ideas. Do one thing that is simple enough and onto the next. In that way you will keep control over the overall design. Otherwise you may decide to add this and that, then ten more of that, and more, until things are out of balance. Rotate your ideas, you could say, and better comparisons can be drawn. Avoid the thinking that it can be good or *should* be good. If it really is then you will know it. It is always a good practice to move onto something else if you find you are stuck on something. The mind has a way of working out things after you refresh it. Some game makers are not done until all of the things have been worked out to their best potential. They are the ones that always create great games.

Rip off artists take the same story but with a different theme. Which would be fine, but it never results in a superior product. Those that are in it for themselves know that they have a good idea in mind and act on it. In a way, copy cats are working for other people. Their games are like fan games of other games- something a little like a musician that only sings cover songs. They'll be given all the revenue from their games though and that is why it is called ripping someone else off.

Some games are awful for just one reason. If that one reason wasn't so then it could have become a classic. But the controls are broken or something else. Some games have one ugly thing about them that follows throughout the game. Such as stiff jumping animation- or more accurately non-animation. Some games were so lazily made that the whole of the music is just a repetitious melody. Some games were missing the better elements contained within their genre- may be too simplistic. Some have been too ambitious but the people making them really had no real grasp on what they were trying to do to begin with. Some on the other hand were rushed out. Along the way someone may have made excuses and too many compromises created a bad game. In making a good game a game maker must be honest with themself in determining if the game is really good or not. They may find that just a small amount of extra work will make the game much better, too.

Some game makers are masters at adding extra touches. Just slight things that make the components of the game better. It is thought and consideration worth putting in. On the other hand sometimes things are given too many new coats of paint. It seems put-on/ trying too hard when that happens. It could make something that should be simple too complex. Adding a nice touch is like a just right stroke of the brush. It isn't a smear so to speak. Just a graceful swipe of the brush. They are things that have no argument of being out of place. The gamer appreciates them. Sometimes it is just turning on the light to something you want the gamer to see. Other times it is overting the gamer's focus on things that are more important.

At some point things are as good as they are going to get. But to continue on them for the sake of perfection changes them around.. changes ideas around that were originally it's foundation.

Some foes are plain. They just charge at you like a fast pace of walking. Might have a weapon in hand. But aren't really anything special. Good enemies in the game are carried out in special ways. Some game makers prefer to have the gamer bombarded with a variety of enemies each with their own patterns and way of attacking. As a result the gamer isn't expected to just go around striking enemies in a shallow way. The game is given more depth when different enemies are attacked in different ways. That substance to them can go beyond their looks and how to attack them too. What happens after you attack them or try are good things to tackle. They could give you a shock if you use your sword on them. They could turn into a usable shell. They could try to leap out of your way, for some examples. How they move around is another thing to address. Do they float around, avoiding you, dashing towards you instead, or leap around? Those are some other questions worth working on. With all of these great and unique enemies can be made add a lot of fun and substance to the game.

Lots of content can lead to over complexity, but it doesn't have to. You can take a complex thing and simplify it. The complex thing didn't change at all, just its representation. For example you have a lot of abilities but changing them is difficult. It isn't the amount of abilities you have that's a problem. It's quickly changing them that is. So the game can make it easier to switch between them. There are too many areas to go through. It's confusing or time consuming. Teleport rooms and maps can address that. So even if you have difficult things in the game other things can simplify them.

For some games like an RPG story is essential. It made one series succeed and another fail. We have some of the best modern stories of all time due to RPG games. It's like classical music. Classical music isn't dead, it just went into games and movies. That reminds me of Final Fantasy 6 and its 16 bit opera or that piano player in Final Fantasy 8. Games are such a strange thing if you take them seriously and immerse yourself. More and more it is a story that you make for yourself. They are like movie producing effects sometimes. While graphics get more and more better these games become like not only a movie you live in but you control. They are like movie producing games if you record them. In the past you couldn't do much more than record them on VHS. Not short movies either by any means but movies of 30 hours or more.

Some levels had been made of just a splash of ugly colors. While others have made them very nice looking. Like one with green bricks, another gray with cracks and vines and red brick doorways. The gamer maker's style is seen in their games. That could be like Akira Toriyama and his Dragon Ball style of art found in the Dragon Quest series and Chrono Trigger. Or Yoshitaka Amano with Final Fantasy, and the differences and uniqueness between them. If we all were to make an original comic book or do 10 drawings we might find our own unique style in it like our artist fingerprint.

Some required pestering things from you. Like the meat you carry for health automatically rots. Or you are required to camp and required to just the right amount. In other words realism was put in them that pesters the player.

Try to find the right balance between ease and difficulty. Give the player what they need to manage the game play well. Avoid any cheap shots against them. Take into mind that any given area should be masterable through practice- and always make practice pay off. Powerups can help with this. Sometimes it requires another way around/ a second or third option. Don't bombard the gamer with too much difficulty at the start. On the

other hand if the total design is intended to be a very difficult game then do so, just be fair with the gamer. Let their practice make them better. That takes good control of the character and some degree of predictability.

Some games win you over while others push you away. Sometimes things are piled too high to enjoy them. They are a flood of content neverending. It is good to have a pause kind of moment to gather yourself. A bonus level for example or just a nice time of leveling up before you continue with the story. A high learning curb from the start is a particularly bad thing. Some games are so BO and BS. I can think of one fool's gold among gems- Final Fantasy Mystic Quest!

The story can be totally involving but predictable enough. Could leave you guessing and awaiting the next steps. Can evoke emotion or be sappy. Could pull you in or could be shallow. In any case the pace of it should be just right. Don't just brush over significant occurrences. What's funny isn't funny at all if spoken by a person without any real humor. Such people take the ridiculous or absurd and think *that's* funny. It usually isn't. Sometimes it is even cringy. As for a good story they require dedication from beginning to end. If you've ever seen a movie that was great when it began but midway it just became unwatchable it was probably because the writer got tired of writing. Sometimes people start working hard but after a while go into "anything goes" mode. They may even convince themselves that whatever they make will be good when that starts to happen. Anything worth doing is worth doing good.

The more you know the more you understand. And there are a lot more ideas for games to pull from than there were before. Find the right mix. Do one thing but in a way that is better. Try to one up your competition in every way, just make sure it all fits together desirably.

 Have a spirit of competition. That is your love affair with other game makers- and all is fair in love and war. They want to outdo you (and you, and you) and you (and you, and you) want to outdo them. Hopefully you do anyway, as if you are to be better than them then that must be your intention. Make them jealous! Make them envious. Become that game that everyone is talking about while their masterpieces are just ignored because of you. Of course that is a lofty goal but the harder you try to do this the better the game you will be made. They say nothing is perfect but perfection is about how close you come to it. It's the best possible you could say.

Usually with more simple games there are among titles very weak ones with maybe one great one. Maybe the programmers just wanted to push out a fast game. The idea behind them was simple, after all. But then among all those is one very good title that is a staple for the genre. Like a casino game for example. One had the works: multiple slots, different tables, more appealing graphics, and so on. The game size of this stuff is so minimal but one would just have one building to roam around in. I guess you could call that "improperly keeping things limited."

Great programmers learn tricks to defy the hardware. And lots of good things can be learned from them. They may have created pseudo 3D or made music that was thought impossible on that hardware. And all they used were tricks to get around it's inherent limitations.

Especially for ports. Taking an arcade game back in the day and doing all you can to make it look as good as the arcade version. While some take the approach of "this isn't a kitchen, you'll eat what I serve," another knows that the fans will not accept a far inferior product.

Good games more often than not call on good programmers more than they do good hardware. One will make an awful game on a system but another a good one. It isn't always the hardware's fault unless your goals are unrealistic (such as puting Street Fighter 2 on an 8 bit system.) And there are those that produced games that it was thought impossible for the hardware.

Some games need extra elements added to them to make them work. Like a special move. Or as simple as holding up and A to throw a weapon. While people may want a simple idea to work it may need a thing added to it in order for it to do so. One weapon may have been originally intended but going back on programming they realize a different kind of weapon will be better overall. The same with sprites that based on hardware needed to be programmed a certain way, Mario was never meant to have a hat. They didn't originally want Mega Man to be blue. The NES had so many shades of blue available though so they went with that.

Conclusion

I hope I've provided ample ideas for you in making a game.

You may just flip around in its reading anytime you need to brainstorm.

This is a public domain book. You may use it in any way you wish. But singular rights for it are not given. You can use it freely with or without crediting me. With or without selling it. The EBooks of this book are free and may be shared with whoever you wish. I love to provide free ideas and free books. I really do! And in the spirit of that the next part is solely about new ideas anyone can use in their game. I hope you find things that are useful for you here.

Making video games is an art of all arts. Within it is drawing, music, stories, and so many other things. It involves a collaboration like no other. People get together- one to write the music, another to draw things out, one for the story, or perhaps a mix. It is good to have the right team on your side.

It is a creative process in which imagination can truly shine. A whole new world can be designed. There is more life to what you create compared to a movie, cartoon, book, or anything else. Not only do you create, you also breathe life into it. If it is a fun and memorable place you make then your game will do well.

The final product will at last be given life. It will exist on its own with no further work needed except for perhaps a sequel or remaster later- but those are themselves their own self contained things. If you are lucky it will sell well and be highly esteemed. Maybe you might even become a good influence for games to come!

Above all strive to make a good product. Make something that will make the gamers say "this is what we wanted! This is what we've been waiting for!" Something that gives the player what they wanted and then some. If you can cause that reaction just like games of the past did (Super Mario Bros. 3, Street Fighter 2, Pac Man, and other legends) then you will have succeeded entirely in making a great game.

Part Three: New Video Game Ideas

This is a public domain book. My intention for writing this book is to provide as many good ideas as I can. I'm not in it for money. I'm in it to help anyone make a great game. So here are as many good ideas as I could come up with and you are free to use them, reject them, change or enhance them. If nothing else they will get your thoughts and imagination flowing.

1- In a platforming game you get coins to use power ups and other things like vehicles. So unless you have five coins you can't take their power, for example. Coins can also

determine how many times you may use a special weapon. If you go over a certain amount of coins then weapons start to become more powerful.

2- There are three rows of gameplay areas that change you according to where you are passing through. On the bottom row you are normal. The middle and top rows both make you play as something else.

3- You get greater and greater floor pounding that breaks you deeper and deeper into the earth, bringing you to new lower areas. You have greater and greater gravity to break into lower areas.

4- You have the weapon of something like a giant fist. It can break things your normal attacks cannot. It can pound down things. It can clutch orbs to give it more power. It can pick up weapons and use them. This fist isn't attached to your body, rather it hovers above you. It can also point out where hidden things are, pick up very heavy things, suck in all of the enemies around you, and wield weapons.

5- You have a magic branch that does things whenever you tap it against something. For example if you tap on a door with the magic branch the door will open but not otherwise. If you tap on a tree it will talk to you. Instead of keys for dungeon doors there is this branch. If you tap on a tombstone a spirit will come out. If you tap on a statue it will come alive and move out of your way.

6- Slime enemies come out of slime.

7- There are a lot of statues that will come alive so you have to maneuver around them like a minefield. In a platforming game.

8- 30 gold coins automatically give you gold armor. 30 silver coins are easier to get but give you silver armor instead. 30 purple coins give you a power up. 30 green coins, red coins, etc. automatically give you their own things.

9- When you kill a bat you get a bat (baseball bat.) When you kill a cat you get a cat of nine tails. When you kill a boar you get a door. There is a word play like that in the game.

10- The objective is to block off The Doors of Evil. Where monsters and demons and things come out. Sealing the Seven doors in any kind of genre. Blowing up bridges, magically sealing off doors, bringing special relics to otherworldly doors or sealing up pits is the overall idea for the game.

11- When you take your regular horse to a special area it turns into a flying unicorn. It is hard to travel there but worth it.

12- Whatever area you are in changes you. If you are in a graveyard you change into a ghost. If you are in a forest, an elf or fairy, if you are under a bridge, you become a troll, if you are on top of a mountain you turn into an angel.

13- You collect alphabetic letters in the game. Each one gives you a number of things to choose from, per letter. Such as the letter S will give you a sword, shield, the letter B will give you bombs or bullets. You choose what you want and can get as many as you have letters for. If you get four B's then you can get four "B" things.

14- The whole game has homes in the background that couldn't be entered into until you beat the game and play the second time.

15- If you open up a certain area of the game then evil beings will pour out everywhere. You are told to never leave town because evil will find the sanctuary of the villagers.

16- Along with coins, stamps. Get 10 stamps for a free item.

17- You are trying to find your brother/ sibling because you know only they can help you.

18- There is a tax in stores that is refunded to you once in a while.

19- More regal characters pay no tax.

20- You can borrow money but if you don't pay it back you will lose all of your inventory. The more valuable your things are, the more money will be lended to you.

21. The higher your royalty is in the game the more you are allowed to do things such as camping out in shacks reserved for royalty, you have better prices for things, you can go into areas others cannot, etc. That may be a "Prince" job class.

22. Other job class ideas: Magic Linguist, they can decipher magic words and use them. Astral Projector, they can leave their body and act on spirit, and can possess things. Evolver, they can evolve into a more powerful character over time. They can also evolve other things. After evolver there is an enhancer, they can change and enhance things, investing magic into them. Transporters, they can drive any vehicle and sumon horses. They can teleport. The Otherworldly, they open up new dimensions for any given person, place, or thing. Another could be "importer." They sell things for more when taken from one area to another. A very powerful job class could be "ruler." They set rules for the game. They make things easier that way, they prevent or cause certain conditions.

23. Some ideas for leveling up: Saying "Level 1B" lets the player know they are halfway to level 2. That can be extended to C and D. When the player wins a battle it will say "Level 1D" and the player will know they are very near to level 2, 3, or whatever it is. There are better battles on farms. Farmers house better battles. It costs a fee, like so much per day or few days but leveling up in them is more rewarding. If you want battle after battle to level up faster than you can cast resurrect on anything. You get experience points after you've defeated them, and just as much more if you cast resurrect on them and defeat them again. Random battles may be determined by the phases of the moon. There could be two moons to add to that effect. There is a safe path that discludes random battles- such a simple idea but one seldomly used. In some

random battles there are beasts that were caged. An unlock spell sets them free for you to fight. Some are good and will help you during that random battle, others are there to get more experience points from.

24. Some ideas for RPG stats: There is a magician that can balance out your stats for a fee. So if you feel you have too much for one but too little for another you can have it balanced out through them. Or you can pay to randomize all of your abilities. Some items require a star stat. Star stats are gotten after a threshold. For example if you get a strength stat up to 30 points that becomes a star and now heavier weapons can be used. In the shops it will indicate this.

25. The ability to create a bridge before you out of thin air.

26. You can become a spirit to roam much faster.

27. You were caught or detained. Fortunately you are a shapeshifter. You turned into a bat and flew away. They didn't even know you were that bat. Or you became a gold piece in the guard's purse.

28. There is a professor in the game you can always turn to. He will tell you useful information about the things you find. He is knowledgeable enough to make things according to what you bring him.

29. There is a scientist in the game with equipment only you and him know about. You are plotting together to take over the world. Or maybe he is a good scientist with plans against an evil ruler.

30. There is a railroad in the game. It seems to be there for no reason- where is the rain? But at some point in the game the doors to the ghost train can be opened and you can travel down it into the spiritual realm.

31. A secret in a level will only be around for 30 seconds so if you are going to get it you must act quick or replay the level to find it.

32. There are magician characters in the game that turn you into different things like animals or magicians yourself. They are helpful too.

33. There are different colors of cotton to harvest. They are each good for their own thing.

34. The value of a thing is color based. The weakest green the strongest gold for any given thing- and nearly everything is so coded. This will give the player an immediate idea for something's worth.

This will be continued in the book "The Game Maker's Bible + New Video Game Idea Book." It will be available for free online.

Right here is a small space where you can list the games that you find most inspiring…

www.ingramcontent.com/pod-product-compliance
Lightning Source LLC
Chambersburg PA
CBHW081001170526
45158CB00010B/2864